THE PEOPLE'S
JUBILEE

First published in 2012

A catalogue record for this book is available from the British Library

ISBN: 978-0-857331-85-4

Published by Haynes Publishing, Sparkford, Yeovil,
Somerset BA22 7JJ, UK
Tel: 01963 442030 Fax: 01963 440001
Int. tel: +44 1963 442030 Int. fax: +44 1963 440001
E-mail: sales@haynes.co.uk
Website: www.haynes.co.uk

Haynes North America Inc., 861 Lawrence Drive,
Newbury Park, California 91320, USA

Images © Mirrorpix

Creative Director: Kevin Gardner
Designed for Haynes by BrainWave

Printed and bound in the US

THE PEOPLE'S
JUBILEE

VICTORIA MURPHY

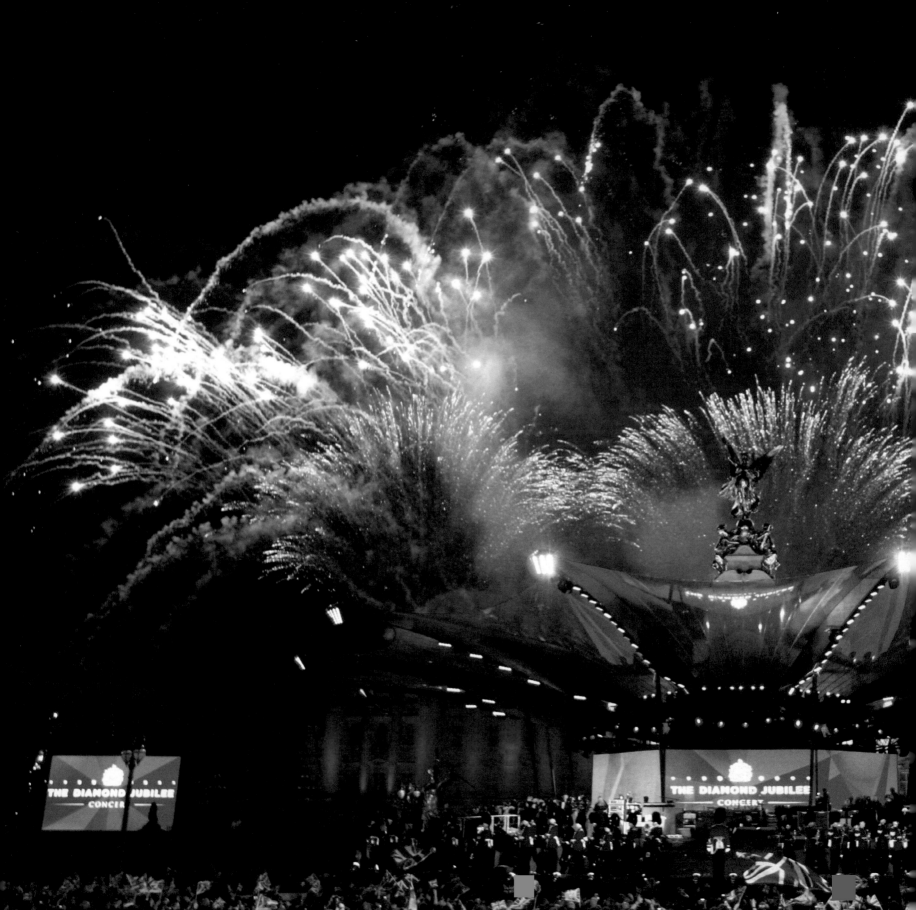

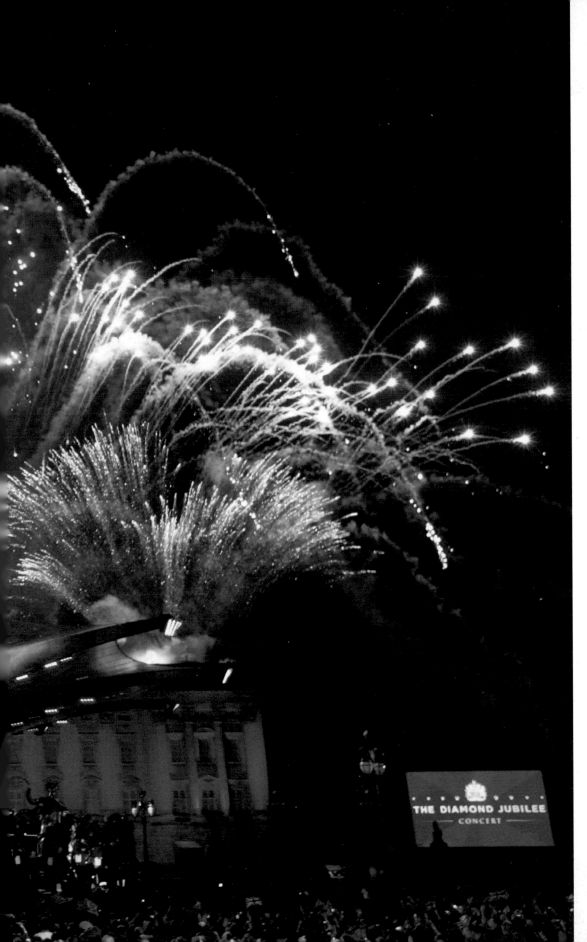

LEFT: **Fireworks explode over Buckingham Palace during the Diamond Jubilee concert, 4th June 2012.**

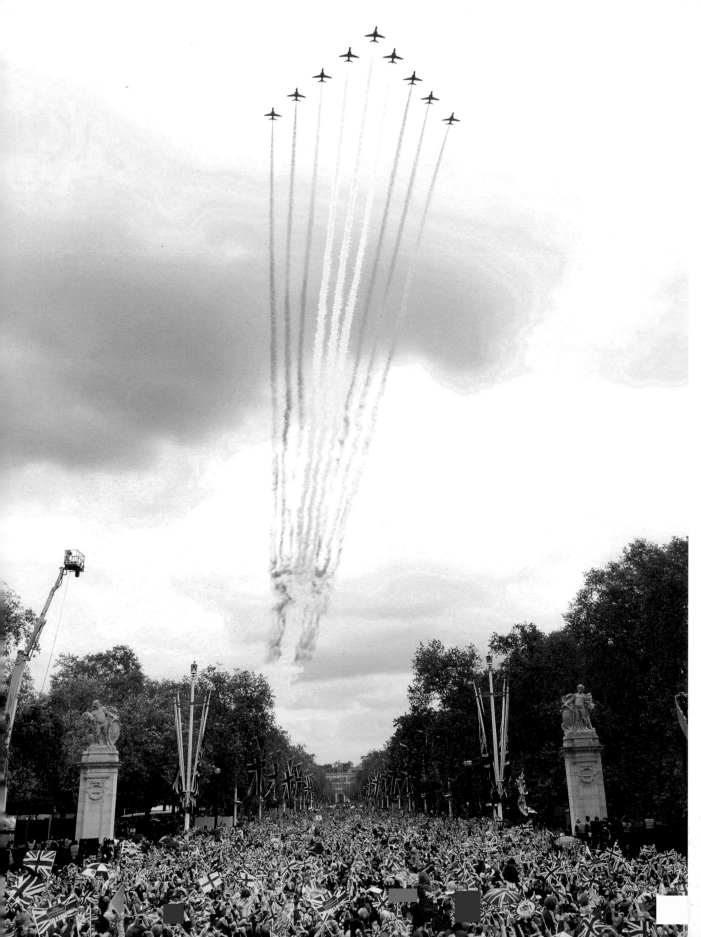

LEFT: Crowds flood the Mall as the Red Arrows perform a fly-past on the final day of the Diamond Jubilee weekend, 5th June 2012.

RIGHT: **Families in Birkdale, Merseyside, enjoy a Diamond Jubilee street party, 4th June 2012.**

"I hope that memories of all this year's happy events will brighten our lives for many years to come."

Queen Elizabeth II message of thanks to the nation following the extended weekend of Diamond Jubilee celebrations, 5th June 2012

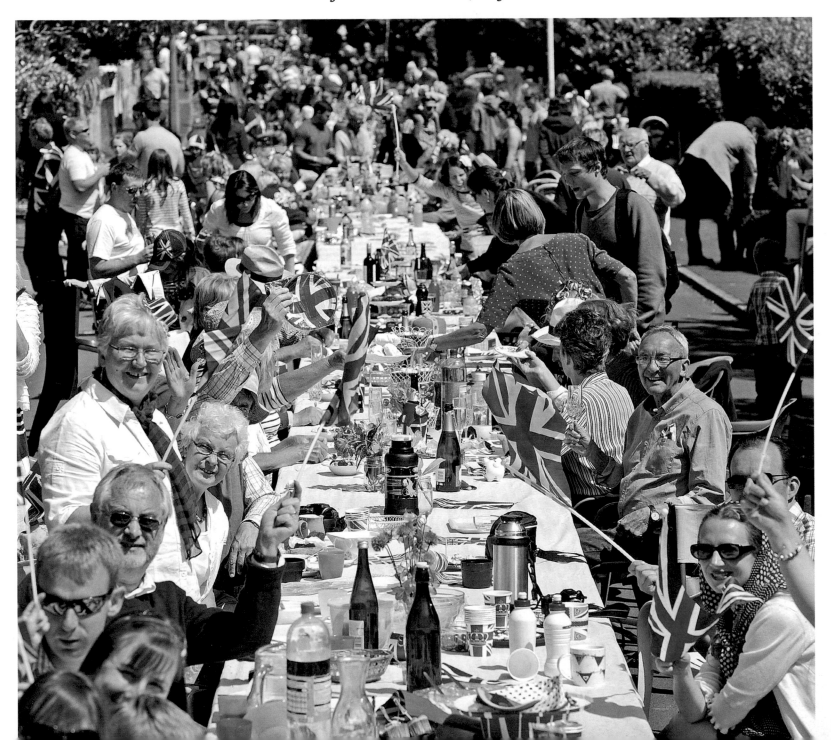

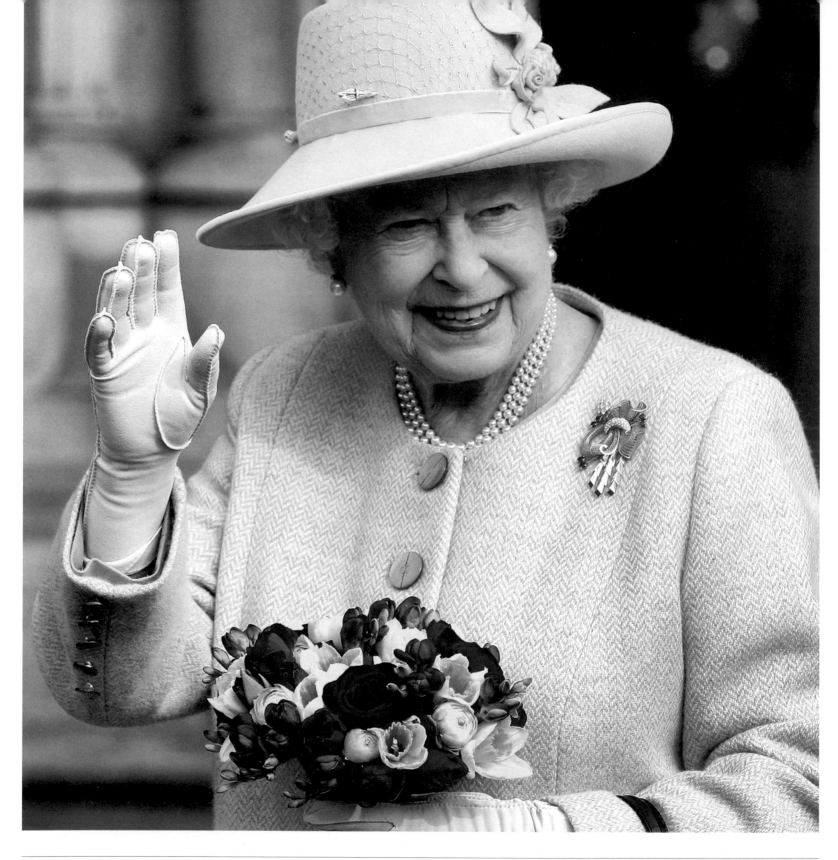

ABOVE: **The Queen waves as she visits Manchester Town Hall during her Diamond Jubilee tour, 23rd March 2012.**

"So, in an era when the regular, worthy rhythm of life is less eye-catching than doing something extraordinary, I am reassured that I am merely the second Sovereign to celebrate a Diamond Jubilee."

Queen Elizabeth II Diamond Jubilee address to Parliament, 20th March 2012

CONTENTS

INTRODUCTION

"I hope also that this Jubilee year will be a time to give thanks for the great advances that have been made since 1952 and to look forward to the future with clear head and warm heart as we join together in our celebrations."

Queen Elizabeth II message to the nation on the 60th anniversary of her accession, 6th February 2012

On 6th February 2012 Queen Elizabeth II became one of only two British monarchs ever to mark a Diamond Jubilee.

It was a huge personal milestone for a woman who has devoted her entire life to serving her country, and it was also a moment of great public celebration.

The months that followed saw the nation, the Commonwealth and the rest of the world join together in an extraordinary display of gratitude for the Queen who has been a constant presence through six full decades of unprecedented change.

In an extended June weekend of spectacular celebrations the Royal Family took centre stage at the Epsom Derby, travelled down the River Thames as part of a record-breaking Flotilla, hosted a picnic and pop concert at Buckingham Palace and attended a Service of Thanksgiving in St Paul's Cathedral.

Everywhere they went crowds of thousands cheered, as cities and communities up and down the land held their own street parties to mark the special year.

And the Queen's unique ability to secure a place in the hearts of generations of Britons was clear by the 130,000 letters and emails received by Buckingham Palace in the first few months of 2012.

Before she became Queen, when she turned 21 in 1947, Princess Elizabeth vowed: "I declare before you all that my whole life whether it be long or short shall be devoted to your service and the service of our great imperial family to which we all belong."

It was less than five years later, on 6th February 1952, that the huge responsibility for the Crown fell on her young shoulders after the death of her beloved father King George VI.

She was in Kenya when she became Queen, but did not know it for several hours as news of the King's death trickled so slowly round the globe.

You only need to contrast this with Diamond Jubilee celebrations communicated instantly to the farthest flung corners of the world via television, the internet and mobile phones to understand how much change her reign has seen.

Through 60 years of 12 Prime Ministers, numerous wars, four recessions and a technological revolution, the Queen has remained a constant, carrying out hundreds of engagements every year.

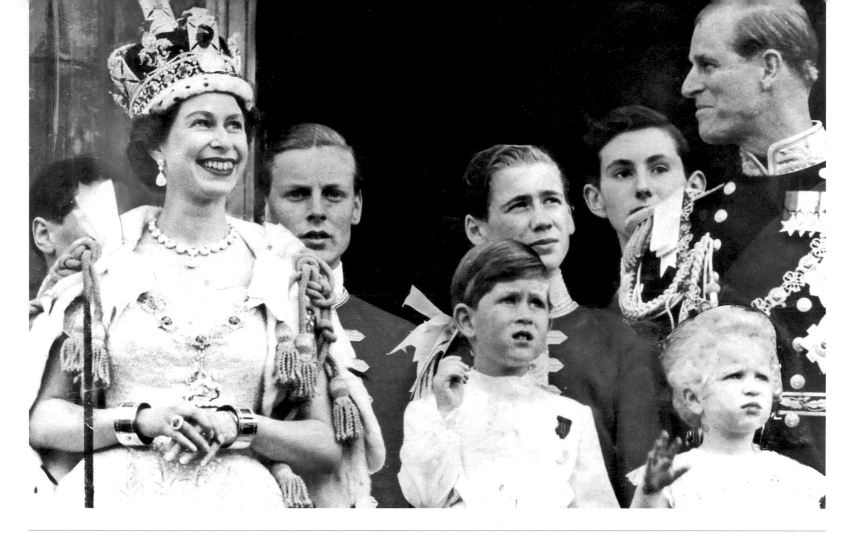

ABOVE: **The Queen, Philip, Charles and Anne on the Buckingham Palace balcony following the Queen's Coronation, 2nd June 1953.**

And, despite turning 86 in her Diamond Jubilee year, an age when most have long retired, the Queen rubbished any suggestion she may abdicate with a simple message issued on the 60th anniversary of her accession. Rededicating herself to public service, she wrote:

Today, as I mark 60 years as your Queen, I am writing to thank you for the wonderful support and encouragement that you have given to me and Prince Philip over these years and to tell you how deeply moved we have been to receive so many kind messages about the Diamond Jubilee.

In this special year, as I dedicate myself anew to your service, I hope we will all be reminded of the power of togetherness and the convening strength of family, friendship and good neighbourliness, examples of which I have been fortunate to see throughout my reign and which my family and I look forward to seeing in many forms as we travel throughout the United Kingdom and the wider Commonwealth.

I hope also that this Jubilee year will be a time to give thanks for the great advances that have been made since 1952 and to look forward to the future with clear head and warm heart as we join together in our celebrations.

I send my sincere good wishes to you all.

ELIZABETH R.

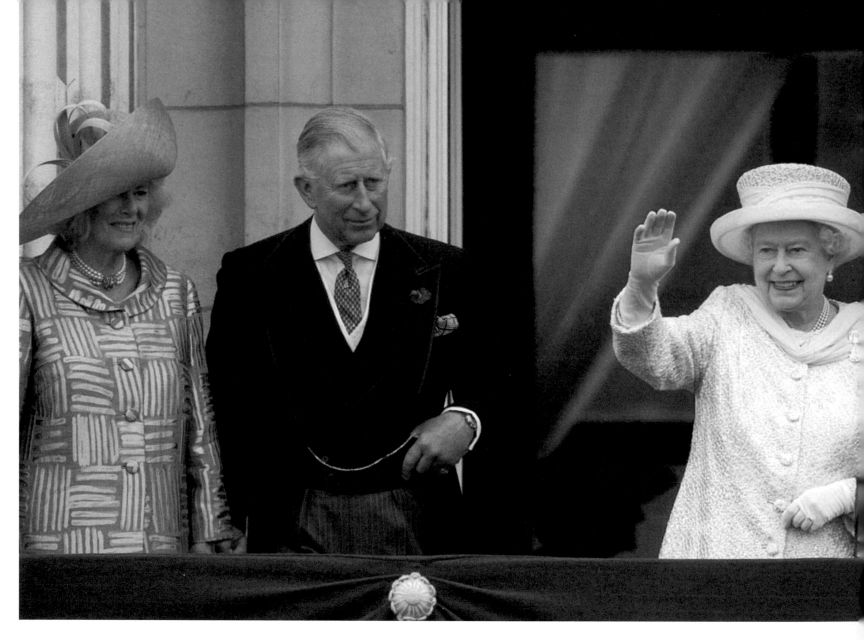

The anniversary of her accession is usually spent in private as it is also the anniversary of the death of her father.

But in her Diamond Jubilee year the Queen chose to be seen in public, spending the day with primary school children at Dersingham Infant and Nursery School in Kings Lynn, Norfolk.

The visit marked the beginning of a jam-packed year of engagements which saw the Queen and husband Prince Philip travel the length and breadth of the UK as the rest of the Royal Family carried out tours to Commonwealth countries, Realms, British Overseas Territories and Crown Dependencies. From the crowds that lined the streets for the launch of the UK tour in Leicester to the Queen's historic handshake with former IRA Commander Martin McGuinness in Belfast, the visits captivated the world.

And the Queen could be sure the future of the Monarchy was in safe hands as she watched Prince Harry's warm welcome in the Caribbean and Latin America and saw the way Prince William and Kate, now the Duke and Duchess of Cambridge since their wedding in April 2011, generated global excitement over their plans to visit Singapore, Malaysia, the Solomon Islands and Tuvalu.

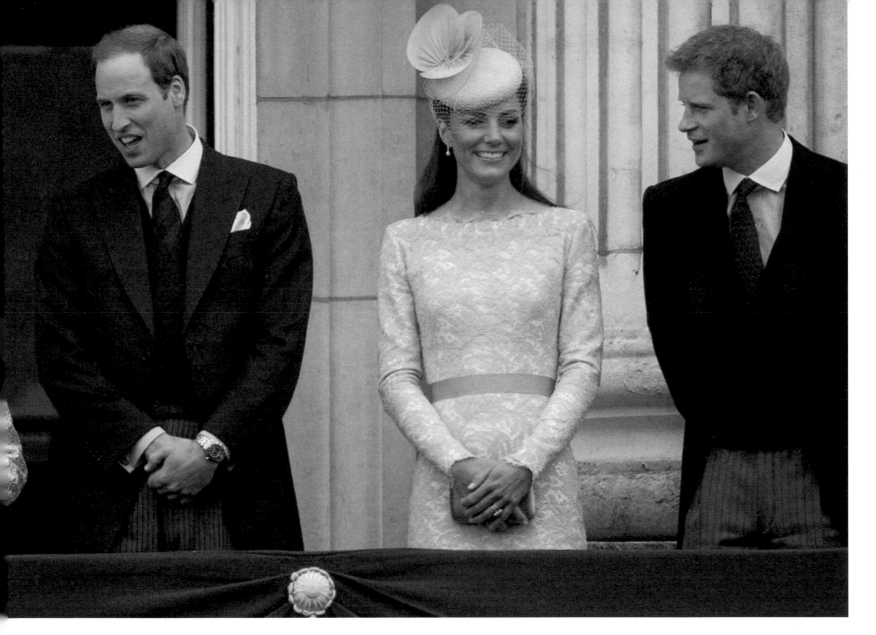

In her Diamond Jubilee address to both Houses of Parliament in March 2012 the Queen joked: "So, in an era when the regular, worthy rhythm of life is less eye-catching than doing something extraordinary, I am reassured that I am merely the second Sovereign to celebrate a Diamond Jubilee."

The only other monarch to reach the milestone was her great-great-grandmother Queen Victoria, who was on the throne for 63 years and 216 days.

However, with her seemingly endless energy for public life,

it looks like the reign of Queen Elizabeth II could go on for even longer.

In her milestone Diamond Jubilee year she rededicated herself to her people. And the millions who came together to celebrate rededicated themselves to their Queen.

ABOVE: **The Queen, Prince Charles, Camilla, Prince William, Kate and Prince Harry on the Buckingham Palace balcony following the Diamond Jubilee Service of Thanksgiving. Prince Philip was unable to join them as he was in hospital with a bladder infection, 5th June 2012.**

CHAPTER ONE

AND THEY'RE OFF

"In this special year, as I dedicate myself anew to your service, I hope we will all be reminded of the power of togetherness and the convening strength of family, friendship and good neighbourliness..."

Queen Elizabeth II message to the nation on the 60th anniversary of her accession, 6th February 2012

RIGHT: The Queen smiles as she watches the horses at the Epsom Derby on the first day of the extended Diamond Jubilee weekend, 2nd June 2012.

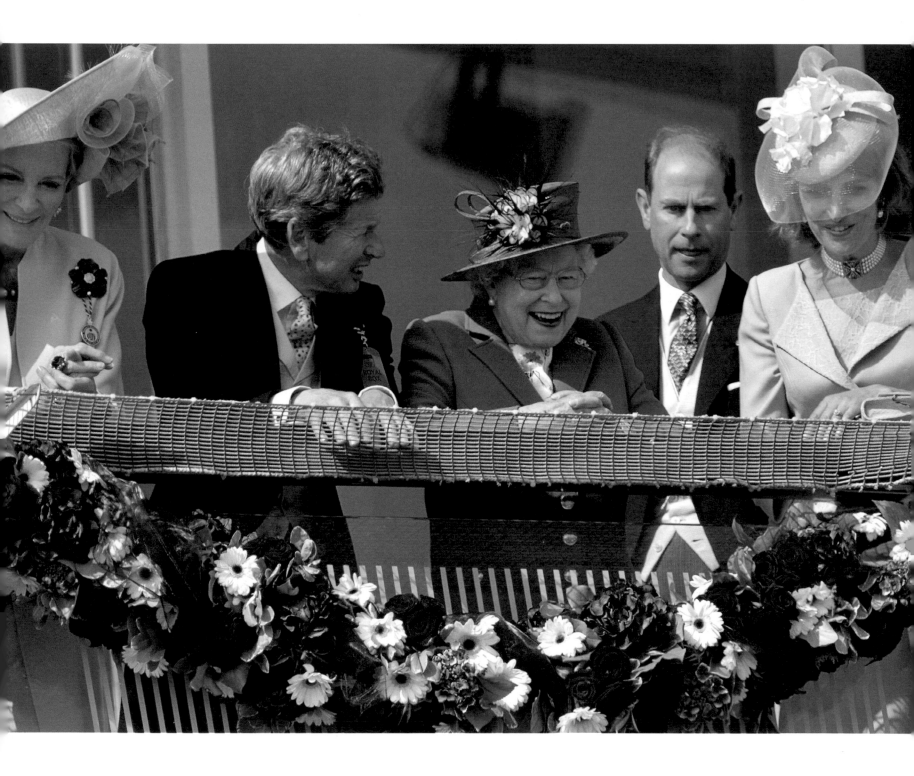

DIAMOND JUBILEE EPSOM DERBY

The extended weekend of Diamond Jubilee celebrations got off to a galloping start as the Queen enjoyed a visit to the Epsom Derby.

Exactly 59 years earlier, on 2nd June 1953, she had been walking down the aisle of Westminster Abbey for her Coronation in a day full of pomp and circumstance.

But on 2nd June 2012 the Queen cut a more relaxed figure as she arrived at the Epsom Downs racecourse in Surrey to indulge her lifelong love of horses. "Well-known for her passion for horses, her visit was a fitting start to the bumper Bank Holiday weekend spectacular," the *Sunday Mirror* reported.

The celebrations began before the royal party arrived, when the British Army's Red Devils performed a spectacular synchronized parachute jump, trailing red smoke and unfurling a 1,800 square metre Union flag as they landed on the course. Then, at 1.00pm, more than 130,000 patriotic racegoers, many wearing red, white and blue, cheered as the royal motorcade arrived, with the Queen and Prince Philip waving from their claret state Bentley.

Wearing a royal blue coat by designer Stewart Parvin and a matching hat by royal milliner Rachel Trevor-Morgan, the Queen was welcomed with a rendition of the National Anthem by Welsh singer Katherine Jenkins, who was accompanied by the band of the Royal Marines.

"I don't think I've ever actually sung the anthem just as close," the mezzo-soprano said afterwards.

"She was literally a few feet away from me. So this is definitely a day that I will never forget."

Providing more entertainment was another of the Queen's favourite animals – dancing dog Pudsey and his owner Ashleigh Butler, who were the winners of hit TV show *Britain's Got Talent* earlier in the year.

"Pudsey definitely caught her eye," Ashleigh said of the Queen.

The Queen and Prince Philip were joined in the royal box by Prince Andrew and his daughters Princesses Beatrice and Eugenie, Prince Edward and Sophie, the Duke and Duchess of Gloucester and Prince and Princess Michael of Kent.

After the fillies had pounded round the track the Queen presented trophies to the winner of the Diamond Jubilee Coronation Cup, a race named in honour of the celebrations and the Derby.

Meanwhile the rest of the country was gearing up for the Diamond Jubilee weekend, with gun salutes taking place around the UK. A 41-gun salute was fired from the Tower of London while others echoed across Edinburgh, Cardiff and Belfast in honour of the special year.

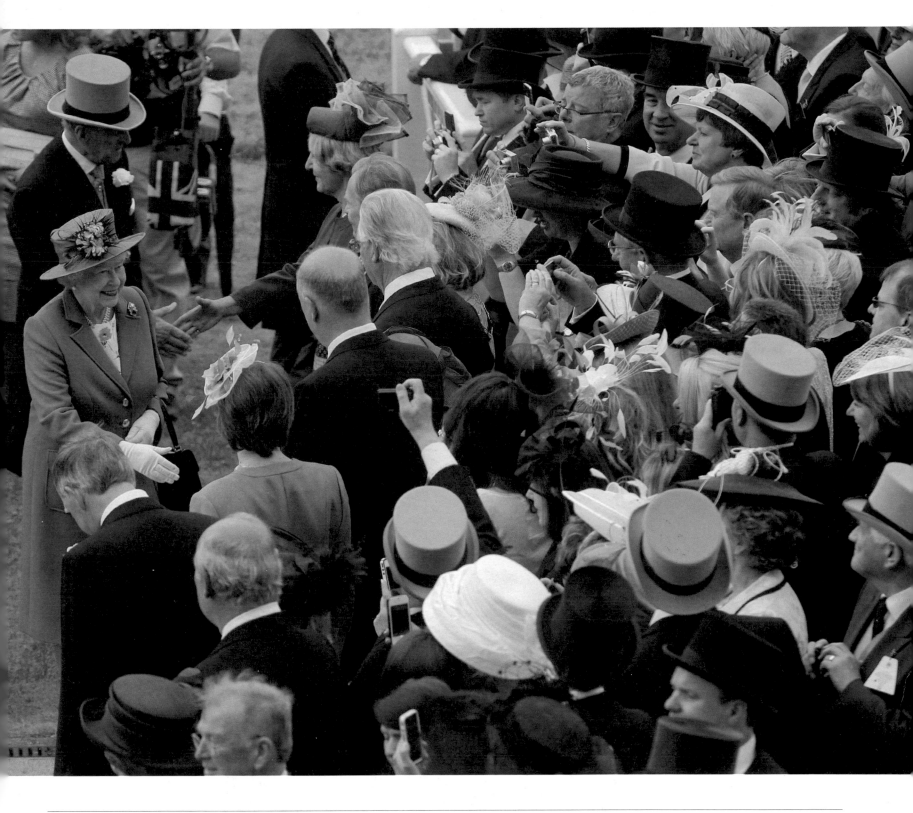

ABOVE: **The Queen and Prince Philip greet the crowds at the Epsom Derby, 2nd June 2012.**

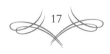

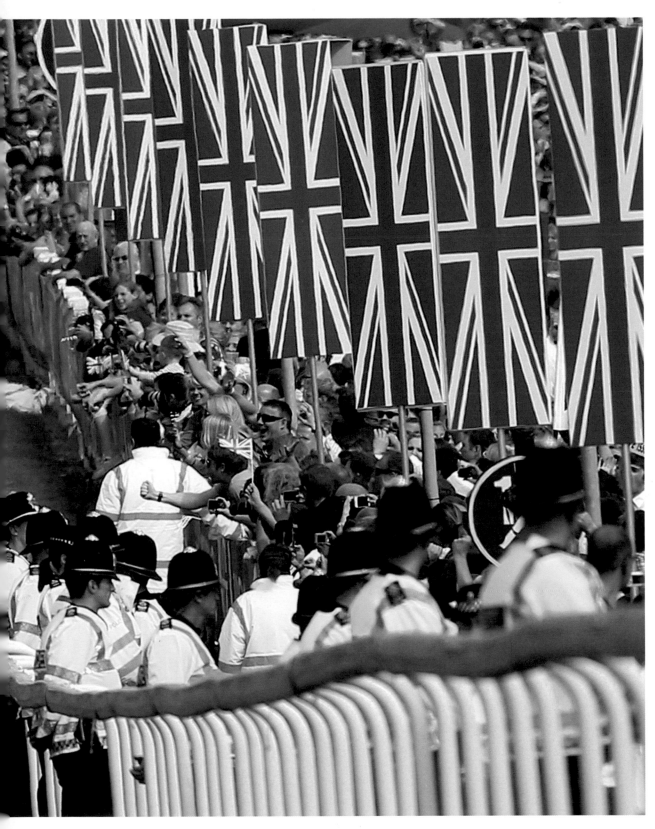

LEFT: **Horse Camelot ridden by Joseph O'Brien races to win the Derby at the Diamond Jubilee Epsom Derby, 2nd June 2012.**

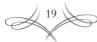

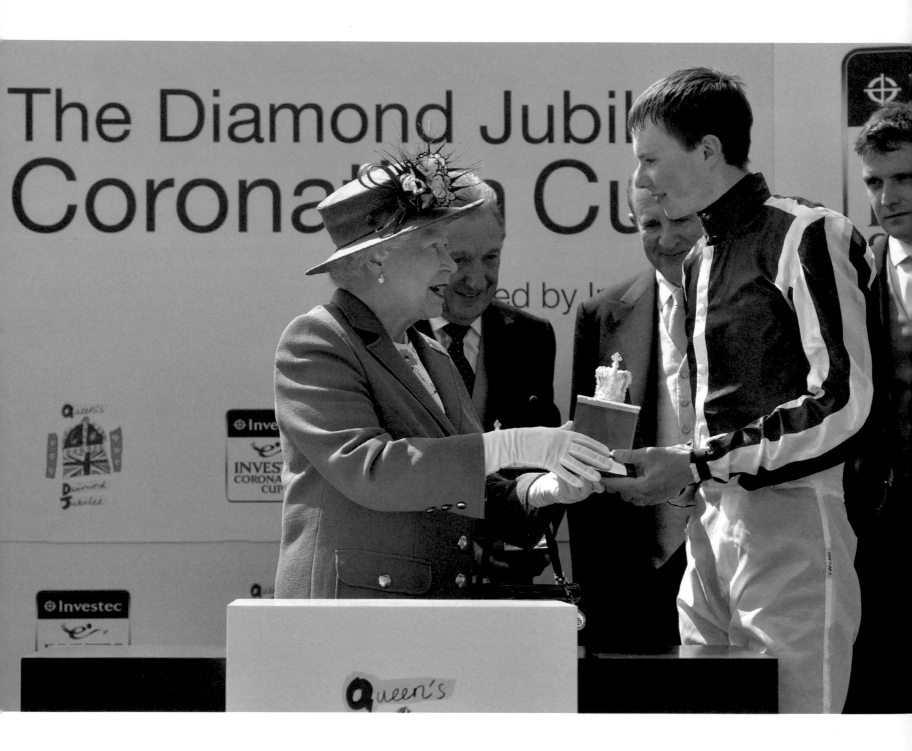

ABOVE: The Queen presents the trophy to jockey Joseph O'Brien, winner of the Diamond Jubilee Coronation Cup. O'Brien also won the Derby on the favourite Camelot, 2nd June 2012.

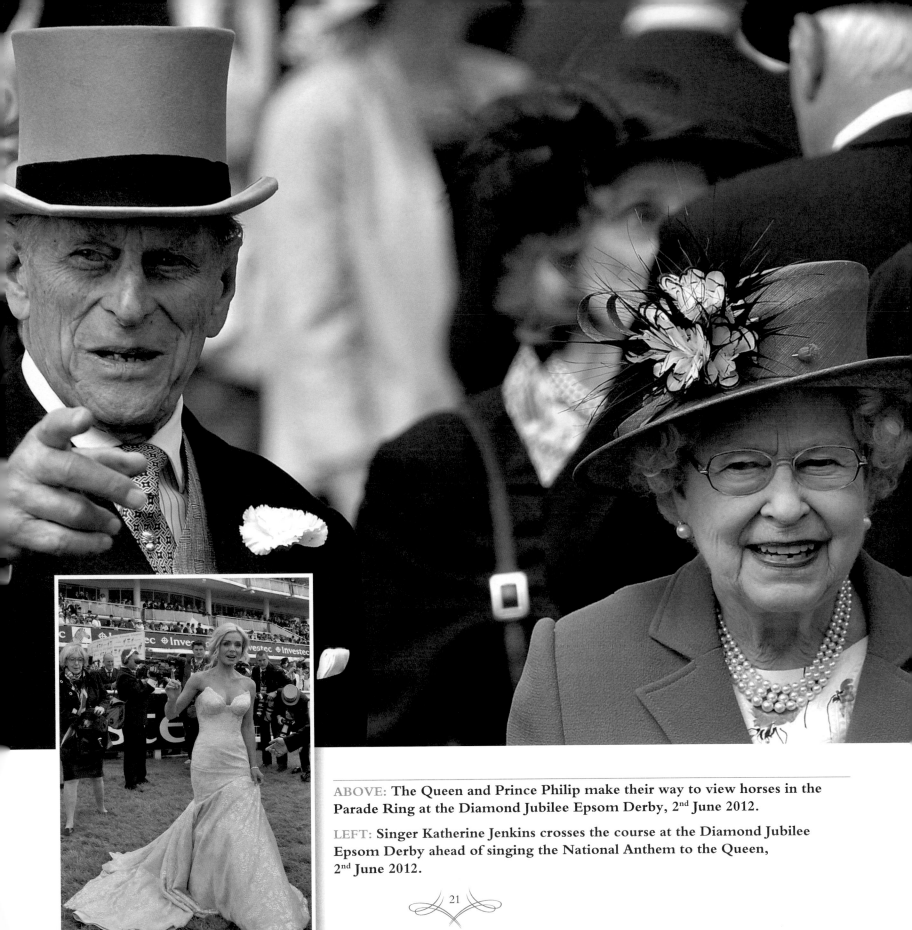

ABOVE: The Queen and Prince Philip make their way to view horses in the Parade Ring at the Diamond Jubilee Epsom Derby, 2nd June 2012.

LEFT: Singer Katherine Jenkins crosses the course at the Diamond Jubilee Epsom Derby ahead of singing the National Anthem to the Queen, 2nd June 2012.

A LIFELONG PASSION

The Diamond Jubilee Epsom Derby attracted worldwide attention, but the Queen has been a regular visitor to the annual race for decades.

An owner and breeder of thoroughbreds and an accomplished rider, she cheers on the horses as a true enthusiast and expert.

"Her love is to come here," Epsom Downs Racecourse Chairman Anthony Cane said at the Diamond Jubilee.

"She comes here in a normal year in a private capacity, not an official visit."

He added: "She's incredibly knowledgeable. Her knowledge of thoroughbreds and breeding goes way back."

The Epsom Derby was first run in 1780, when Diomed won the inaugural race, and has been held every year, usually in June, ever since.

Successive monarchs since the reign of King George III have enjoyed the unique atmosphere of Britain's richest race, known as the "mother of all flat races" with its one mile, four furlongs and 10 yards long course.

While many aspects of the race meeting, from the fashions to the transport, the horses to the prize money have changed considerably, the excitement of the day remains the same as it did more than 230 years ago.

From walking across the course with her father King George VI in 1948 to punching the air watching the finish of the Derby in 1978 to sipping tea from the royal box in 1982, some of the most iconic images of the Queen have been taken at the Surrey racecourse.

A total of 10 of her horses have run in the Derby, the first in her Coronation year of 1953 and the most recent in 2011 when Carlton House finished third.

But she is yet to have a winner there.

RIGHT: **The Queen and Queen Mother at the Derby in 1954.**

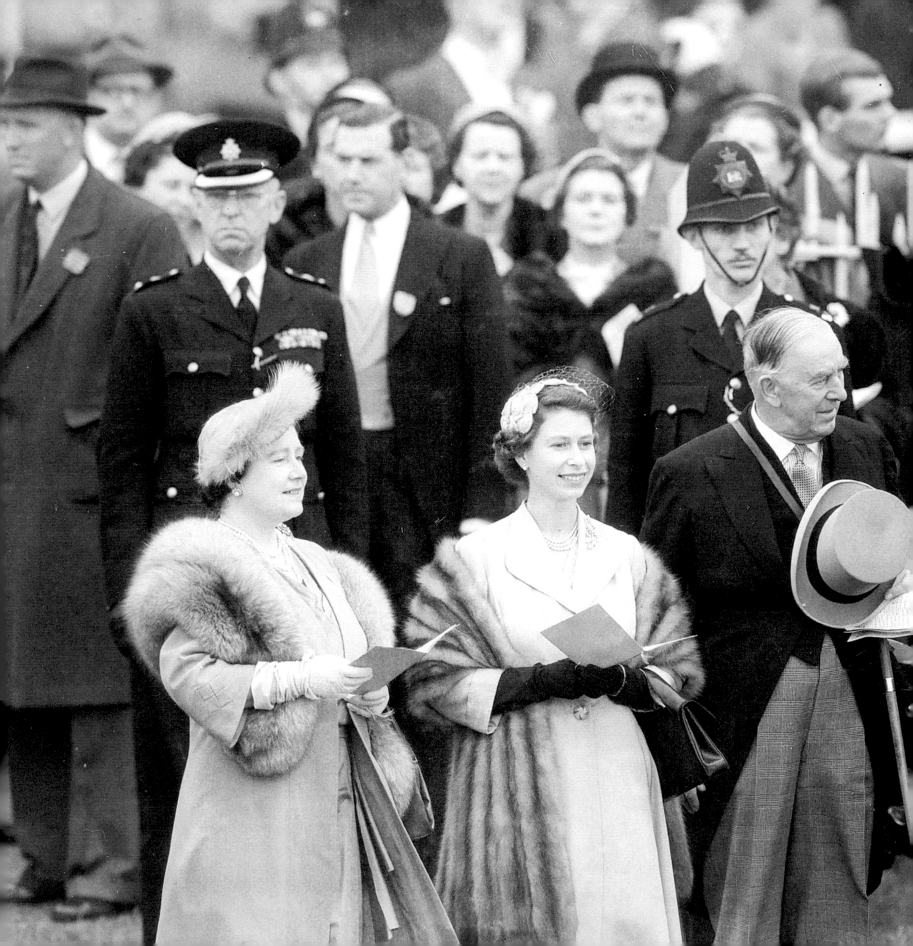

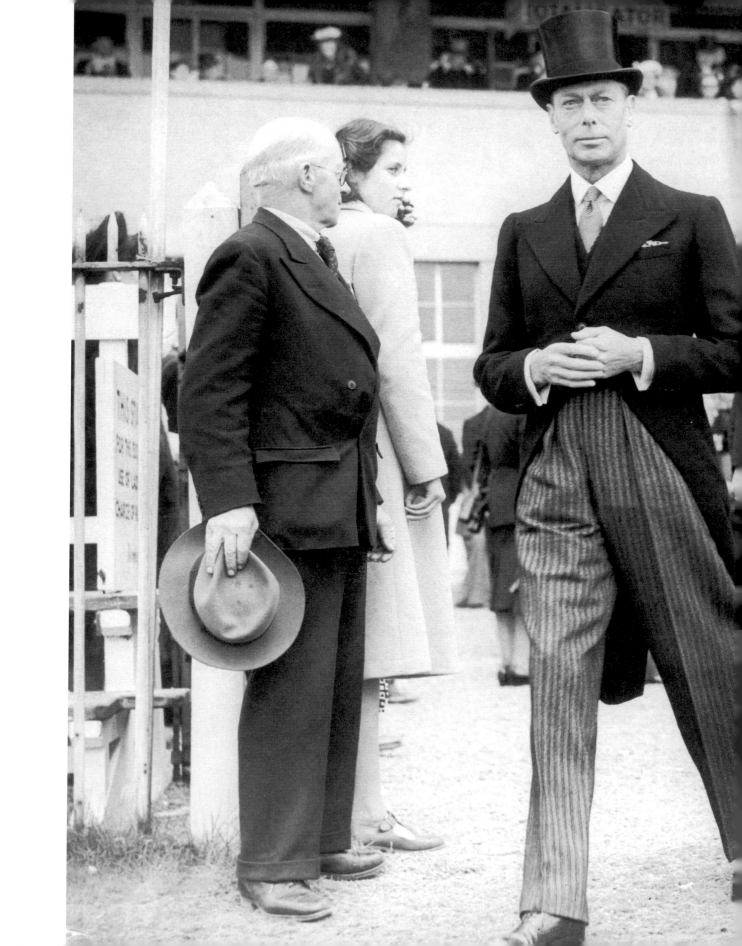

LEFT: **Princess Elizabeth and her father King George VI leave the royal box at the Epsom Derby, 5th June 1948.**

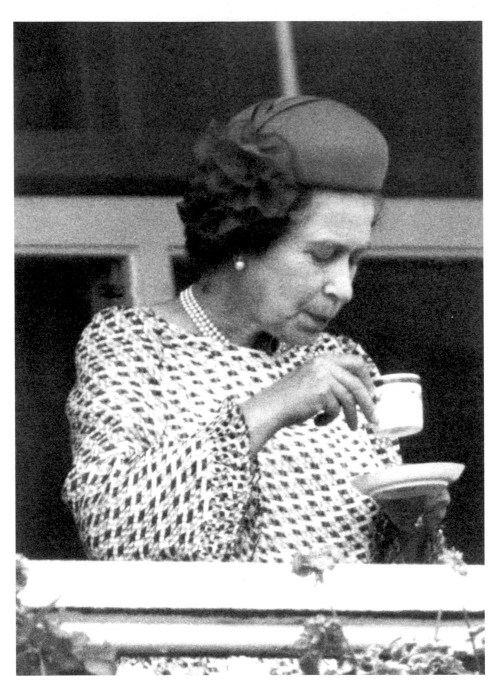

ABOVE: The Queen sips tea from the royal box at the Epsom Derby, 2nd June 1982.

RIGHT: Jockey Gordon Richards is congratulated by the Queen after winning the Epsom Derby on Pinza in this Coronation year. The Queen's horse Aureole finished second, the closest she has ever come to winning the Derby, 6th June 1953.

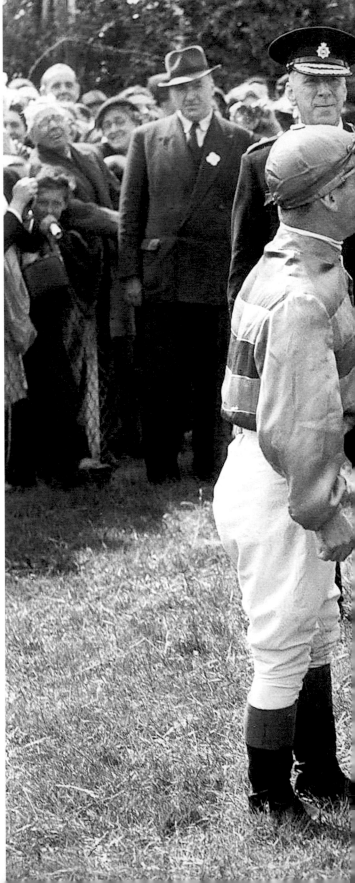

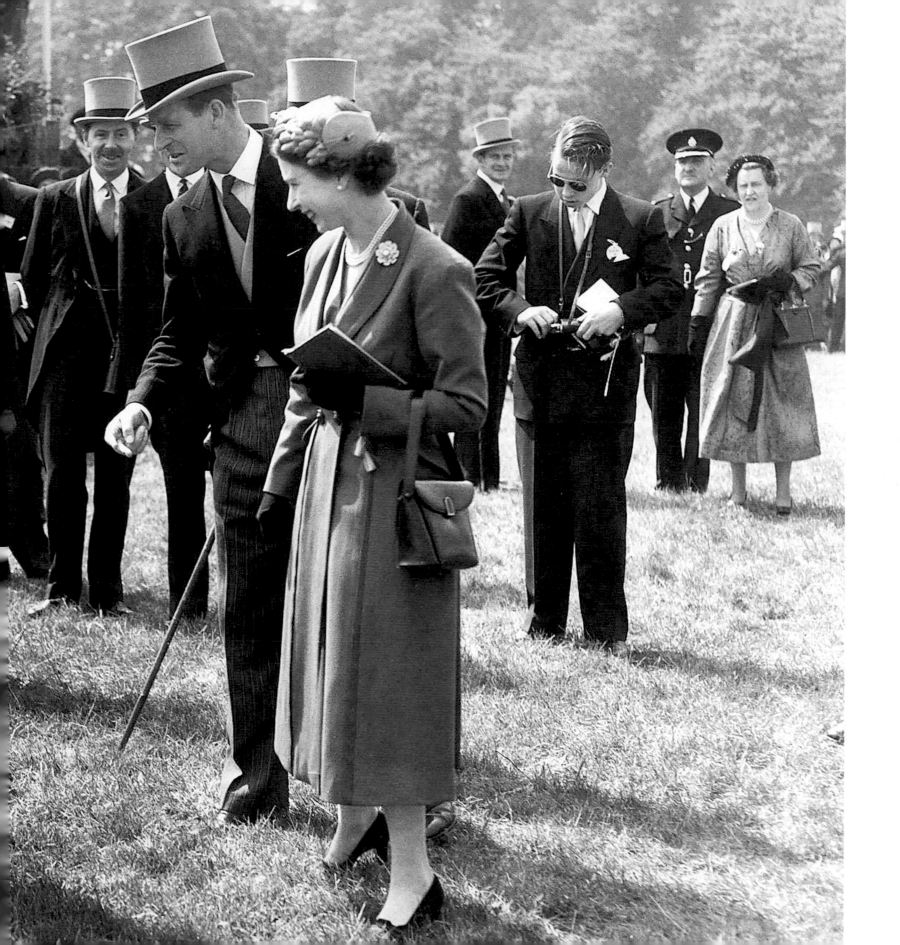

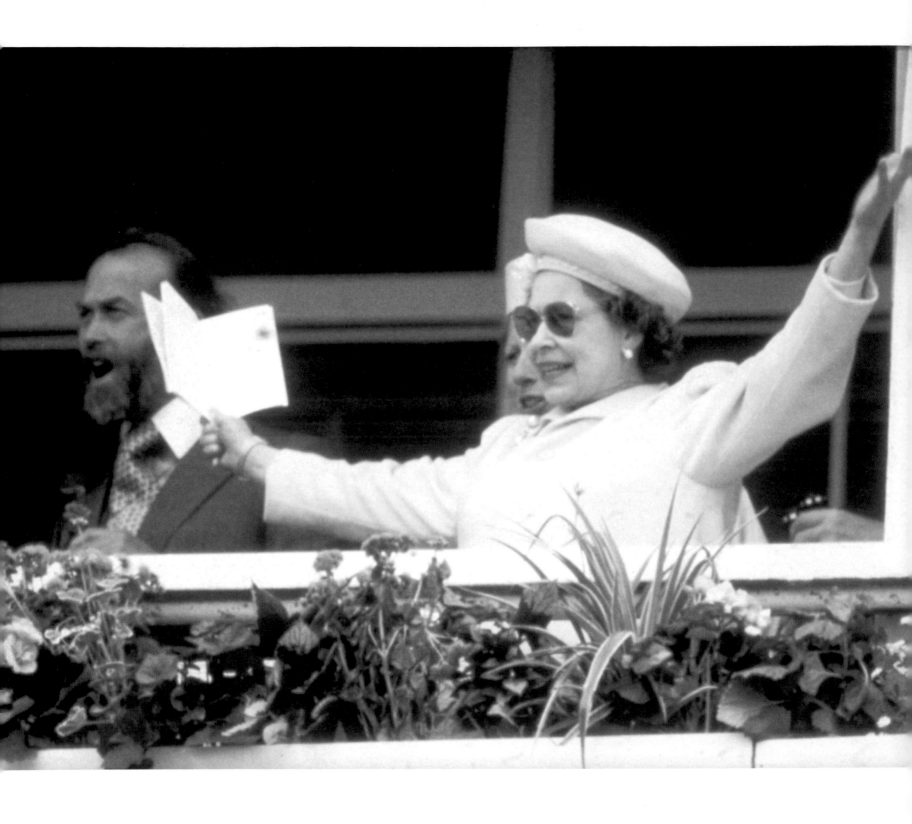

ABOVE: **The Queen gets excited about a race at the Epsom Derby, 1ˢᵗ June 1988.**

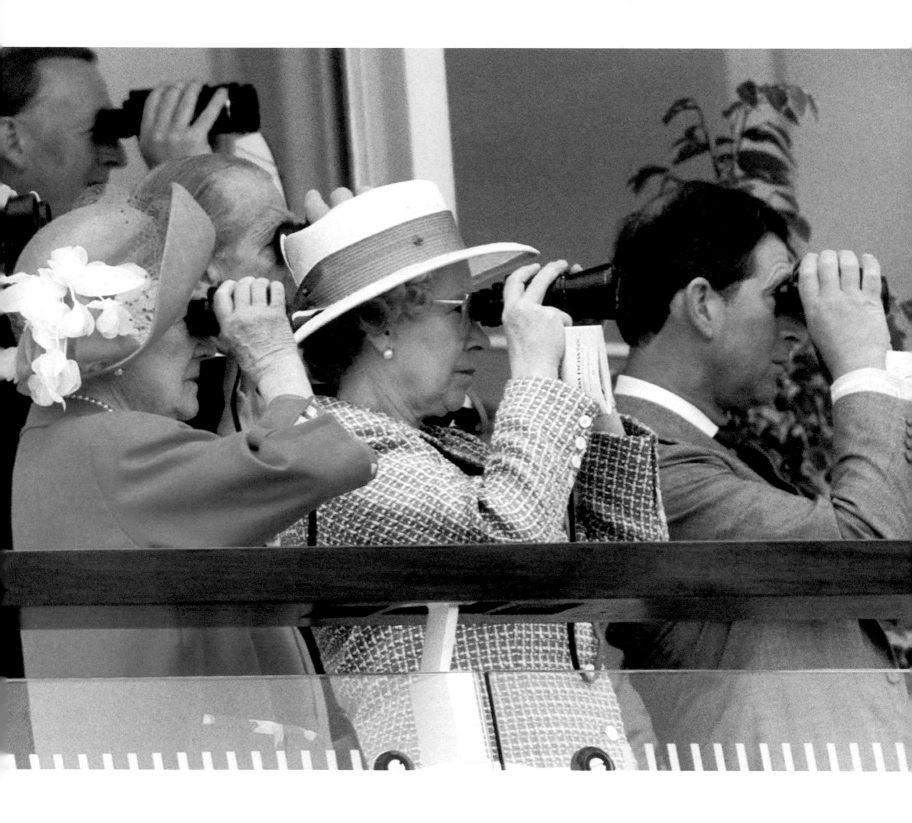

ABOVE: **The Queen, the Queen Mother and Prince Charles watch the Epsom Derby through binoculars, 3rd June 1993.**

OTHER RACES

The Queen is also an annual visitor to Royal Ascot, which is just 6 miles from her usual weekend residence of Windsor Castle.

She arrives at the Berkshire course daily during the five-day meeting in late June, riding in a horse-drawn carriage procession as the Queen's Royal Standard flag is raised.

She is often joined by members of the Royal Family and their friends, and during her Diamond Jubilee Royal Ascot the Queen chose to invite Kate's parents Carole and Michael Middleton into the royal box.

Founded in 1711 by Queen Anne, Royal Ascot has enjoyed the patronage of a further 11 monarchs. The Queen takes a close interest in the racecourse, where the colour of her hat is a hot daily betting topic.

In her Diamond Jubilee year she celebrated her 21st Royal Ascot victory when her horse Estimate won the aptly named race the Queen's Vase.

Her racing colours are a purple body with gold braid, scarlet sleeves and black velvet cap with gold fringe.

The Queen also attends other race meetings and equestrian events; these have included trips to stallion stations and stud farms in Kentucky in 1984, 1986 and 1991.

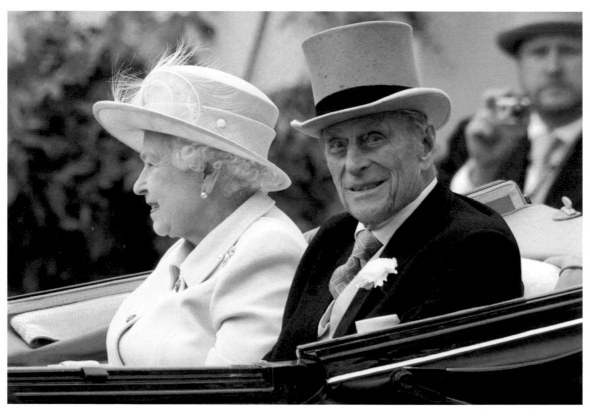

LEFT: **The Queen and Prince Philip arrive for Ladies' Day at Royal Ascot, 21st June 2012.**

RIGHT: **The Queen in the parade ring on the on the second day of Royal Ascot, 20th June 2012.**

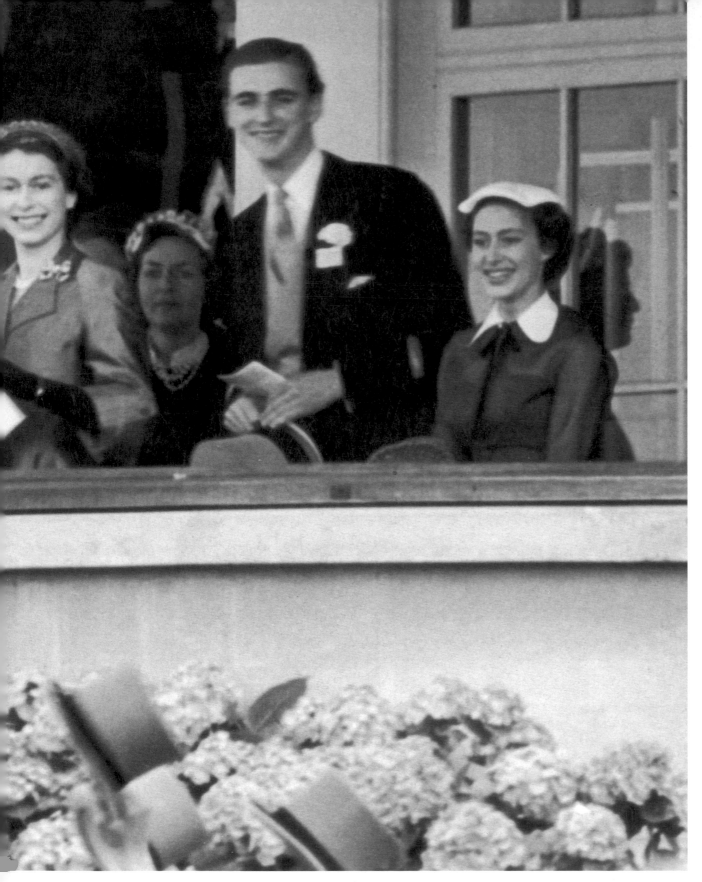

LEFT: The Queen looks delighted after her horse Choir Coy wins the Royal Hunt Cup race at Royal Ascot. She is joined in the royal box by family and friends, including the Queen Mother and Princess Margaret, 18th June 1953.

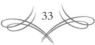

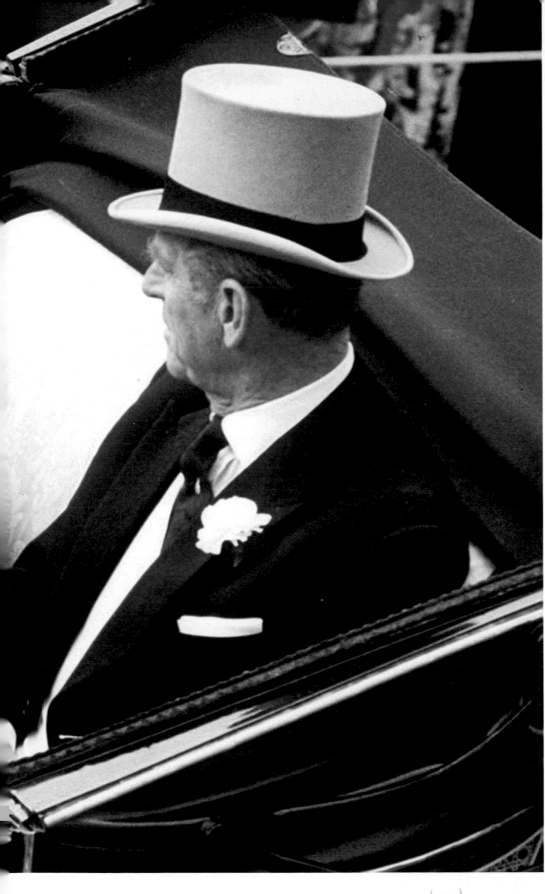

LEFT: **The Queen waves to the crowds as she arrives at Royal Ascot with Prince Philip, 18th June 1991.**

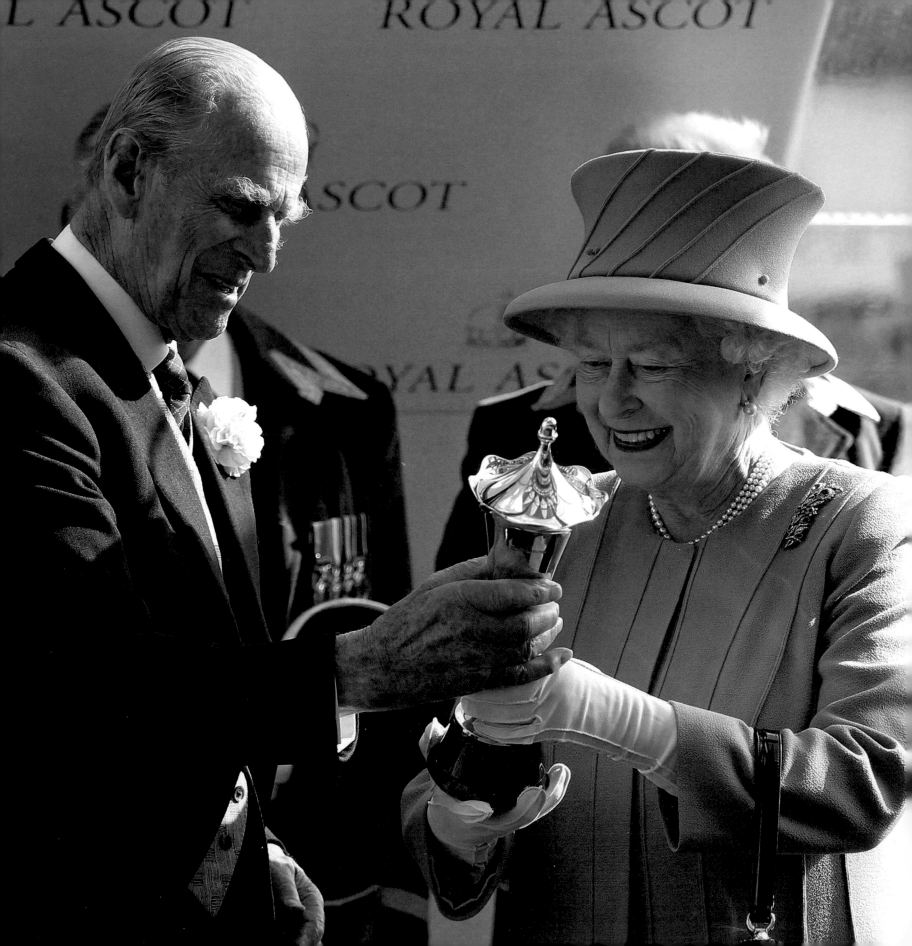

LEFT: **Prince Philip presents the Queen with the trophy after her horse Estimate wins the Queen's Vase on the fourth day of Royal Ascot, 22nd June 2012.**

BELOW: **Kate's mother, Carole Middleton, and Prince Philip watch the winners' presentation after the Gold Cup at Royal Ascot Ladies' Day, 21st June 2012.**

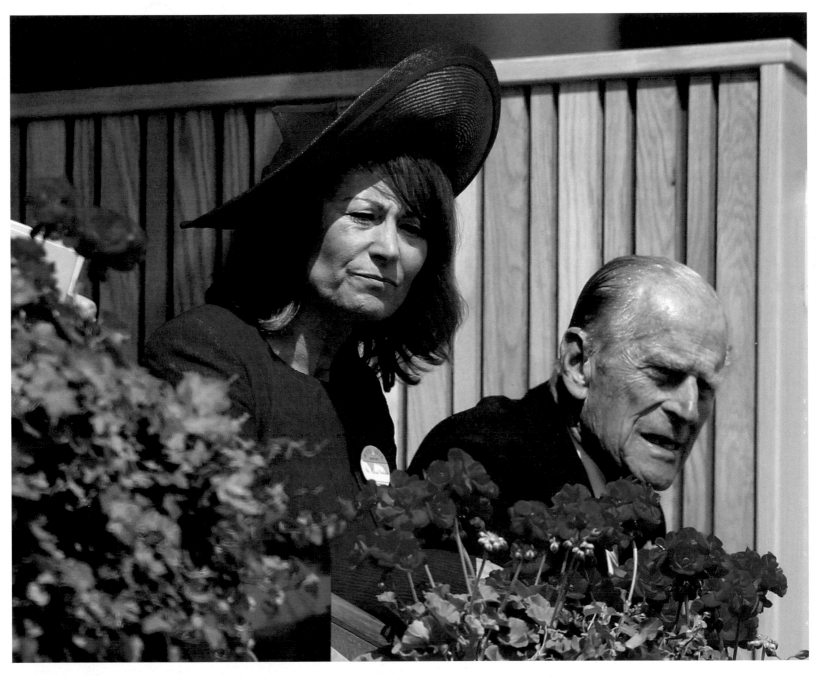

CHAPTER TWO

SAILING INTO HISTORY

"It has been a massive challenge, and I am sure that everyone who has enjoyed these festive occasions realises how much work has been involved."

Queen Elizabeth II message of thanks to the nation following the extended weekend of Diamond Jubilee celebrations, 5th June 2012

RIGHT: Boats sail down the river during the Thames Diamond Jubilee Pageant, 3rd June 2012.

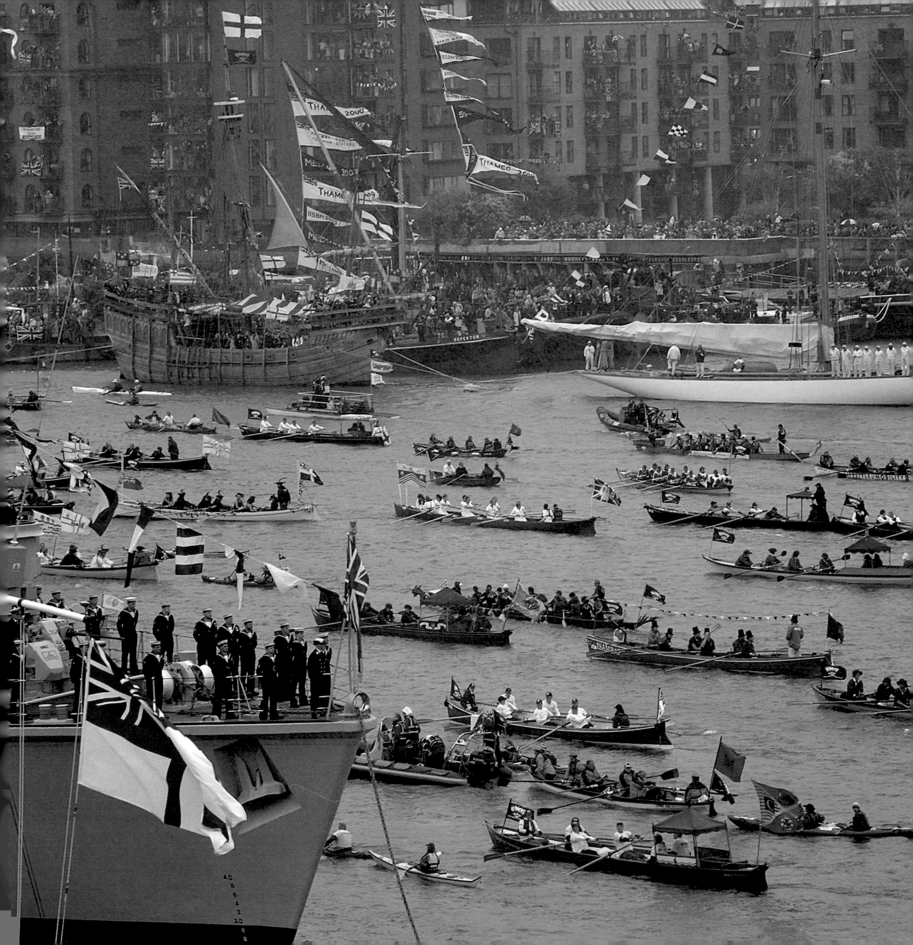

AN UNPRECEDENTED TRIBUTE

On the second day of her Diamond Jubilee celebrations the Queen took centre stage at a spectacular pageant of 1,000 boats on London's River Thames.

The 7-mile flotilla broke the Guinness World Record for the world's largest parade of boats and had taken organizers two and a half years and £10.5 million in donations to make a reality.

Such scenes of maritime pomp and pageantry had not been seen on the river since 1662 during the reign of King Charles II when the Thames was twice as wide.

Then, diarist Samuel Pepys documented the event using a quill and parchment. On 3rd June 2012, the 1.2 million people who lined the river banks used their digital cameras and mobile phones to record their own piece of history.

The Queen, Prince Philip, Prince Charles, Camilla, Prince William, Kate and Prince Harry waved to crowds from the *Spirit of Chartwell*, a 64-metre luxury cruiser transformed into the Royal Barge for the day.

The Queen's silver and white outfit took a year to plan and was designed by her dresser Angela Kelly to stand out against the red, gold and purple of the barge.

The lavishly decorated vessel was adorned with 10,000 flowers from the Queen's gardens, and had a 9ft squared red velvet banner covered in more than half a million gold-coloured buttons draped over its stern. It was joined on the river by boats of all shapes and sizes from the UK, the Commonwealth and around the world, including Dunkirk little ships, kayaks and historic boats and barges.

More than 5,000 police officers and 7,000 stewards on land and water were drafted in to keep everyone safe, and the Thames barrier was closed to keep the water levels stable while the flotilla made its journey from Battersea Bridge to Tower Bridge.

The only thing that could not be controlled was the infamous British weather, but even the grey skies and downpours did not deter the crowds.

"The clouds may have been grey but the spirits of crowds who packed the banks of the Thames couldn't have been brighter," reported the *Daily Mirror*.

Royal photographer Kent Gavin, who was aboard the Royal Barge, said: "The scenes were so wild that at times it seemed as though Her Majesty didn't know which side to look. She seemed totally taken aback by the number of people who had come to celebrate her 60-year reign."

He described how the Queen turned to Philip and said: "Look at all these people! Look at all these people."

RIGHT: **The Queen gasps at the crowds and spectacle of 1,000 boats from Royal Barge the *Spirit of Chartwell* during the Thames Diamond Jubilee Pageant, 3rd June 2012.**

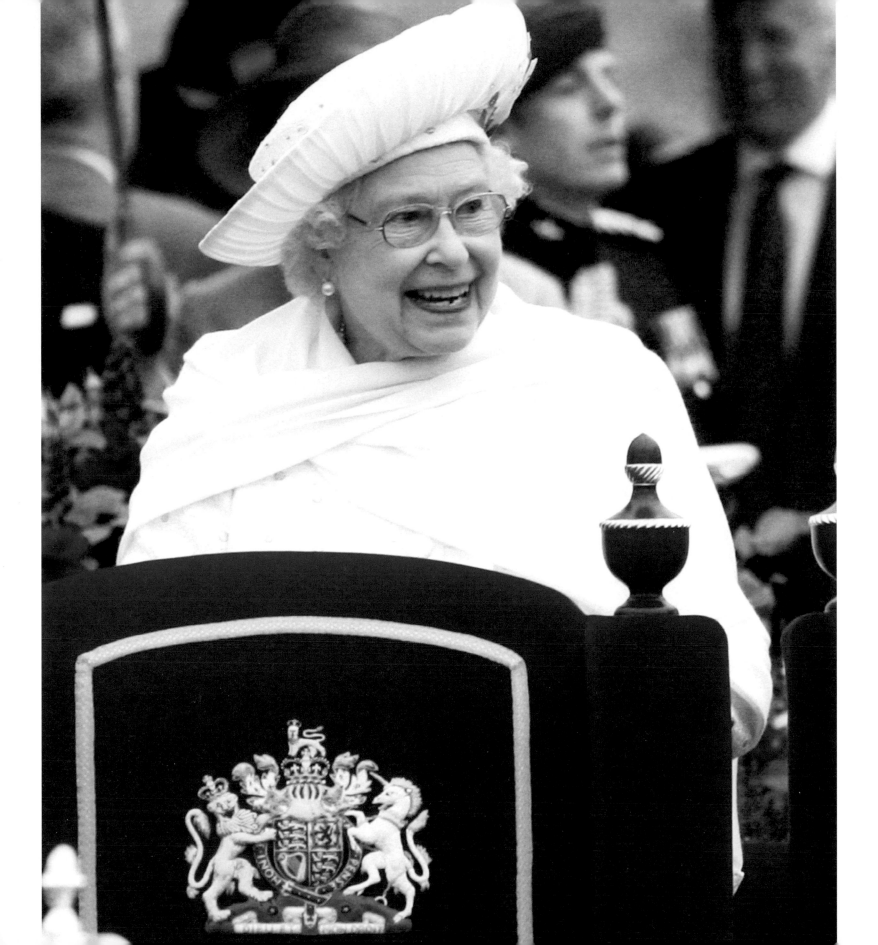

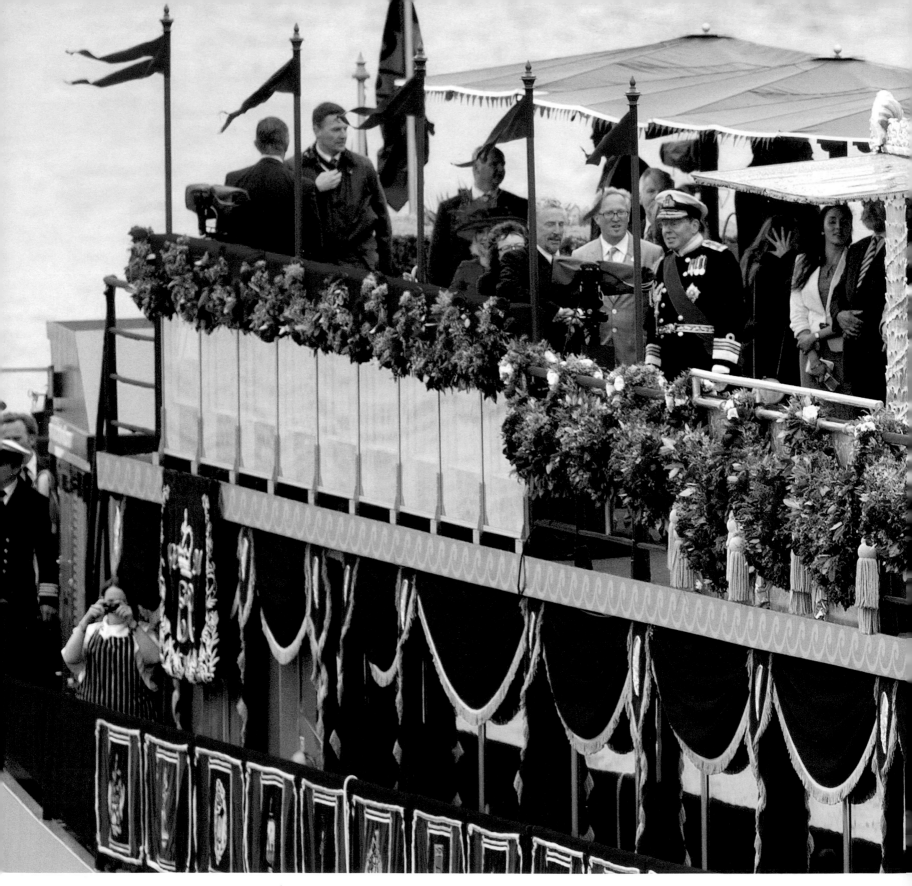

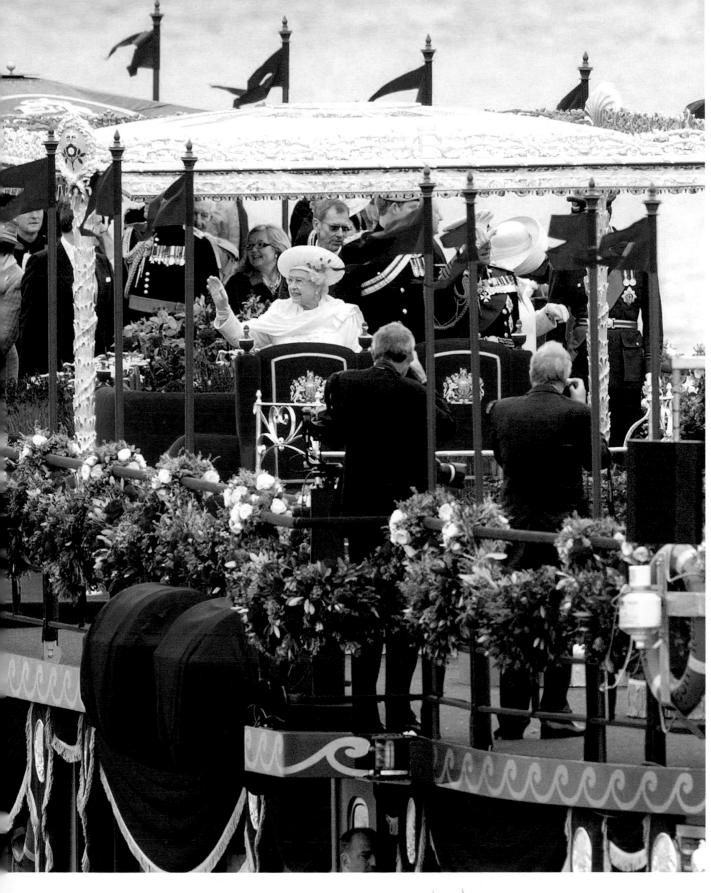

LEFT: **The Queen waves from the** *Spirit of Chartwell* **during the Thames Diamond Jubilee Pageant, 3rd June 2012.**

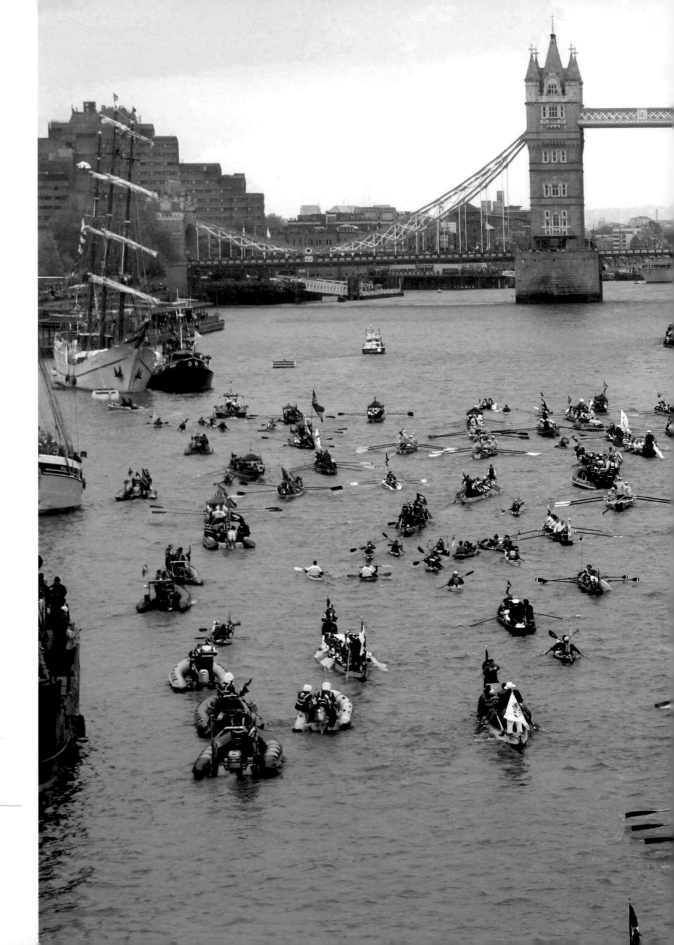

RIGHT: Boats sail towards Tower Bridge during the Thames Diamond Jubilee Pageant, 3rd June 2012.

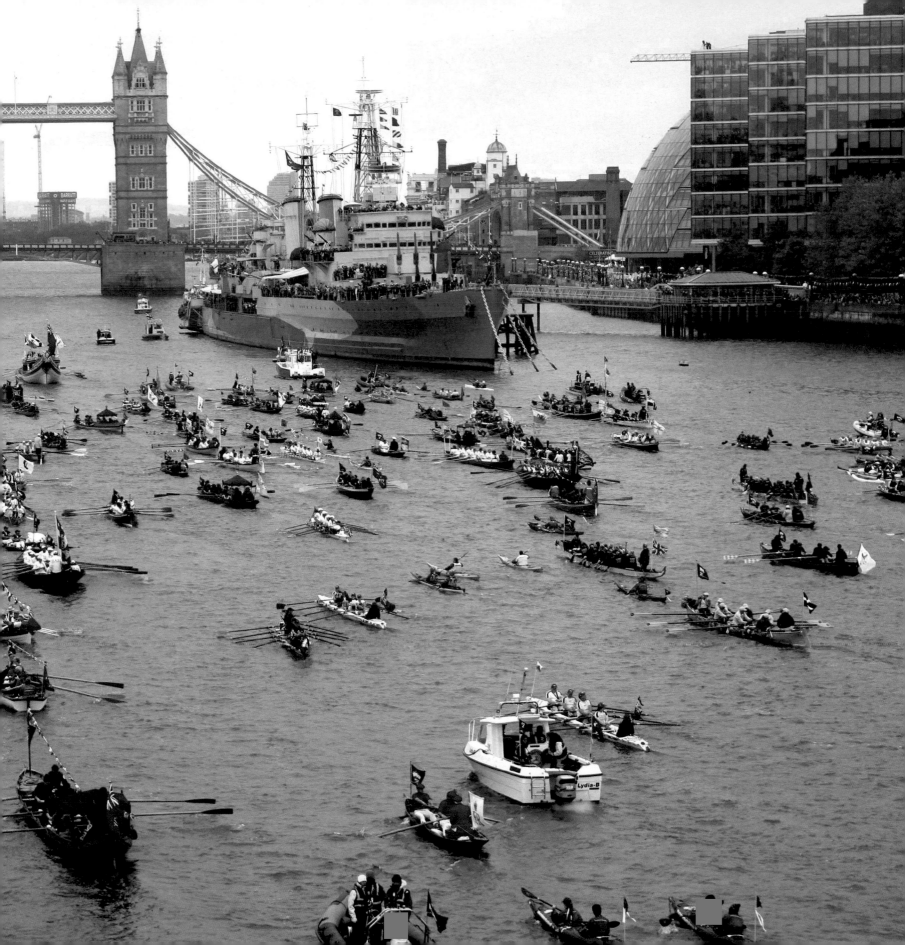

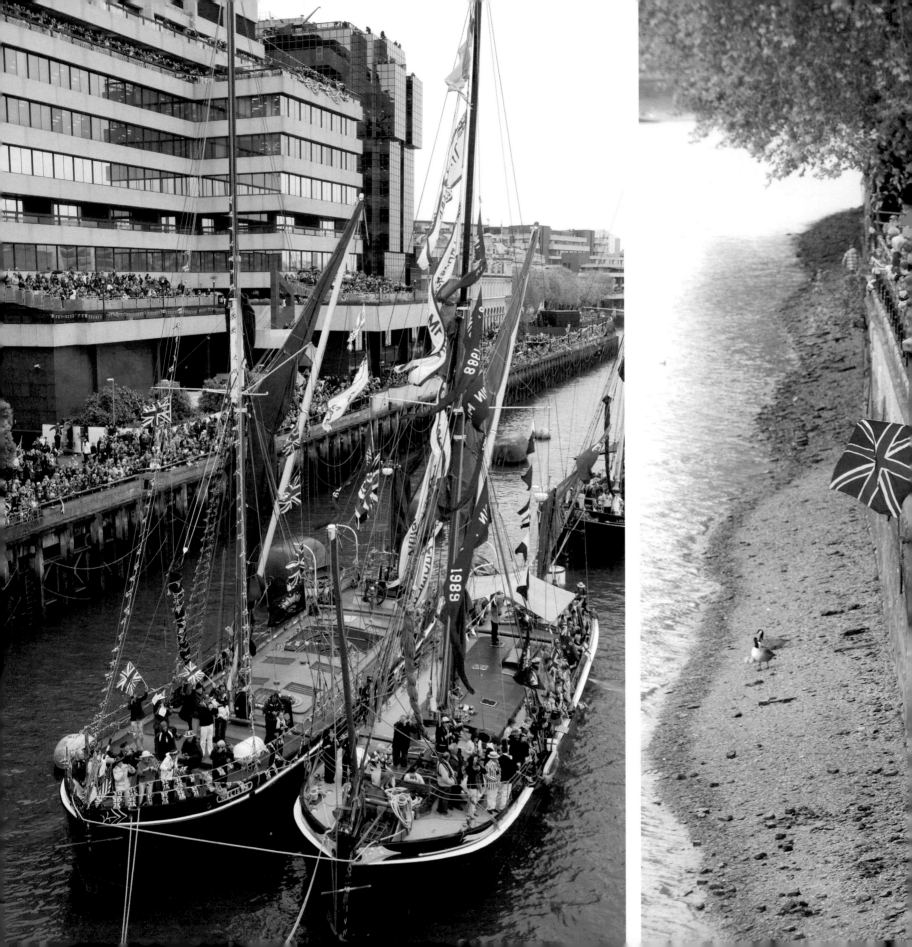

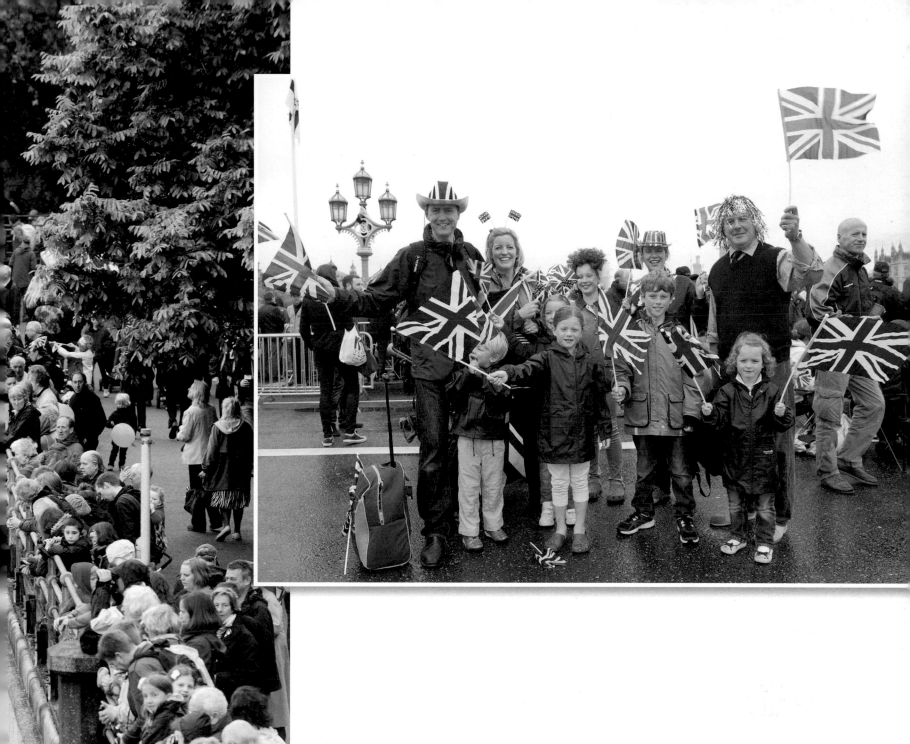

OPPOSITE: Despite the grey skies and rain, crowds line the river bank to catch a glimpse of the Thames Diamond Jubilee Pageant, 3rd June 2012.

LEFT: Crowds line the banks of the Thames in Fulham to watch the pageant.

ABOVE: Families brave the cold and rain to line up along Westminster Bridge.

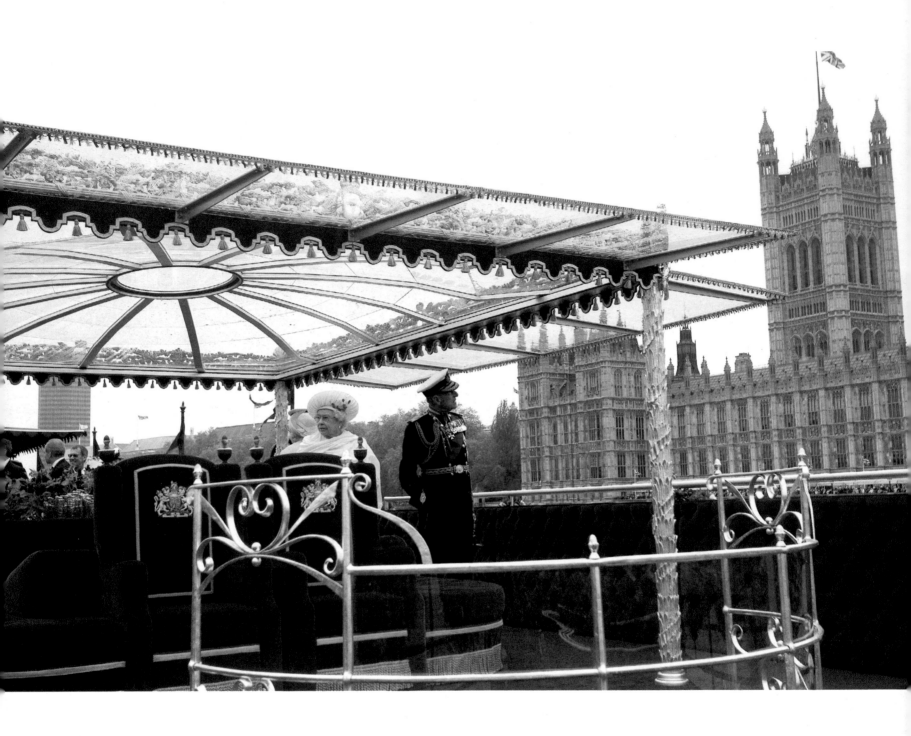

ABOVE: **The Queen and Prince Philip enjoy the view of Westminster from the Royal Barge during the Thames Diamond Jubilee Pageant, 3rd June 2012.**

RIGHT: **An overhead view as the Thames Diamond Jubilee Pageant passes the Houses of Parliament.**

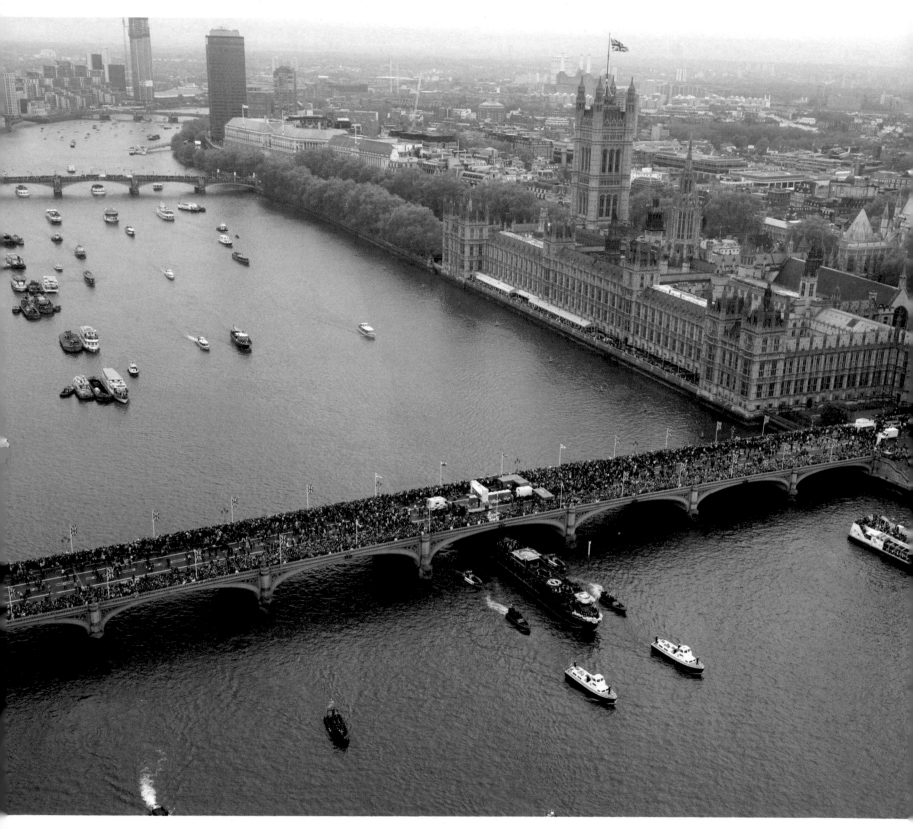

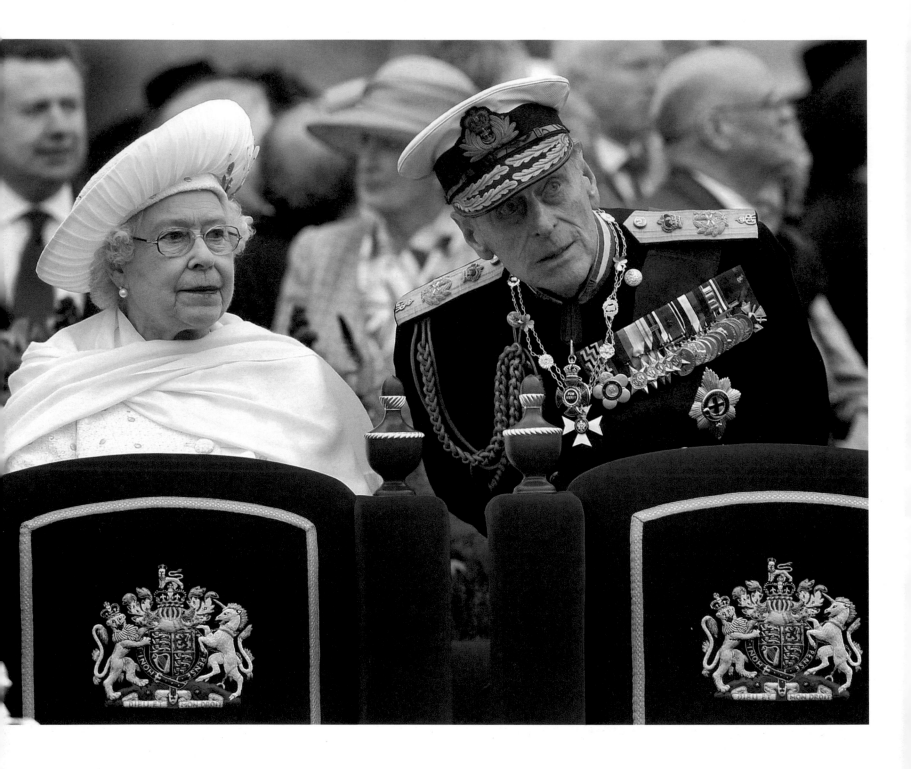

ABOVE: **The Queen and Prince Philip chat on Royal Barge the** *Spirit of Chartwell* **during the Thames Diamond Jubilee Pageant.**

RIGHT: **The Queen stares intently at the view from the** *Spirit of Chartwell.*

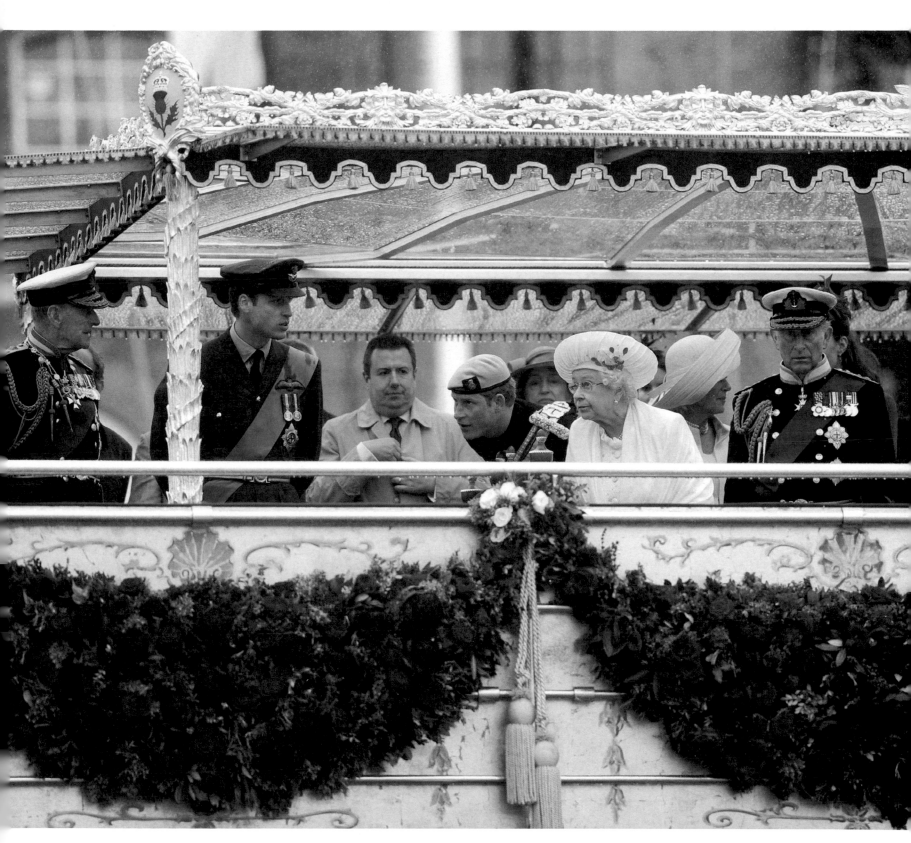

A THOUSAND BOATS FOR ONE QUEEN

Every vessel imaginable, from the smallest kayaks to the grandest cruisers and military boats, took to the waters for the unforgettable Thames Diamond Jubilee Pageant.

The spectacle began just after 2.10pm when the Queen and Prince Philip arrived at Chelsea Harbour pier to be met by a guard of honour of Chelsea Pensioners.

To get to the Royal Barge the royal couple took a nostalgic trip on one of the vessels belonging to the Royal Yacht *Britannia*, remembering the 44 years of service the beloved yacht gave them from its launch in the Coronation year.

As the Queen boarded the *Spirit of Chartwell* at Cadogan Pier, the crowds, 10-deep in places and waving Union flags, gave her a spontaneous rendition of the National Anthem.

The flotilla, which was divided into 10 sections with a musical barge separating each one, set off with a peal of the bells from the lead vessel, the "floating belfry". This 180ft barge carried eight bells representing eight royals – The Queen, Prince Philip, Prince Charles, Prince Andrew, Prince Edward, Princess Anne, Prince William and Prince Harry.

Then, the manpowered vessels led by £1 million rowbarge *Gloriana* with 18 rowers including Olympians Sir Steve Redgrave and Sir Matthew Pinset set the flotilla pace of a steady 4 knots (4.6 miles per hour). As the rowers passed the Royal Barge they gave a salute to the Queen with their oars.

Following the rowers were small five-man boats bearing the 54 Commonwealth flags led by the *Edwardian*, which had on board the Academy of Ancient Music playing Handel's Water Music. This was followed by the royal section, which included the *Spirit of Chartwell*.

Following the Queen's vessel was former hydrographic survey launch *Havengore*, carrying Prince Andrew and his daughters Princess Beatrice and Princess Eugenie, as well as Prince Edward and his wife Sophie and the Duke and Duchess of Gloucester and Prince and Princess Michael of Kent.

Then came Princess Anne and Timothy Laurence travelling on *Trinity House No 1*, followed by the Duke of Kent and Princess Alexandra on board the RNLI *Diamond Jubilee*, an RNLI lifeboat renamed in honour of the celebrations.

Kate's parents Carole and Michael Middleton and her sister Pippa and brother James also enjoyed pride of place on the river in paddle steamer, *The Elizabethan*.

The royal section was followed by about 40 Dunkirk little ships, reuniting vessels that had evacuated Allied vessels from French beaches in 1940 during the Second World War.

RIGHT: The Queen is welcomed by a guard of honour of Chelsea Pensioners as she arrives at Chelsea Harbour pier for the beginning of the Thames Diamond Jubilee Pageant, 3rd June 2012.

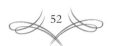

Historic and service vessels followed, then working boats, recreational motor boats, narrow boats and barges and, finally, passenger boats.

The Queen shrieked with delight when she passed the National Theatre to see a puppet of War Horse Joey running along the roof. And at 3.40pm, a 41-gun salute echoed from the Tower of London to the excitement of the crowds nearby.

At 4.20pm the bascules of Tower Bridge were lifted and the Royal Barge sailed through before stopping to allow the spectacle to go past.

The pageant came to a close at 6.00pm when the last boat, *Symphony*, carrying the London Philharmonic Orchestra and Royal College of Music Chamber Choir, sailed past the Queen playing 'Land of Hope and Glory', 'Rule Britannia' and, finally, the National Anthem.

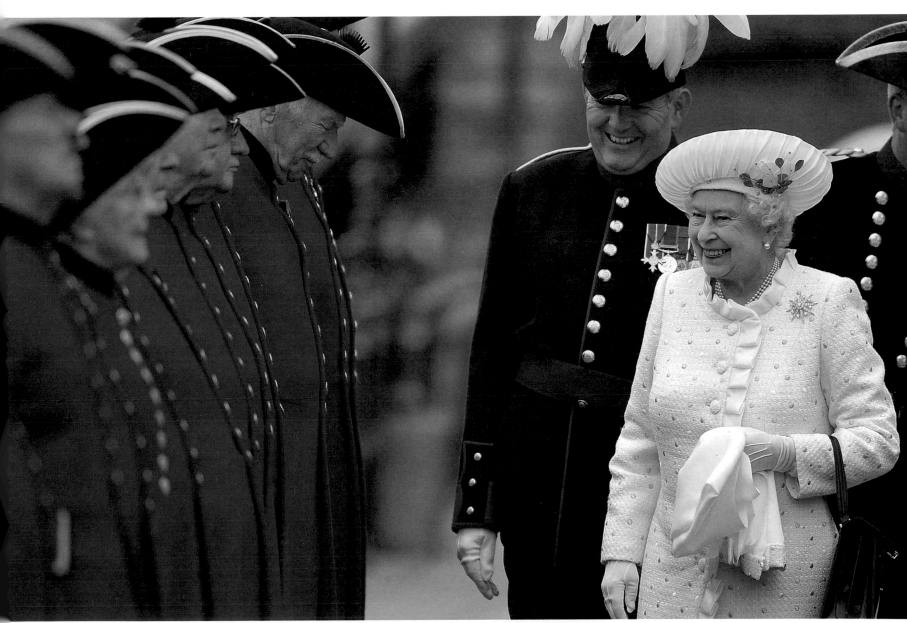

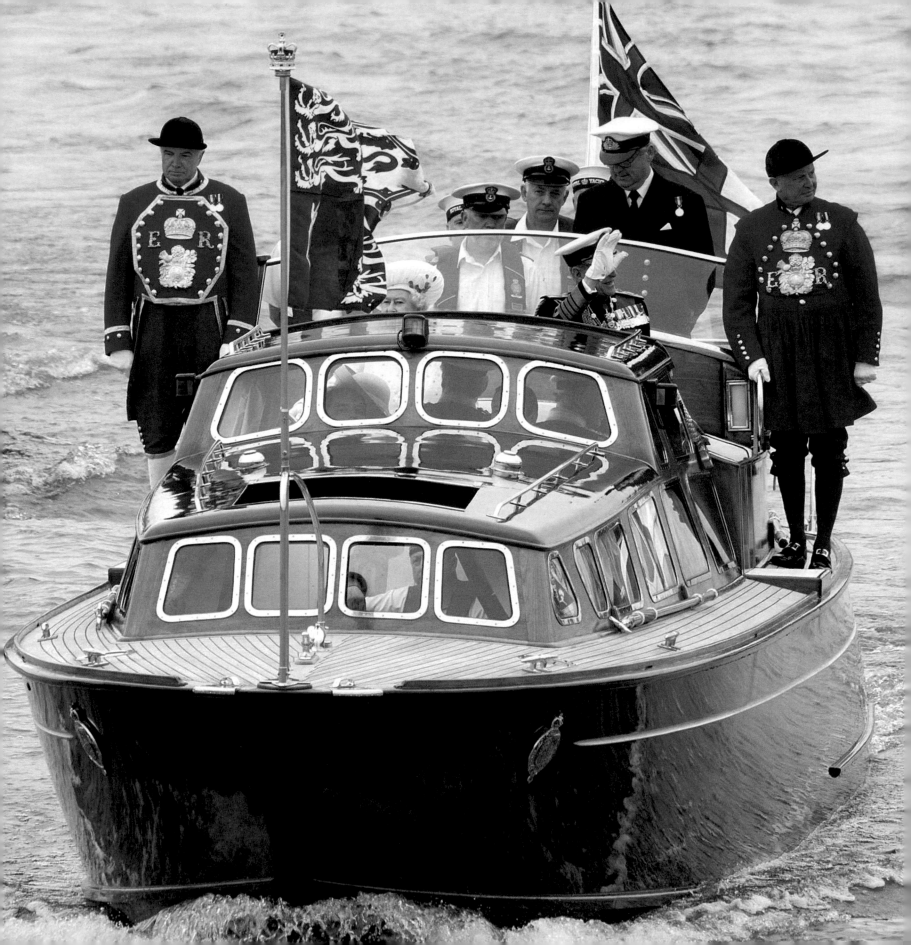

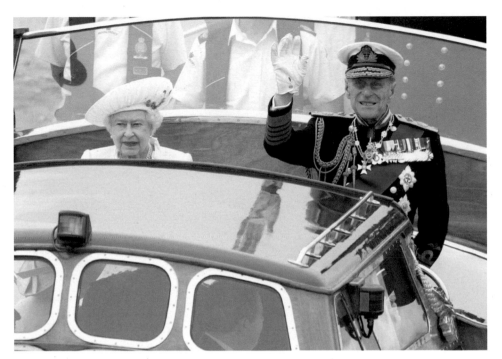

OPPOSITE & LEFT: The Queen and Prince Philip take a trip on one of the vessels belonging to the Royal Yacht *Britannia* to get to the Royal Barge the *Spirit of Chartwell* ahead of the Thames Diamond Jubilee Pageant. The Queen was greatly attached to the *Britannia*, which had given her almost 44 years of service. She famously wiped a tear from her eye when it was decommissioned in 1997. It is currently moored in Edinburgh where it is a successful tourist attraction. The vessel the Queen and Philip are in here is one they used countless times to get from *Britannia* to the shore when visiting places where the harbour was not deep enough for *Britannia* to dock in, 3rd June 2012.

BELOW: The Queen is joined by members of her family on Royal Barge *Spirit of Chartwell*.

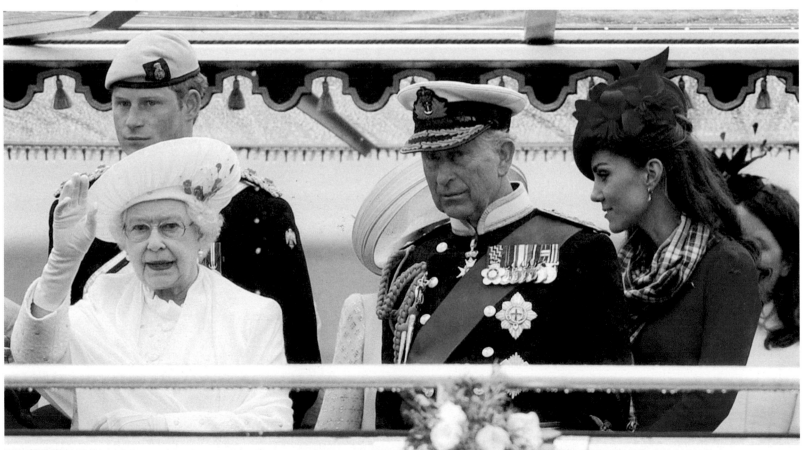

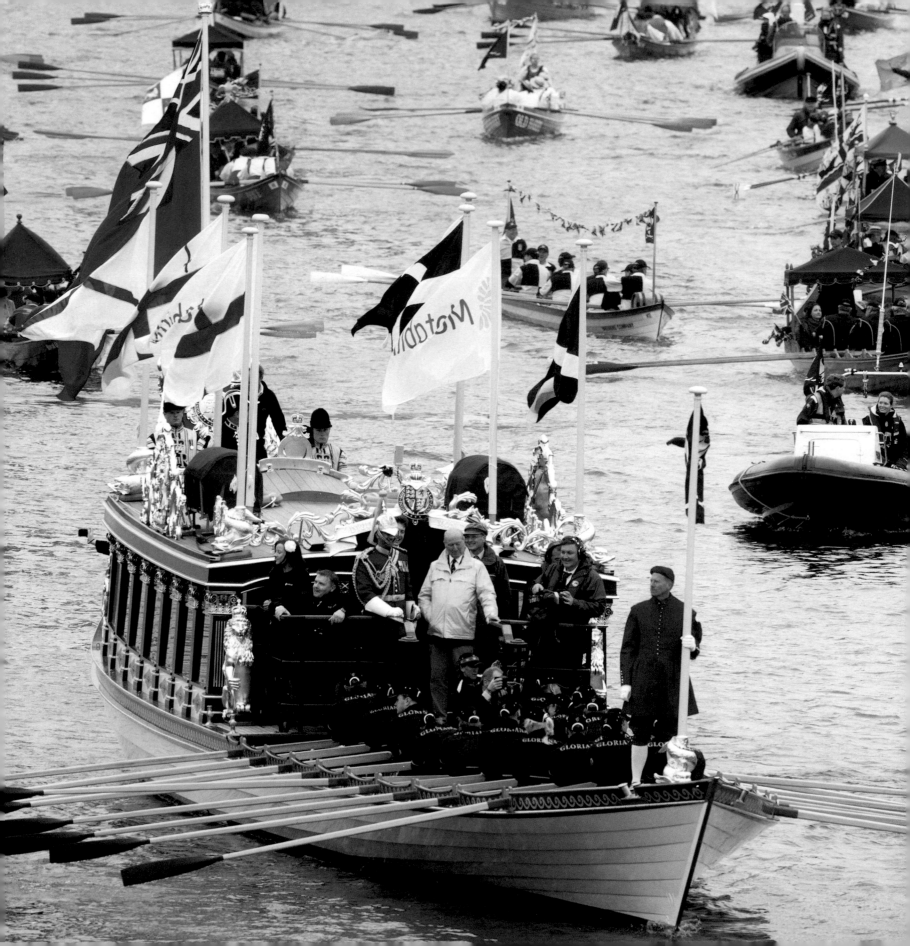

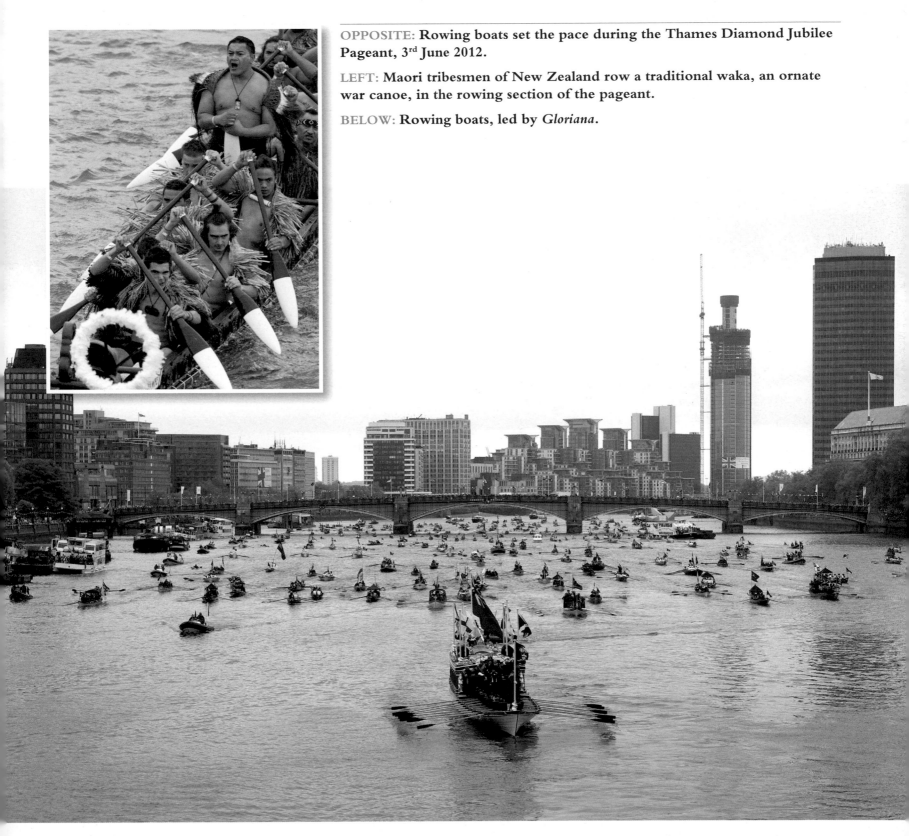

OPPOSITE: Rowing boats set the pace during the Thames Diamond Jubilee Pageant, 3rd June 2012.

LEFT: Maori tribesmen of New Zealand row a traditional waka, an ornate war canoe, in the rowing section of the pageant.

BELOW: Rowing boats, led by *Gloriana*.

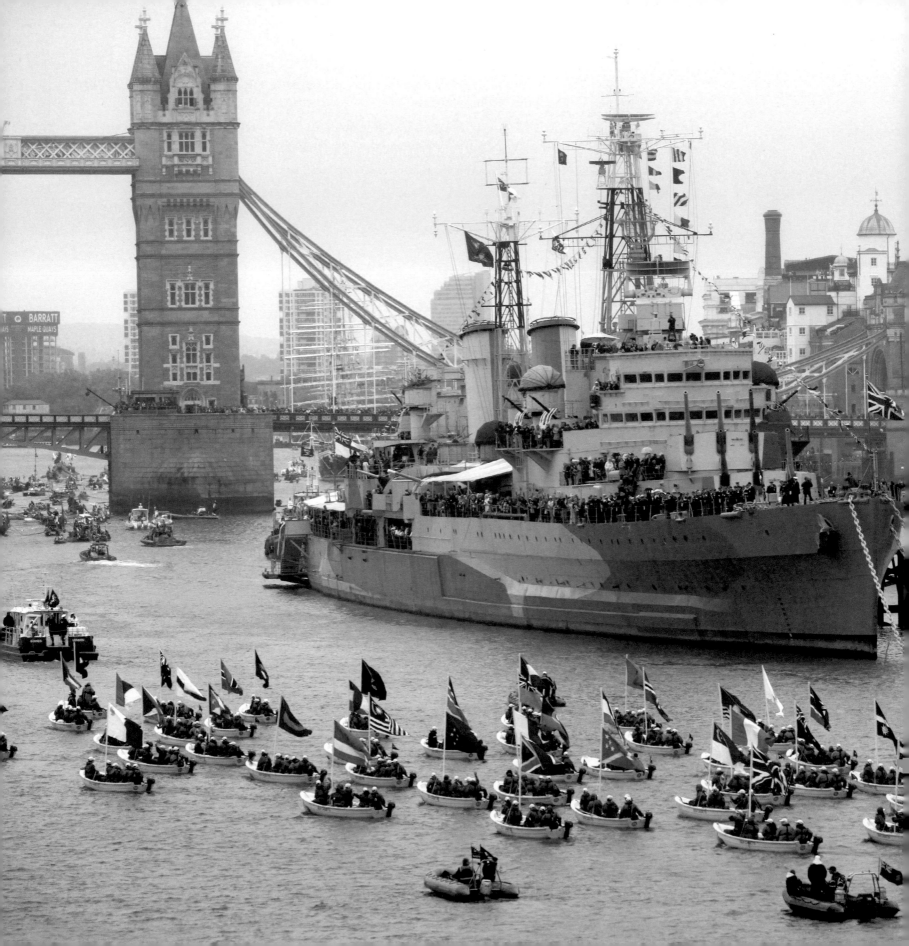

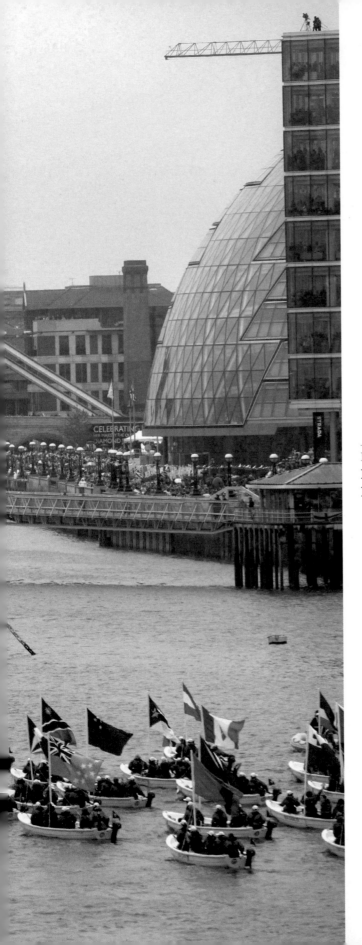

LEFT: Little five-man boats with the Commonwealth flags sail past HMS *Belfast* towards Tower Bridge during the Thames Diamond Jubilee Pageant, 3rd June 2012.

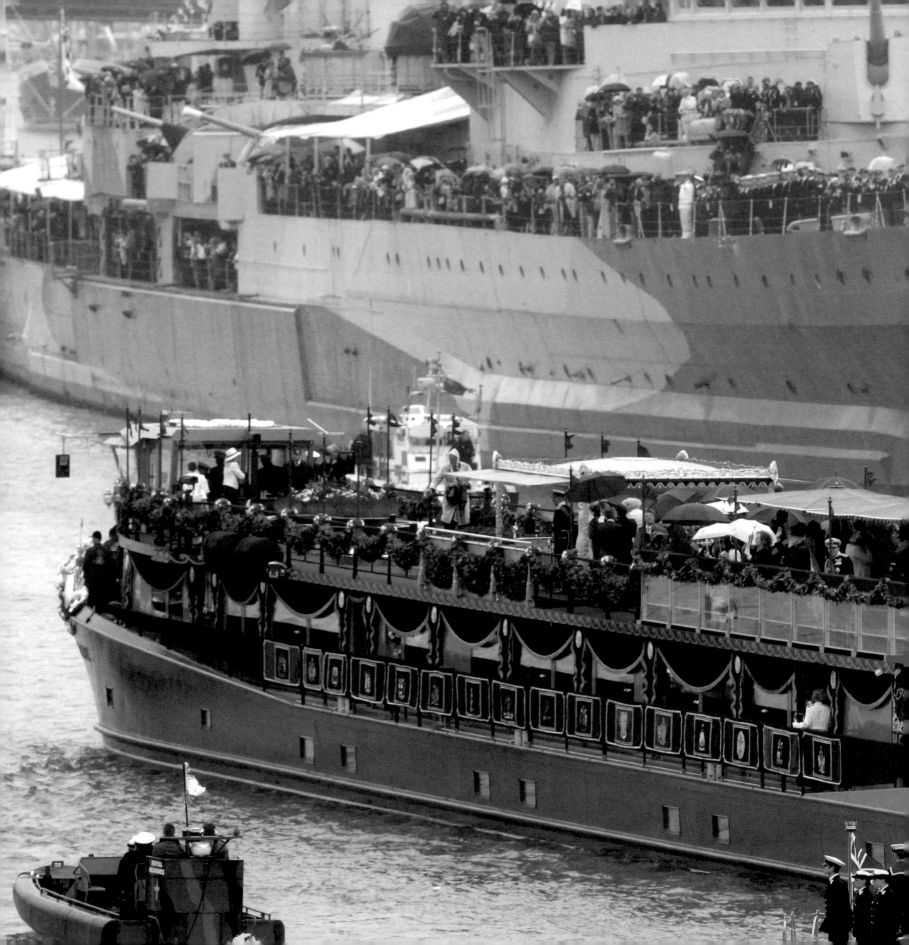

LEFT: **Royal Barge** the *Spirit of Chartwell* **with HMS** *Belfast* **in the background.**

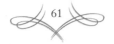

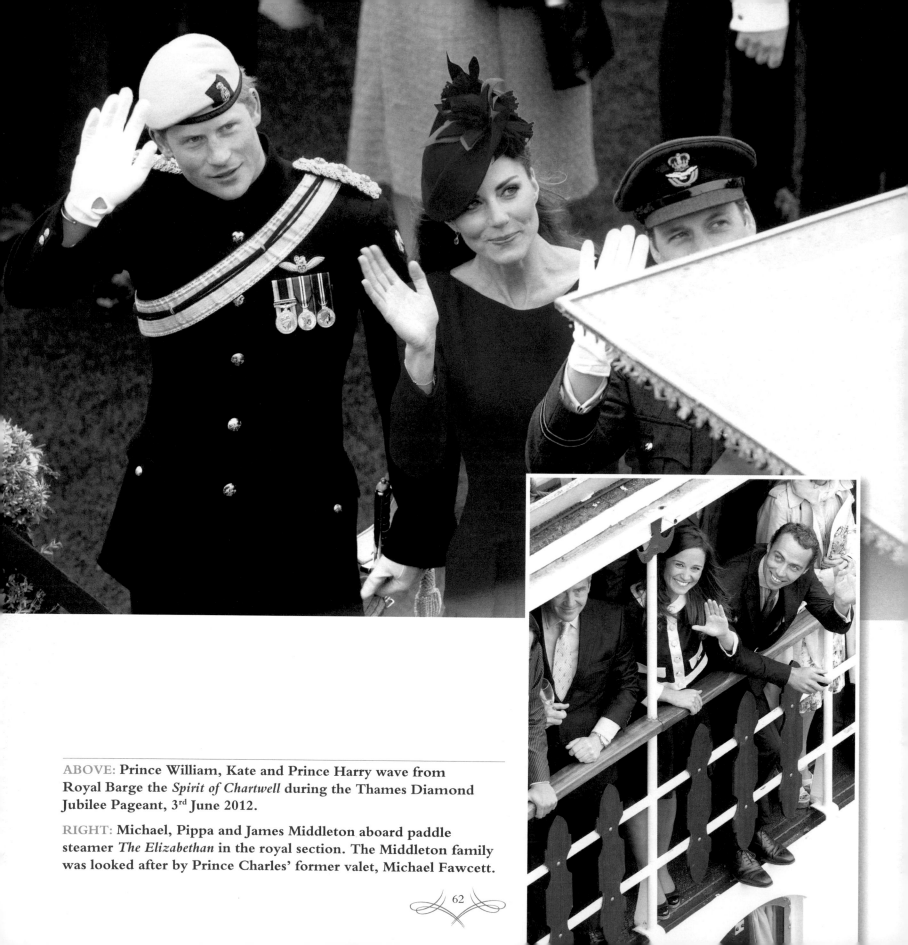

ABOVE: Prince William, Kate and Prince Harry wave from Royal Barge the *Spirit of Chartwell* during the Thames Diamond Jubilee Pageant, 3rd June 2012.

RIGHT: Michael, Pippa and James Middleton aboard paddle steamer *The Elizabethan* in the royal section. The Middleton family was looked after by Prince Charles' former valet, Michael Fawcett.

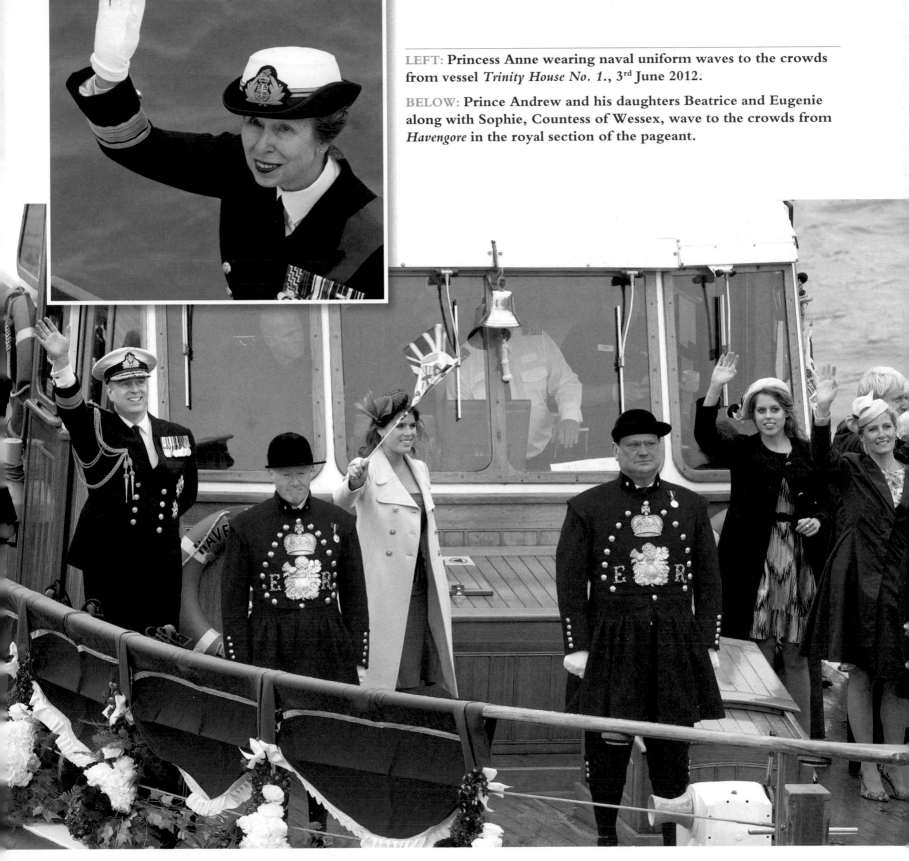

LEFT: Princess Anne wearing naval uniform waves to the crowds from vessel *Trinity House No. 1.*, 3rd June 2012.

BELOW: Prince Andrew and his daughters Beatrice and Eugenie along with Sophie, Countess of Wessex, wave to the crowds from *Havengore* in the royal section of the pageant.

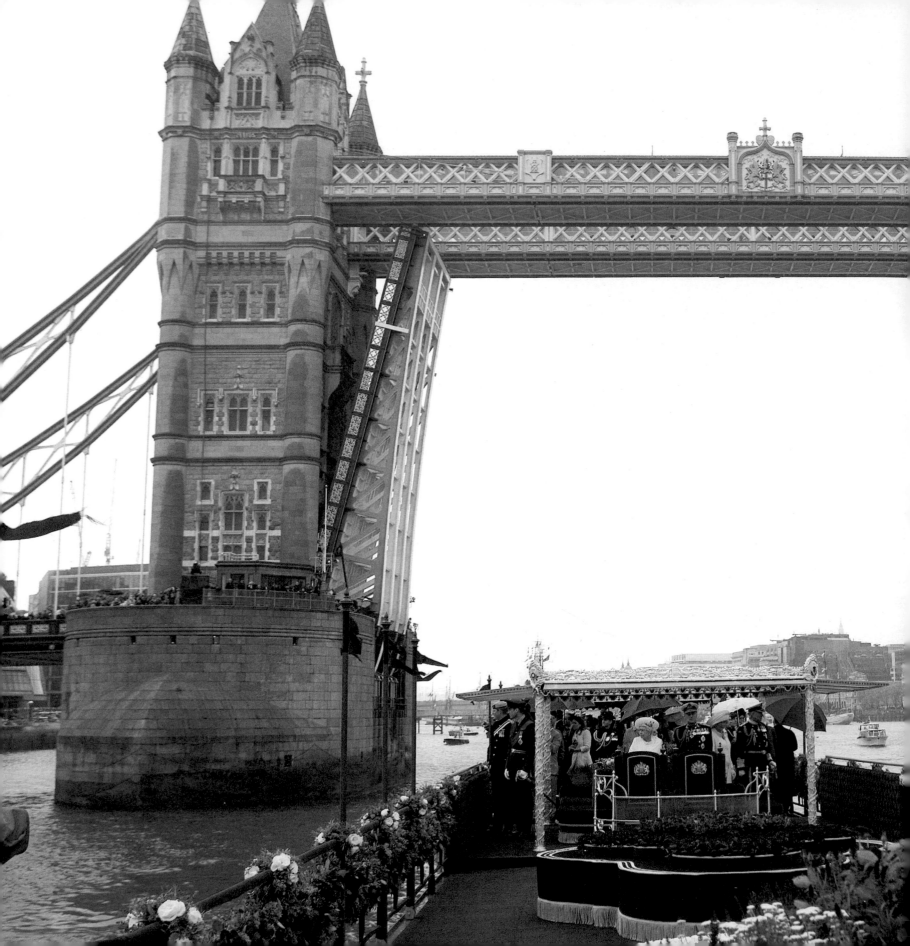

LEFT: The bascules of Tower Bridge lift for Royal Barge the *Spirit of Chartwell* during the Thames Diamond Jubilee Pageant. Once the barge had passed through it stopped on the other side to allow the rest of the boats to sail past, 3rd June 2012.

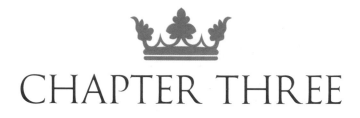

CHAPTER THREE

A PALACE PARTY

"It has touched me deeply to see so many thousands of families, neighbours and friends celebrating together in such a happy atmosphere."

Queen Elizabeth II message of thanks to the nation following the extended weekend of Diamond Jubilee celebrations, 5th June 2012

RIGHT: **Crowds fill the Mall during the Diamond Jubilee concert outside Buckingham Palace, 4th June 2012.**

THE SHOW MUST GO ON

After two days of joyful Diamond Jubilee celebrations an unexpected disaster hit the Royal Family. Just as preparations for the third day of festivities began it was announced that Prince Philip had suddenly been taken to hospital.

The 90-year-old Duke of Edinburgh was at Windsor Castle with the Queen when an ambulance was called. He was rushed to King Edward VII Hospital where he was diagnosed with a bladder infection.

The palace announced it was a "precautionary measure", but his stay lasted five nights and resulted in his missing the rest of the Diamond Jubilee weekend.

"He is, understandably, disappointed," a statement from Buckingham Palace said.

Many commentators and experts linked his illness to the 80 minutes he had spent braving the elements on the Royal Barge the previous day at the Thames Diamond Jubilee Pageant.

"Standing in the cold for hours on Sunday could have affected his immune system and his ability to withstand the infection," Consultant Urological Surgeon Rizwan Hamid wrote in the *Daily Mirror*.

The Queen and Royal Family were, of course, concerned, but Prince Philip insisted that the celebrations should continue without him, and on Monday 4th June the party took place right at the heart of the Queen's London home.

The doors of Buckingham Palace were opened to 12,000 ticket-holders made up of 10,000 lucky ballot winners together with 2,000 guests from the Royal Family's charities.

They all enjoyed a picnic in the Queen's garden followed by a spectacular star-studded concert in the Mall, with the royal palace as a backdrop.

Performers from right across the Queen's reign showcased musical styles, ranging from classical pianist Lang Lang to legendary singer/songwriter Stevie Wonder and pop princess Kylie Minogue.

Meanwhile, more than 4,200 beacons were lit round the UK, the Commonwealth and the world. The first was set alight in New Zealand and the last was the National Beacon lit by the Queen following the concert.

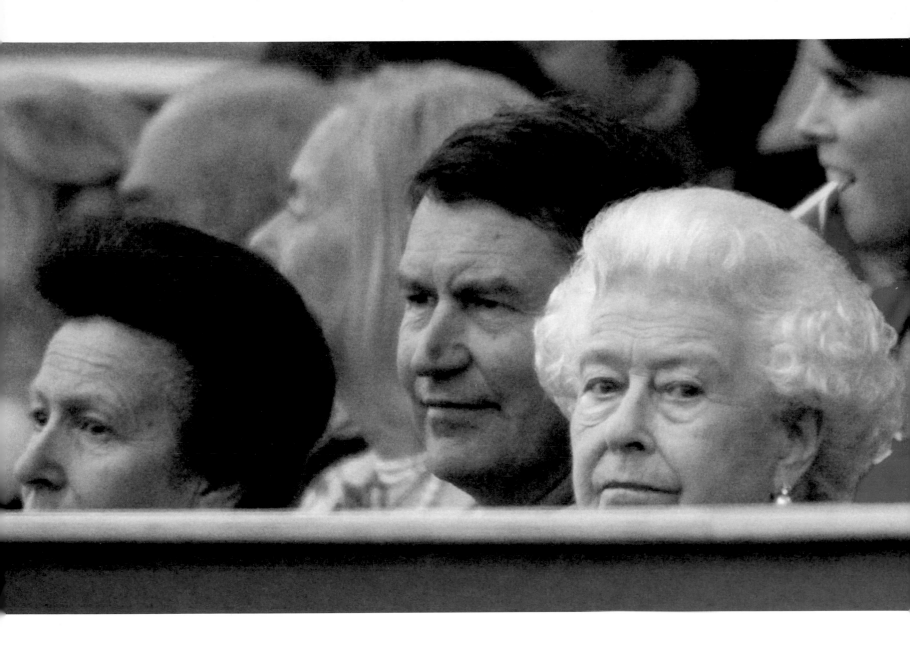

ABOVE: **The Queen in the royal box during the Diamond Jubilee concert, 4th June 2012.**

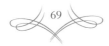

A ROYAL FEAST

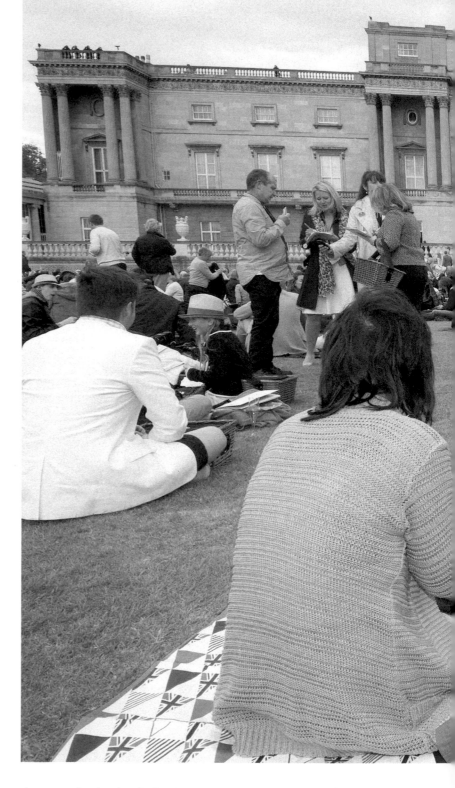

The Queen's 40-acre gardens were invaded by 12,000 patriotic picnickers on the afternoon of 4th June. The excited guests sat on the grass to enjoy a feast from specially designed wicker hampers prepared by Michelin-starred chef Heston Blumenthal and Royal Chef Mark Flanagan.

Many dressed in patriotic red, white and blue and waved Union flags as they tucked into chilled soup, Scottish salmon, Coronation Chicken or mushroom parfait, a strawberry, cream and yoghurt dessert followed by cakes and English cheeses. The meal was washed down with Moet & Chandon champagne, Cobra beer and Hildon spring water, as the guests from all across the UK stared in awe at their impressive surroundings.

"The palace looks unbelievable, it's such an honour to be in here," said Diane Dourish, 63, from Alnwick, Northumberland, who had won tickets for herself and her husband through the ballot.

"It's been so special, the celebrations are exactly what this country needs," added Marilyn Northcote, 55, from Bhute in Cornwall.

Members of the Royal Family also mingled with the picnickers, including Prince Andrew and daughters Princesses Beatrice and Eugenie and Sophie, Countess of Wessex.

"Hello everyone. Who are you all excited to see – apart from Granny?" Eugenie asked the crowds.

Among the invited charity guests were 25 wounded servicemen and their families, including former commanding officer David Richmond, 45, from Salisbury, who was shot in the left leg in Afghanistan in June 2008

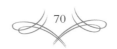

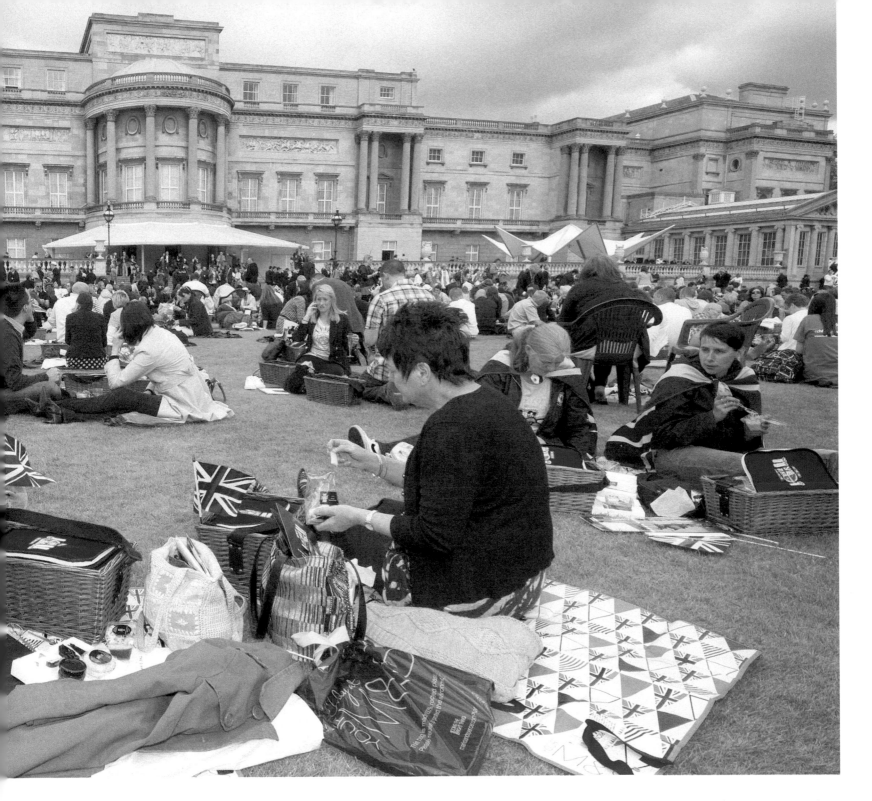

and lost 10 cm of his thigh. He said: "It's amazing to be here. The Queen is the epitome of service so to be here in her garden having a picnic to celebrate her sixty years is just amazing."

ABOVE: Ticket holders enjoy a Diamond Jubilee picnic in the grounds of Buckingham Palace, 4th June 2012.

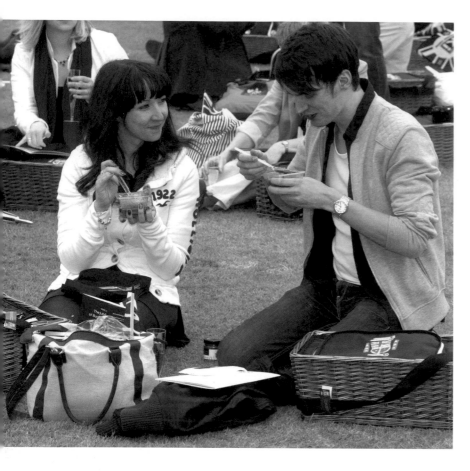

ABOVE: **A couple enjoying the Diamond Jubilee picnic, 4th June 2012.**

RIGHT: **A schoolboy shows off a red, white and blue wig while enjoying his Diamond Jubilee picnic.**

ABOVE: **Picnickers show off their red, white and blue outfits at the Diamond Jubilee picnic, 4th June 2012.**

LEFT: **The Queen's Royal Diamond Jubilee picnic basket.**

LEFT & ABOVE: Picnickers get into the Jubilee spirit waving flags and dressing up in the gardens of Buckingham Palace, 4th June 2012.

A MUSICAL TRIBUTE

For two weeks before the Diamond Jubilee concert, the outside of Buckingham Palace was unrecognizable as the Queen Victoria Memorial was transformed into a 360-degree stage. The stage, designed by architect Mark Fisher, was fitted with £300,000 worth of lighting and projections to create an unforgettable show on the evening of 4th June.

The spectacle was organized by the BBC and musician Gary Barlow, and the Take That star revealed he had some interesting conversations with the Queen ahead of the concert.

He told a chat show host: "I went, 'Your Majesty, this is what the concert is going to look like, it's going to be incredible, this is where it's going to be, in front of the palace.'

She looked at me and went, 'So, all that equipment, how long is it going to take to dismantle it?'."

During the months of build up there was much speculation about whether or not the concert would be as lavish as the Golden Jubilee Party at the Palace, where Queen guitarist Brian May played 'God Save The Queen' from the roof of Buckingham Palace.

However, the Diamond Jubilee concert went one better and put a whole band on the roof, where Madness performed 'Our House' and 'It Must Be Love'.

From the moment opening performer Robbie Williams dropped to his knees on stage and declared "Let me entertain you" the crowd inside the specially built seating area and the thousands more watching on big screens down the Mall and in London's parks did not stop cheering.

The first host of the evening was comedian Rob Brydon, who got a laugh from the audience when he said: "Sixty years of reign. Sounds like a Welsh summer."

One after another, the world's most sought after performers took to the stage including Sir Cliff Richard, Sir Tom Jones, Sir Elton John, Dame Shirley Bassey, Will.i.am, Cheryl Cole, Jools Holland and Kylie Minogue.

As the music blared through London the front of Buckingham Palace was transformed by light projections of all shapes and colours including moving video montages of the Queen's life and reign.

Legendary US performer Stevie Wonder dedicated his song 'Isn't She Lovely' to the Queen, Sir Cliff Richard performed 1968 hit 'Congratulations' and told the crowd: "It was meant to be sung tonight!", and Rolf Harris hailed the event as the highlight of his career.

There were also some eccentric performances, such as Grace Jones who sung 'Slave To The Rhythm' while hula-hooping and Annie Lennox who wore a giant pair of feathered wings.

RIGHT: A rainbow beams through the sky as crowds take their seats at the start of the Diamond Jubilee concert, 4th June 2012.

The stage was packed when Gary Barlow and composer Andrew Lloyd Webber were joined by the hundreds of performers for their official Diamond Jubilee song 'Sing'.

Gary had travelled through the Commonwealth for inspiration to write the piece, which included the African Children's Choir, Slum Drummers from Kenya, the Sydney Symphony Orchestra and the Military Wives Choir from the UK.

Sir Paul McCartney brought the concert to a close with a five-song set finishing with 'Ob-La-Di, Ob-La-Da' where he was joined on stage by all the evening's performers.

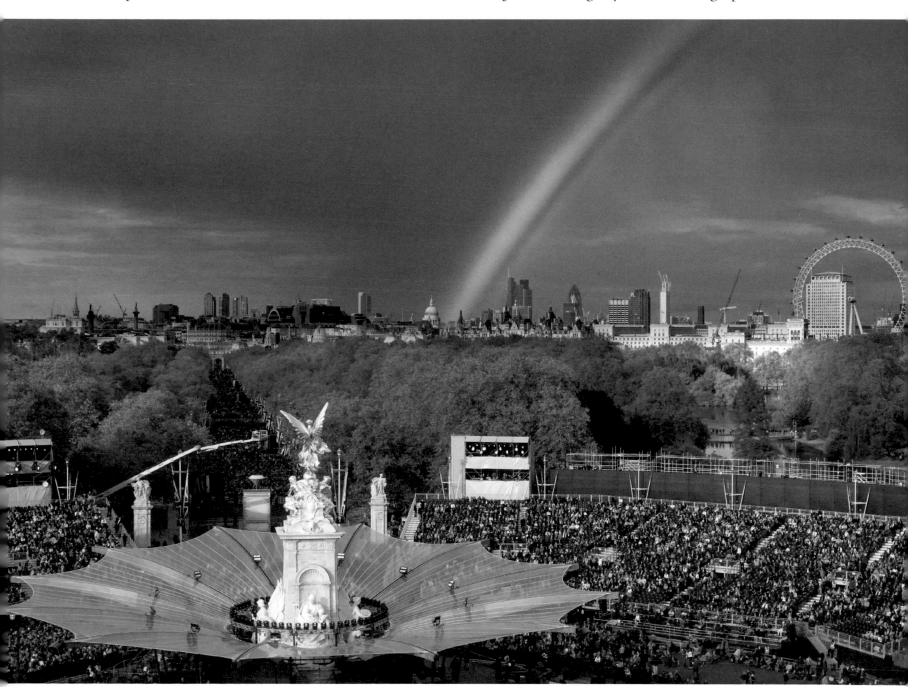

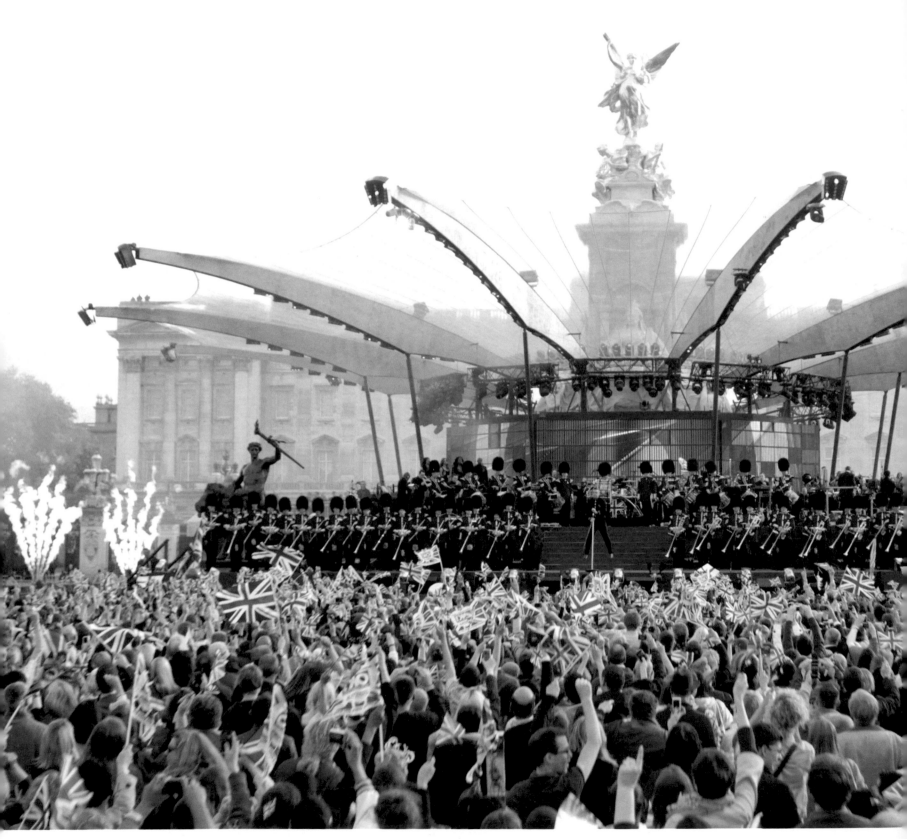

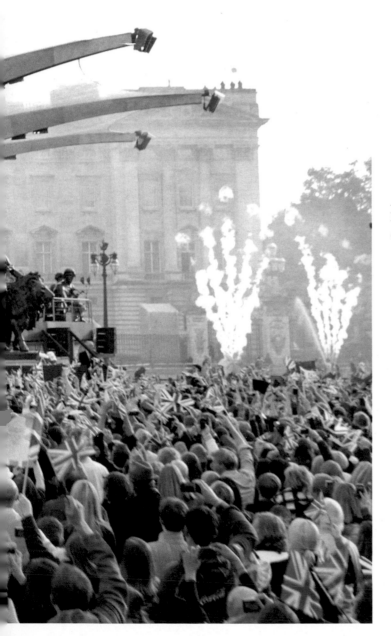

LEFT: **Singer Robbie Williams opens the Diamond Jubilee concert outside Buckingham Palace.**

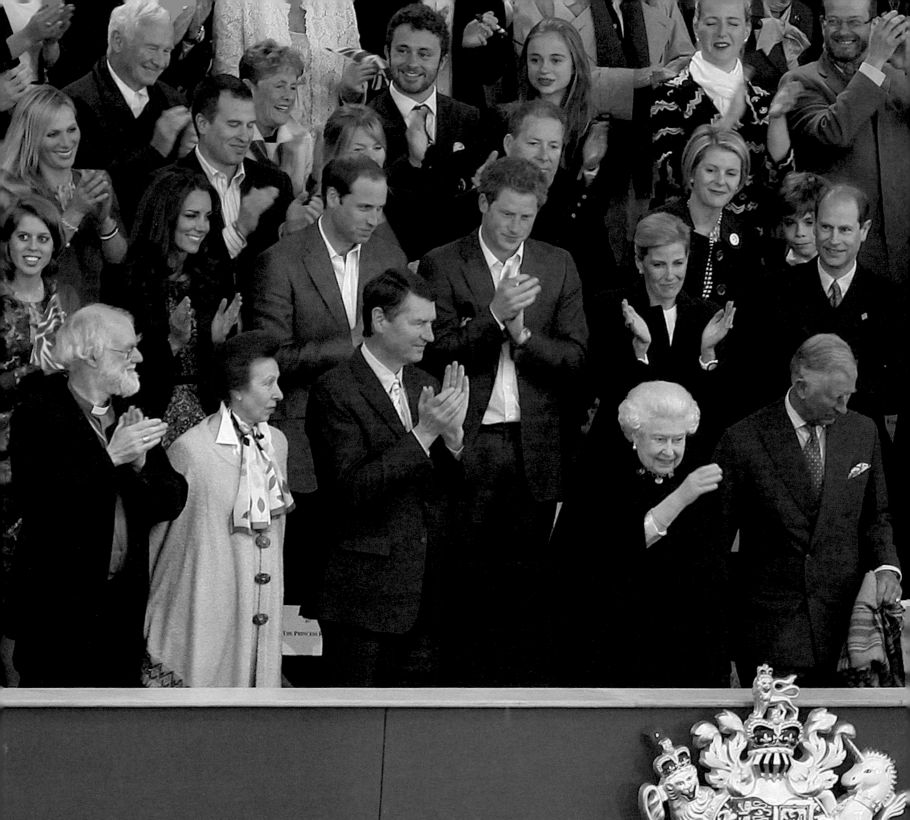

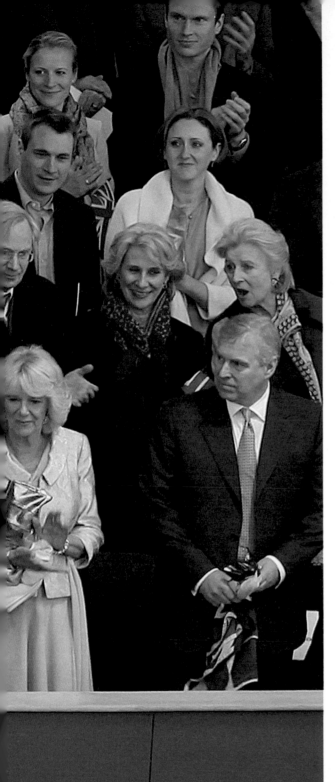

LEFT: **The Queen waves to the crowd attending the Diamond Jubilee concert in front of Buckingham Palace, 4ᵗʰ June 2012.**

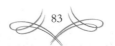

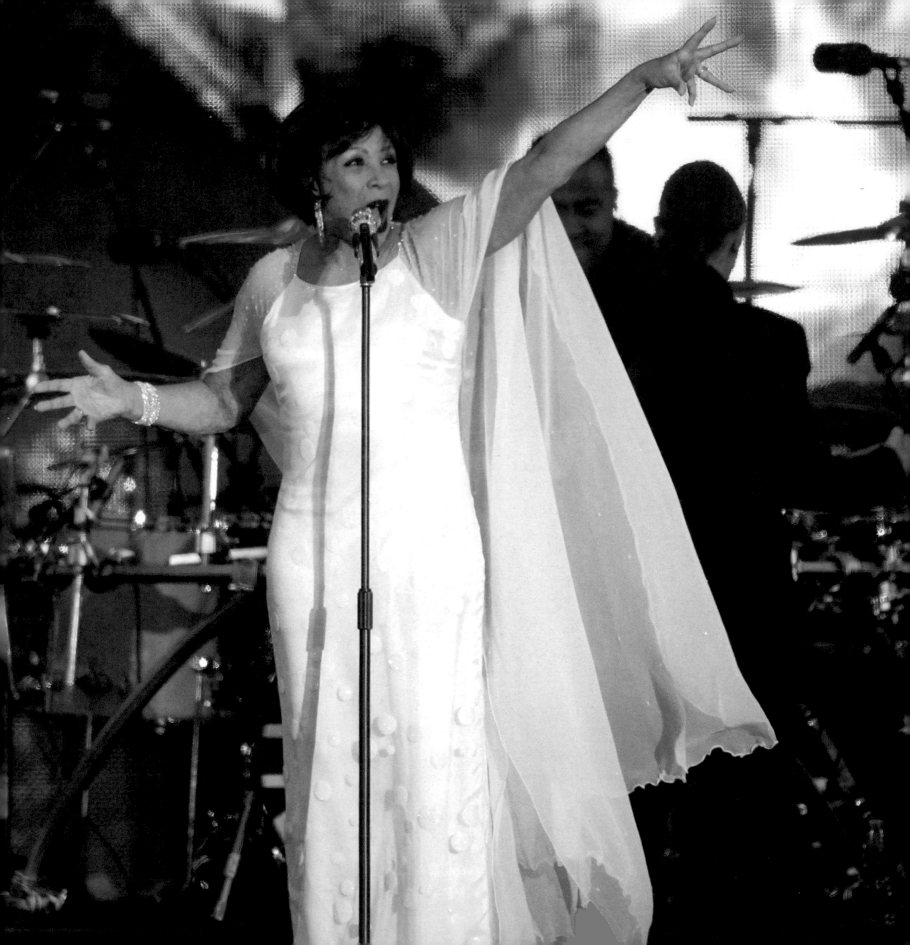

ABOVE: **Gary Barlow and Cheryl Cole hold hands after performing Lady Antebellum's hit 'Need You Now' during the Diamond Jubilee concert, 4th June 2012.**

LEFT: Dame Shirley Bassey performs 'Diamonds Are Forever'.

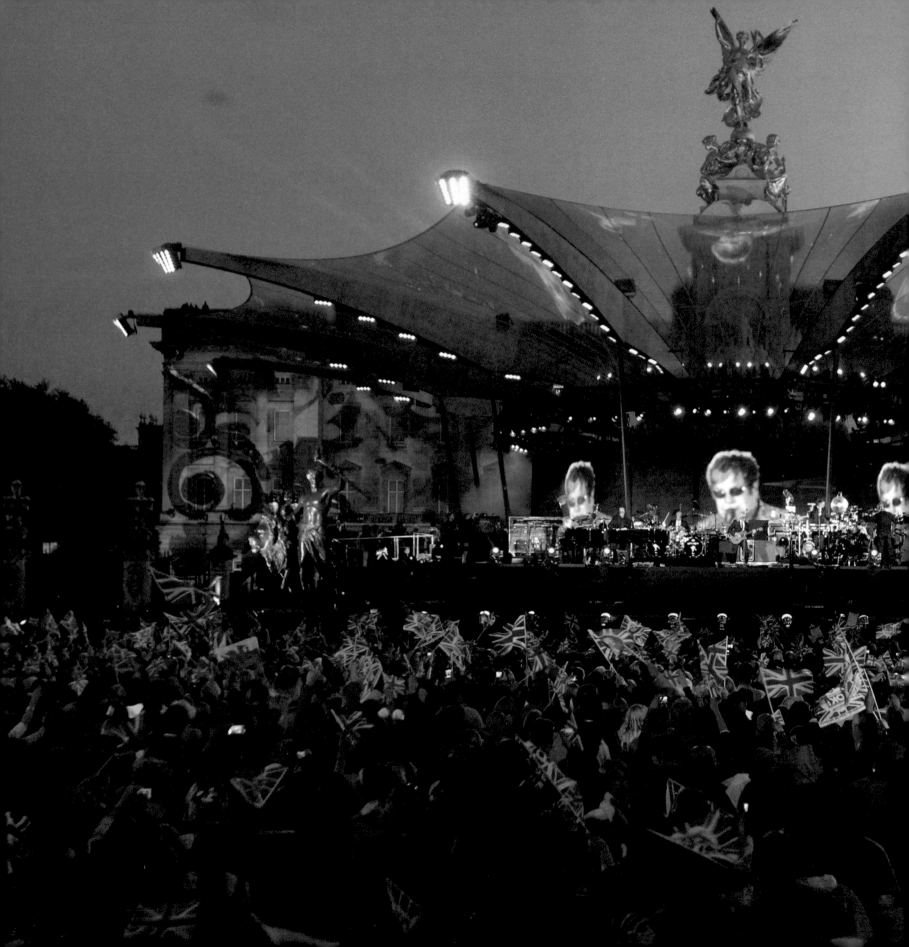

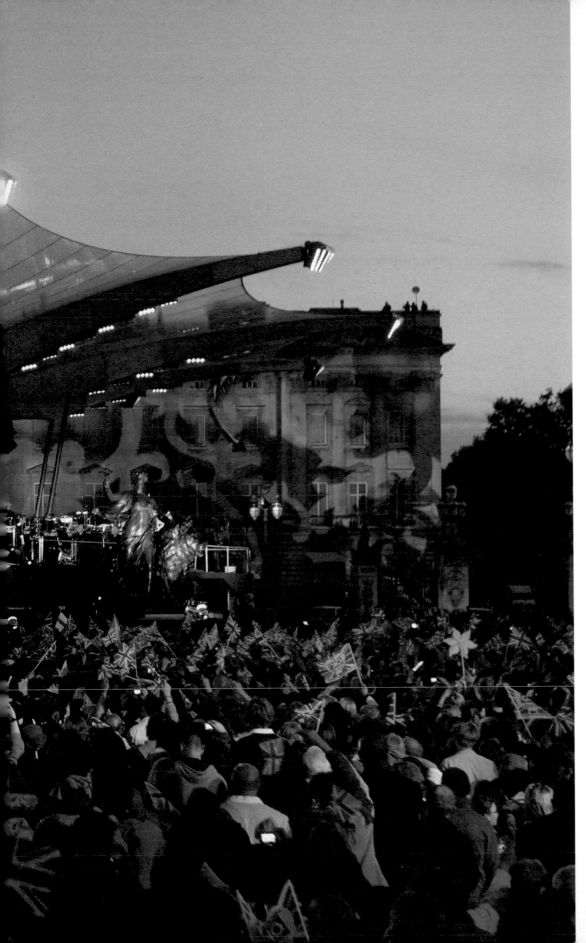

LEFT: **Sir Elton John performs at the Diamond Jubilee Concert, 4th June 2012.**

YOUR MAJESTY, MUMMY

The Queen arrived at the concert at 9.00pm and was escorted to her seat by Prince Charles before waving to the crowds.

Sitting next to the empty chair where Prince Philip should have been, she was surrounded by her family, politicians, dignitaries and celebrities in the royal box.

She wore a stunning golden cocktail dress concealed beneath a black cape, and a pair of earplugs could just be seen above her pearl and diamond earrings.

The Queen arrived just in time to hear the Diamond Jubilee song 'Sing', watch Dame Shirley Bassey's dramatic performance of 'Diamonds Are Forever' and also see classical singers Alfie Boe and Renee Fleming give a rendition of *West Side Story*'s 'Somewhere' from the palace balcony.

After Sir Paul McCartney had performed the final song, the Royal Family arrived on stage to the cheers and waving of Union flags, the Queen's glamorous, sparkling outfit by Angela Kelly now in full view.

Prince Charles paid a heartfelt tribute to his mother beginning with the words "Your Majesty, mummy".

He thanked all the "wonderful people" who had made the concert possible before urging the crowd to shout for Prince Philip as he lay in hospital.

Prince Charles said: "The only sad thing about this evening is that my father could not be here with us because unfortunately he was taken unwell. But, ladies and gentlemen, if we shout loud enough he might just hear us in hospital and get better."

The Queen was visibly moved as thousands of voices cheered "Philip, Philip, Philip!"

Then, turning to his mother, Charles said: "Your Majesty, a Diamond Jubilee is a unique and special event. Some of us have had the joy of celebrating three Jubilees with you. And I have the medals to prove it. And we are now celebrating the life and service of a very special person over the last 60 years. I was three when my grandfather George VI died and suddenly, unexpectedly, your and my father's lives were irrevocably changed.

"So, as a nation, this is our opportunity to thank you and my father for always being there for us. For inspiring us with your selfless duty and service and for making us proud to be British."

Prince Charles then led the audience in three cheers for the Queen before kissing his mother's hand and joining the audience in a rendition of the National Anthem.

Then the Queen put a diamond-shaped Jubilee crystal into a pod, which triggered the lighting of the National Beacon before a spectacular fireworks display lit up the sky.

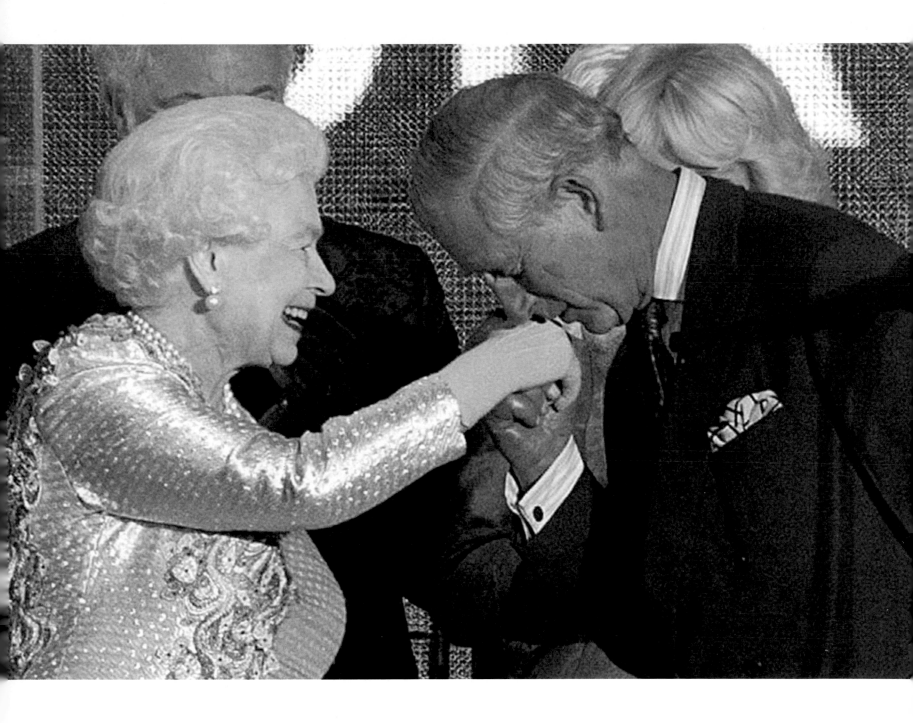

ABOVE: **Prince Charles kisses the Queen's hand after making a heartfelt speech in her honour at the Diamond Jubilee concert, 4th June 2012.**

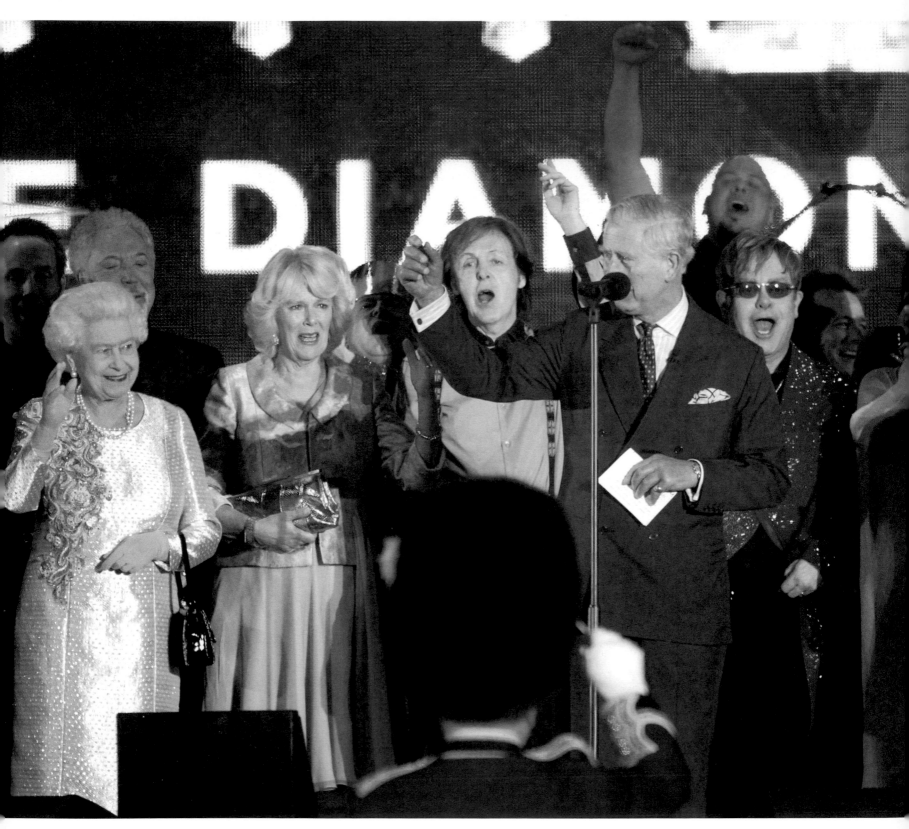

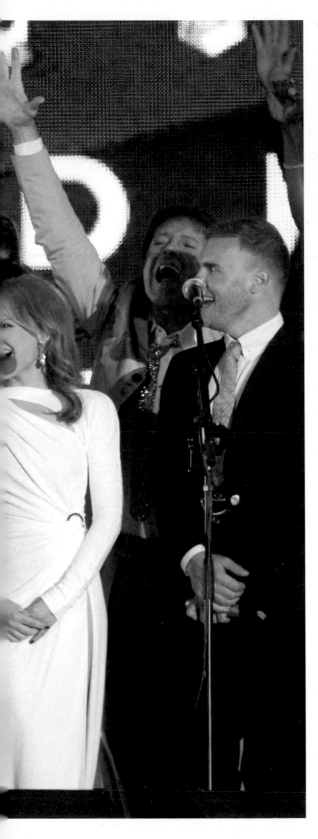

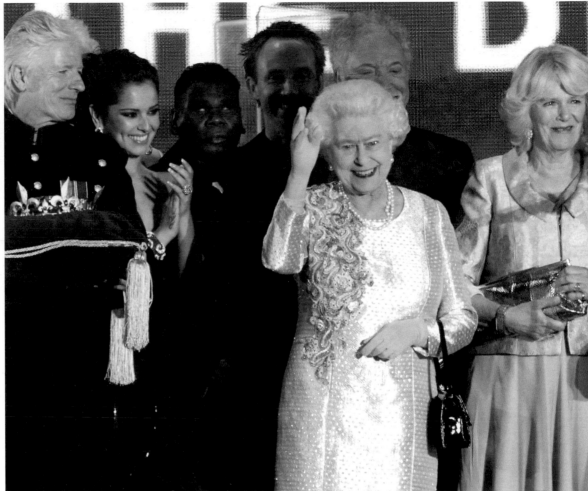

ABOVE: The Queen waves to the crowd as the Jubilee crystal is brought onto the stage ready for her to light the National Beacon following the concert. More than 4,200 beacons were lit across the world, including one at each of Britain's four highest peaks. Forces charity Help for Heroes conquered Ben Nevis in Scotland, Walking with the Wounded climbed Snowdon in Wales, Cancer Research UK scaled England's Scafell Pike, while Fields of Life took on Northern Ireland's highest peak, Slieve Donard, in the Mourne mountain range in County Down.

LEFT: Prince Charles makes a moving speech, paying tribute to his mother's inspirational sense of duty.

RIGHT: **Fireworks light up the Mall following the Diamond Jubilee concert, 4th June 2012.**

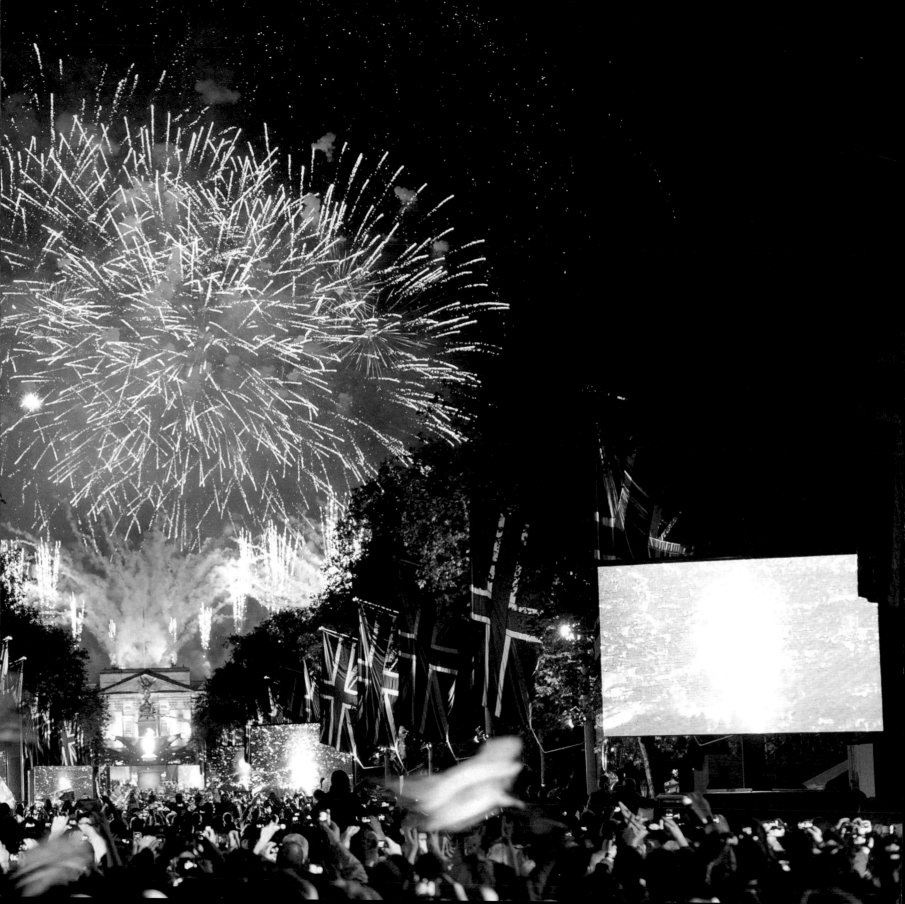

CHAPTER FOUR

TIME TO REFLECT

"The events that I have attended to mark my Diamond Jubilee have been a humbling experience."

Queen Elizabeth II message of thanks to the nation following the extended weekend of Diamond Jubilee celebrations, 5th June 2012

RIGHT: The Queen arrives at St Paul's Cathedral to begin her procession down the aisle for the Diamond Jubilee Service of Thanksgiving. She is being led into the Cathedral by the Lord Mayor of London, David Wootton, bearing the ceremonial Pearl Sword, 5th June 2012.

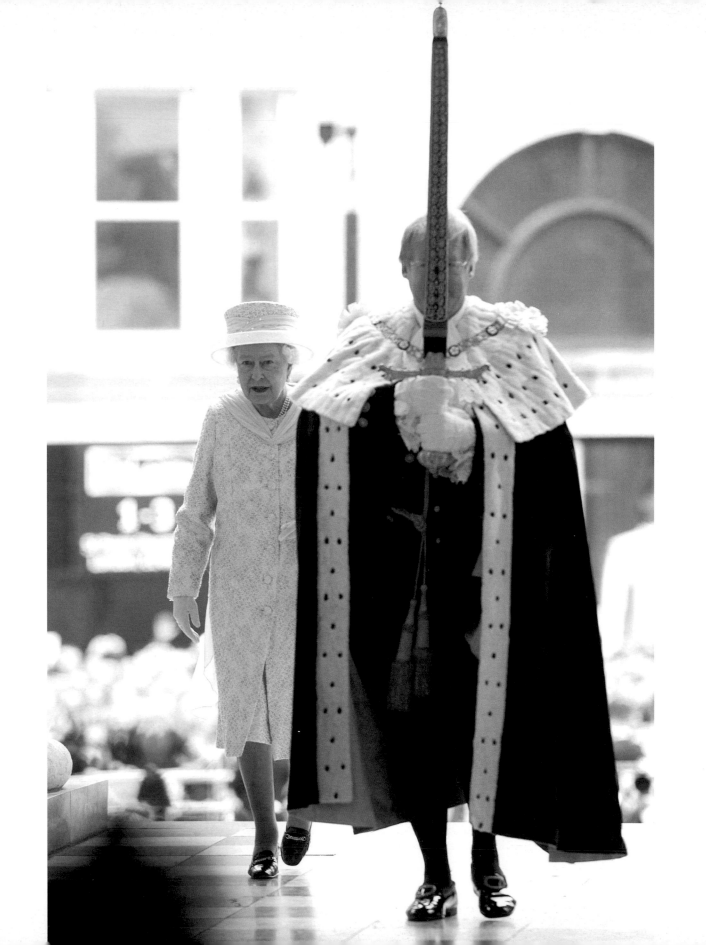

SERVICE OF THANKSGIVING

After three days of fun-filled, spirited celebrations the final day of the Diamond Jubilee weekend was a more solemn affair, steeped in the tradition of royal pomp and circumstance.

The Queen was the guest of honour at a Service of Thanksgiving in St Paul's Cathedral, which was also attended by 57 members of her extended family and 2,000 invited guests.

She made history as only the second British Sovereign to have a Diamond Jubilee Service of Thanksgiving, and the first to climb the 74 steps into the cathedral. When Queen Victoria celebrated 60 years on the throne in 1897 aged 78, she was so frail her Service of Thanksgiving had to be held outside.

At exactly 10.30am the specially composed trumpet tune 'Jubilate' bounced off the walls of the lavish 17th-century cathedral as the Queen and most senior royals arrived at the Great West Door.

First came Prince Harry, followed by William and Kate, then Charles and Camilla and, finally, the Queen. They all walked slowly down the aisle towards the high altar.

In the absence of Prince Philip, who lay 3 miles away in King Edward VII Hospital, the Queen walked alone. Her ornate red and gold chair had been moved from the centre, where she would have sat with Philip, to a position close to Prince Charles. The rest of the Royal Family took their seats on the front row.

Other guests decked out in their morning suits, dresses and hats included Prime Minister David Cameron and his wife, Samantha; Deputy Prime Minister Nick Clegg and his wife, Miriam Gonzales; Labour Party Leader Ed Miliband and his wife, Justine Thornton; Foreign Secretary William Hague and his wife, Ffion; Scotland's First Minister Alex Salmond; and London Mayor Boris Johnson.

When everyone was seated the Very Reverend David Ison, Dean of St Paul's, told the congregation: "We give thanks for the blessings bestowed by God on our Sovereign Lady Queen Elizabeth, and we celebrate the identity and variety which our nations under her have enjoyed."

The 75-minute service included a performance of Will Todd's new composition 'The Call of Wisdom' sung by 41 schoolchildren aged 10 to 13 in the specially selected Diamond Choir. The children were auditioned from 400 pupils across the country and were bolstered by the combined choirs of St Paul's Cathedral and Her Majesty's Chapel Royal as the rousing music reverberated round the cathedral. At one point, the Queen looked as though she was wiping away a tear.

A Diamond Jubilee Prayer was also said, written specially for the occasion by the Chapter of St Paul's at the Queen's direction. It gave thanks for the Queen, who is head of the Church of England, describing her as "beloved and glorious".

Prime Minister David Cameron gave an accomplished reading of the New Testament reading Romans 12 verses

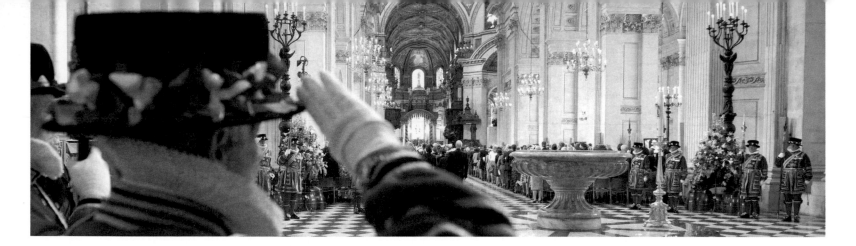

ABOVE: Inside St Paul's Cathedral just after the Queen's arrival for the Diamond Jubilee Service of Thanksgiving, 5th June 2012.

1–18, which includes the words: "Let love be genuine; hate what is evil, hold fast to what is good; love one another with mutual affection; outdo one another in showing honour."

The Archbishop of Canterbury made a last-minute addition to his sermon to include a mention of Philip's illness – appropriately placed after he spoke about what makes the Queen happiest. He said: "She has made her 'public' happy and all the signs are that she is herself happy, fulfilled and at home in these encounters. The same, of course, can manifestly be said of Prince Philip; and our prayers and thoughts are very much with him this morning." The Archbishop praised the Queen's "lifelong dedication", adding: "I don't think it's at all fanciful to say that, in all her public engagements, our Queen has shown a quality of joy in the happiness of others."

Later, he observed: "But we are marking today the anniversary of one historic and very public act of dedication – a dedication that has endured faithfully, calmly and generously through most of the adult lives of most of us here. We are marking six decades of living proof that public service is possible and that it is a place where happiness can be found."

The only hitch came during the Litany of Prayer and Thanksgiving when the first reader, young St John's

Ambulance National Cadet of the Year Jemma Samuel, began reading and realized that the page marker had been left in the wrong place.

After a pause to find the right place in the programme, she carried on flawlessly.

The final hymn was a special moment for Prince William and Kate when they joined the congregation singing Cwm Rhondda, music to 'Guide Me O Thou Great Redeemer', which they had chosen for their wedding last April. It was also the last hymn at Princess Diana's funeral in 1997.

After two verses of the National Anthem, the royals processed out in the opposite order from which they had arrived in – the Queen at the helm followed by the royals in order of precedence as the cathedral bells rang out joyously.

The Diamond Queen beamed and waved as she stepped into daylight to see the cheering crowds who had gathered to wish her well.

The Very Reverend David Ison, Dean of St Paul's, guided her to a carved inscription.

Dated June 22 1897, it reads: "Here Queen Victoria returned thanks to Almighty God for the 60th anniversary of her accession."

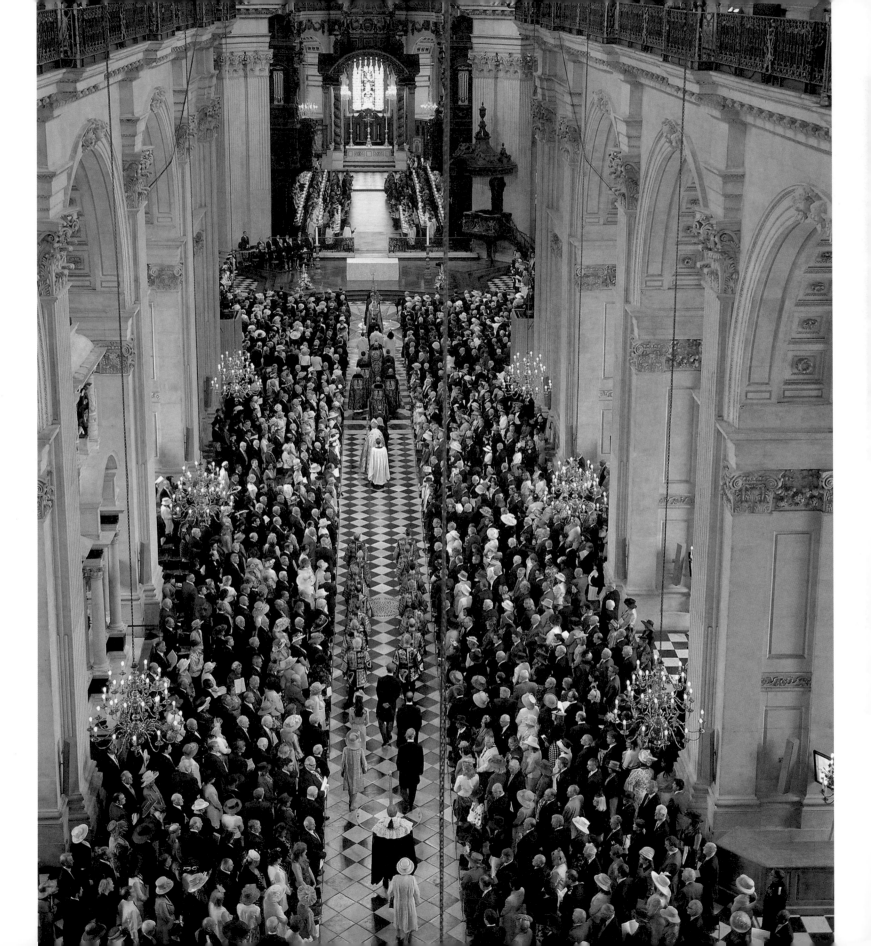

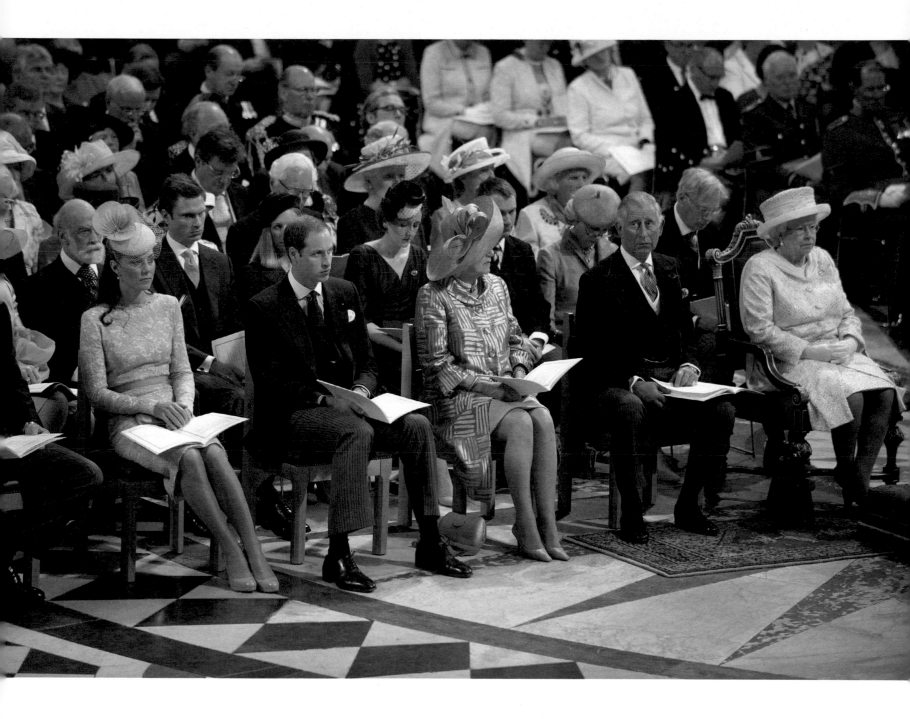

LEFT: **The Queen begins her procession into St Paul's Cathedral for the Diamond Jubilee Service of Thanksgiving, 5ᵗʰ June 2012.**

ABOVE: **The Queen and Royal Family sit along the front row at the Diamond Jubilee Service of Thanksgiving, 5ᵗʰ June 2012.**

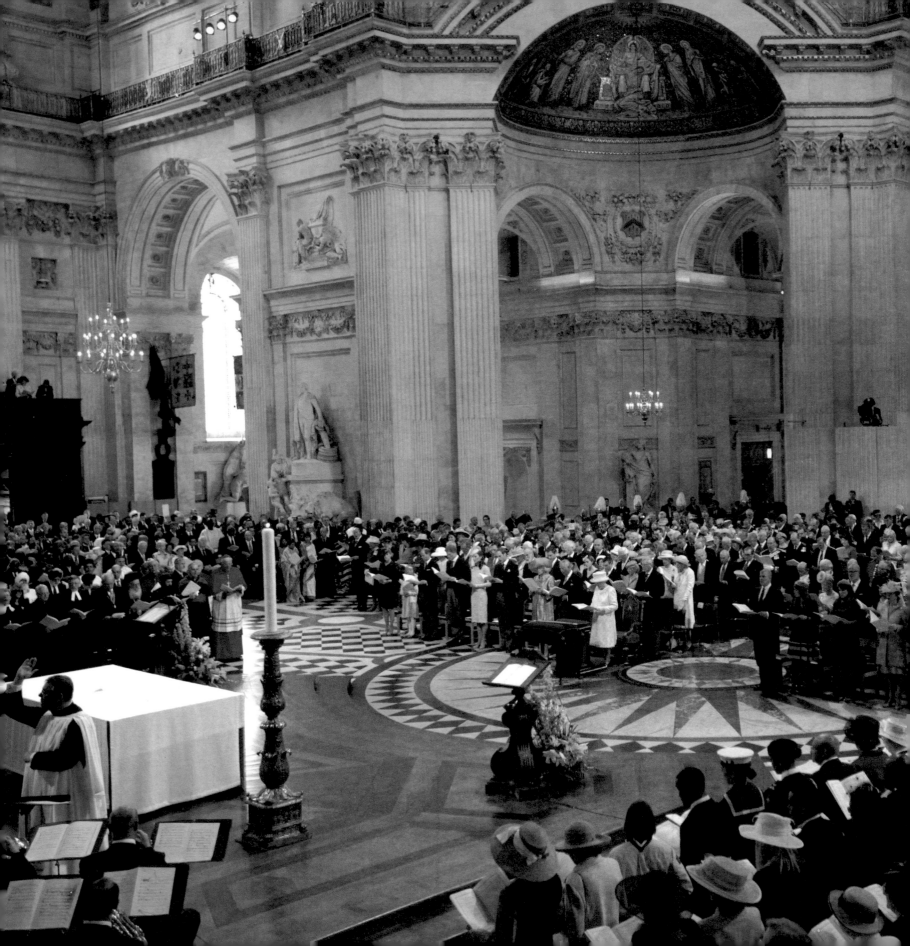

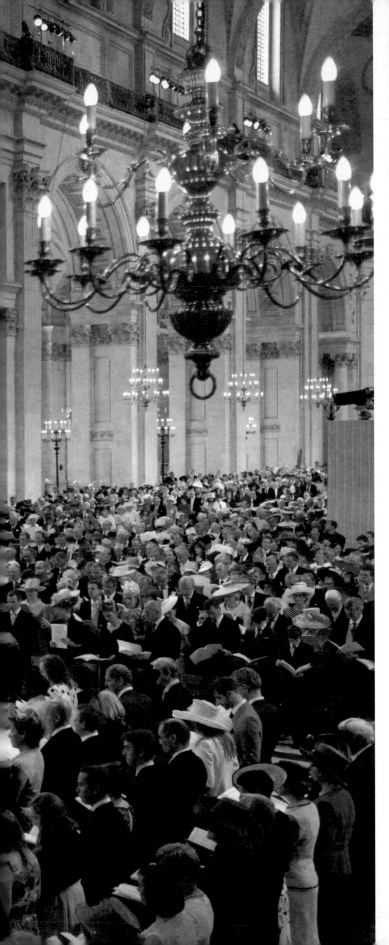

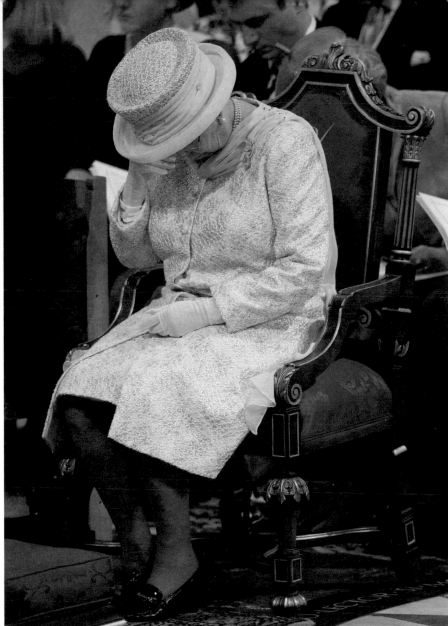

LEFT: The Queen and congregation stand for a hymn during the Diamond Jubilee Service of Thanksgiving. Instead of sitting in the centre with Philip as had been planned, the Queen's ornate chair was placed next to Prince Charles'. Next to him was Camilla, who was beside William and Kate. On Kate's right were Harry, Prince Edward, his daughter Louise and wife, Sophie.

On the opposite side of the aisle were Prince Andrew and his daughters Beatrice and Eugenie along with Princess Anne and Vice Admiral Timothy Laurence, Peter Phillips and his wife, Autumn, and Zara Phillips and her husband, Mike Tindall, 5th June 2012.

ABOVE: A tender moment for the Queen as she wipes her eyes during the Service.

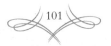

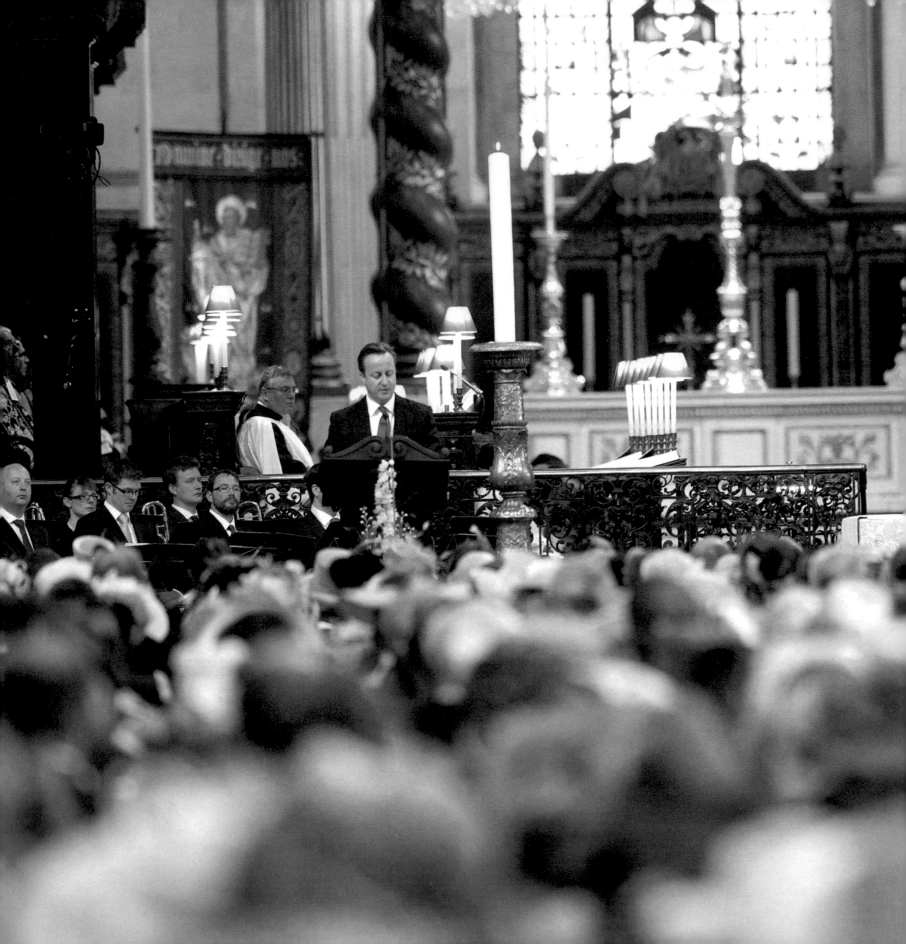

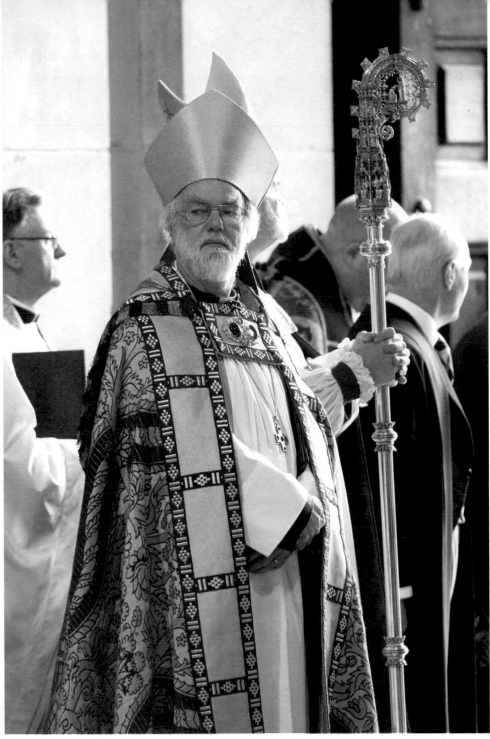

ABOVE: The Archbishop of Canterbury, Dr Rowan Williams, inside St Paul's Cathedral during the Diamond Jubilee Service of Thanksgiving. The Archbishop, who also married Prince William and Kate in Westminster Abbey on 29th April 2011, delivered the sermon, 5th June 2012.

LEFT: Prime Minister David Cameron gives a reading during the service.

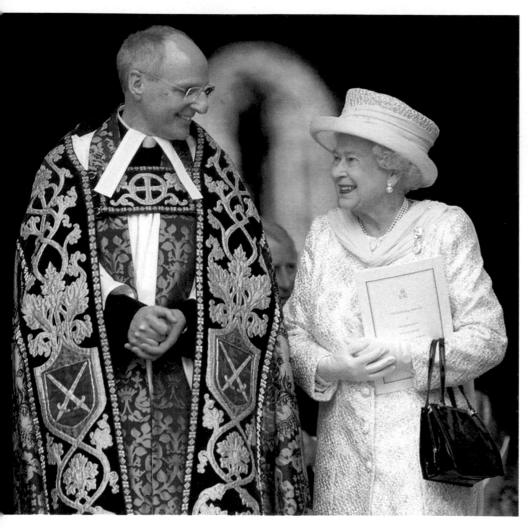

ABOVE: The Queen shares a smile with the Dean of St Paul's Cathedral, the Very Reverend David Ison following the Diamond Jubilee Service of Thanksgiving, 5th June 2012.

RIGHT: Members of the Royal Family gather on the steps of St Paul's Cathedral after the service.

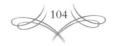

PROCESSION AND BALCONY APPEARANCE

The pomp and pageantry of the day continued after the Service of Thanksgiving when the Queen was a guest of honour at a reception at Mansion House.

Smiling broadly, she was greeted by the Lord Mayor of the City of London, David Wootton, before joining 250 guests in the impressive Egyptian Hall.

Just down the road in the Guildhall, one of London's most historic buildings, a larger reception was taking place with Prince Charles, Camilla, Prince William, Kate and Prince Harry before they joined the Queen at Westminster Hall for lunch.

The royals made their entrance into the hall to a fanfare by the State Trumpeters of the Household Cavalry before joining 700 guests who enjoyed a special menu that paid tribute to the UK's finest produce. They feasted on a first course of marinated Uist Island salmon with Lyme Bay crab, followed by saddle of Welsh Cambrian Mountain lamb with braised shoulder of lamb, grilled Isle of Wight asparagus, Jersey Royal potatoes and Jubilee sauce. As they enjoyed their desert of chocolate delice, bread and butter pudding and berry compote with Sandringham apple sauce, they were serenaded by the National Children's Orchestra.

After lunch more than 2,000 military personnel from the Army, Navy and Air Force lined the route from Westminster Hall to Buckingham Palace for a carriage procession.

The Queen, Charles and Camilla travelled in the 1902 State Landau, the same carriage in which Prince William and Kate travelled in on their wedding day, while William, Kate and Harry followed behind in another State Landau.

As the carriages pulled up at Buckingham Palace to a guard of honour, the King's Troop Royal Horse Artillery fired a 60-gun salute.

Then, at exactly 3.30pm, the estimated one and a half million people lining the Mall cheered as the Queen walked out onto the Buckingham Palace balcony followed by Prince Charles, Camilla, Prince William, Kate and Prince Harry.

The royals craned their heads to watch the spectacular fly-past of Second World War aircraft and a stunning display by the Red Arrows, followed by a feu de joie – a celebratory rifle cascade of fire.

A lip-reader told how the Queen turned to Prince Charles and said about Prince Philip: "It's a pity he couldn't be with me today."

She also told her son: "An incredible day and afternoon … It's been absolutely wonderful."

And Philip was given a run-down of the celebrations later in the day when Prince Edward, Sophie and their children visited him in hospital.

That evening, as four breathless days came to a close, the Queen thanked the nation in a televised address. The two-minute broadcast at 6.00pm had been recorded in the Buckingham Palace Presence Room the night before.

The Queen said:

"The events that I have attended to mark my Diamond Jubilee have been a humbling experience. It has touched me deeply to see so many thousands of families, neighbours and friends celebrating together in such a happy atmosphere. But Prince Philip and I want to take this opportunity to offer our special thanks and appreciation to all those who have had a hand in organising these Jubilee celebrations. It has been a massive challenge, and I am sure that everyone who has enjoyed these festive occasions realises how much work has been involved. I hope that memories of all this year's happy events will brighten our lives for many years to come. I will continue to treasure and draw inspiration from the countless kindnesses shown to me in this country and throughout the Commonwealth. Thank you all."

BELOW: **The Queen, accompanied by Prince Charles and Camilla, travels in a carriage procession from St Paul's Cathedral to Buckingham Palace as military personnel line the streets, 5th June 2012.**

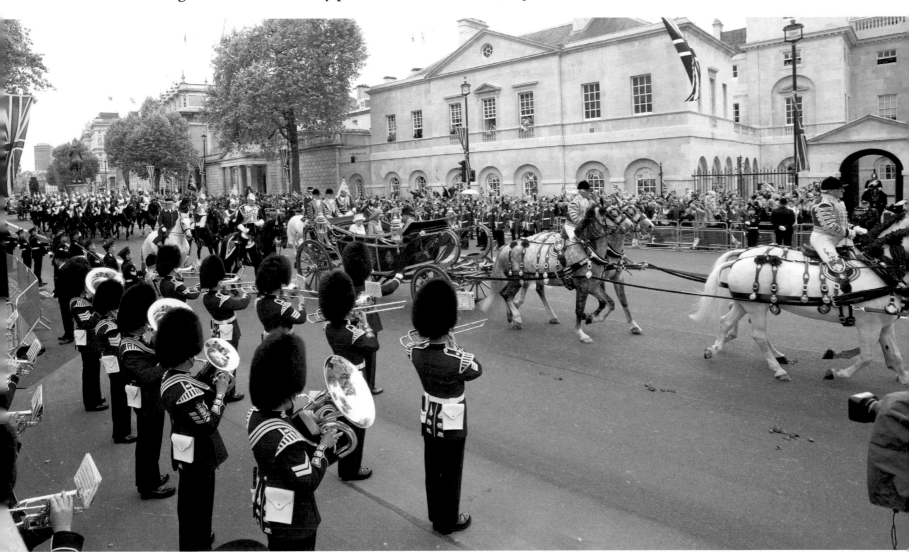

LEFT: The Queen is greeted by the National Children's Orchestra as she arrives at Westminster Hall for lunch on the final day of her Diamond Jubilee celebrations, 5th June 2012.

BELOW: Crowds in London's Mall rush forward to get a good look at the Royal Family as they appear on the Buckingham Palace balcony.

RIGHT: The Queen waves to the crowds from the Buckingham Palace balcony on the final day of the Diamond Jubilee celebrations.

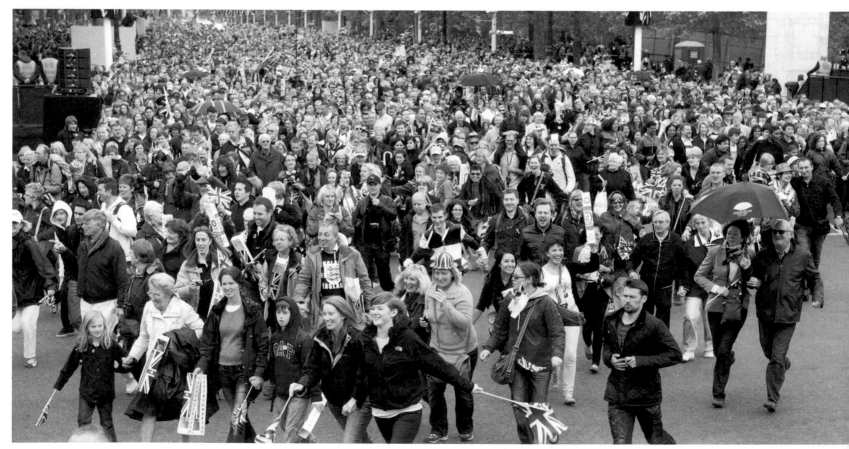

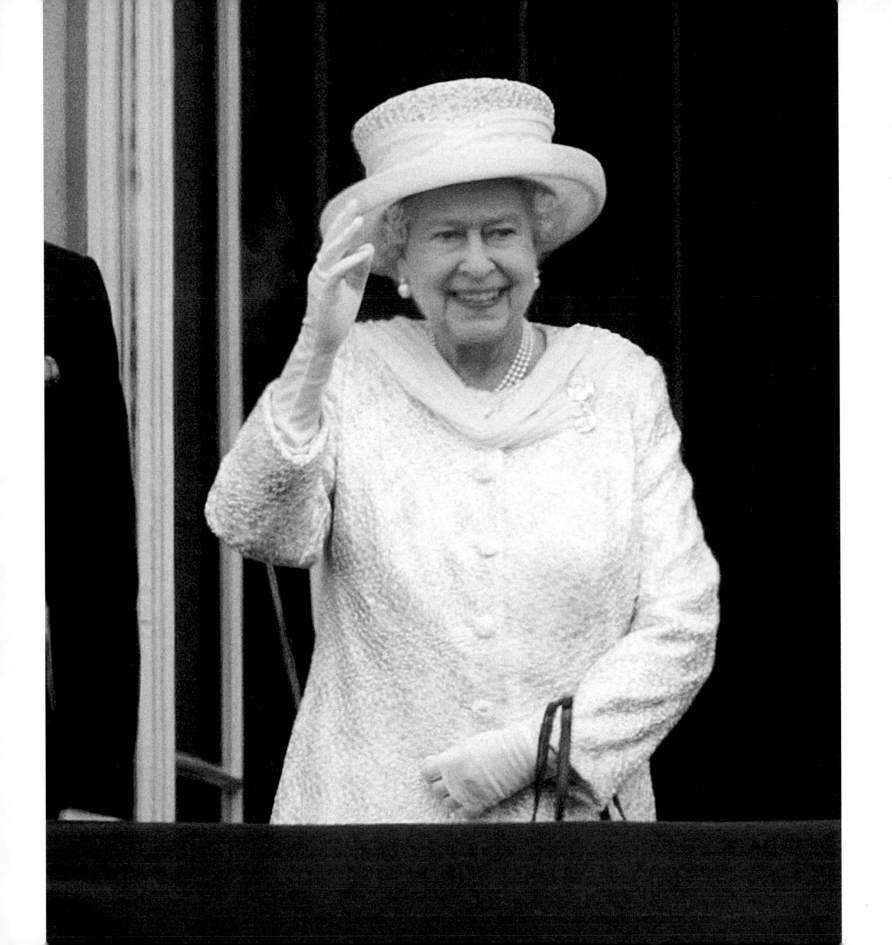

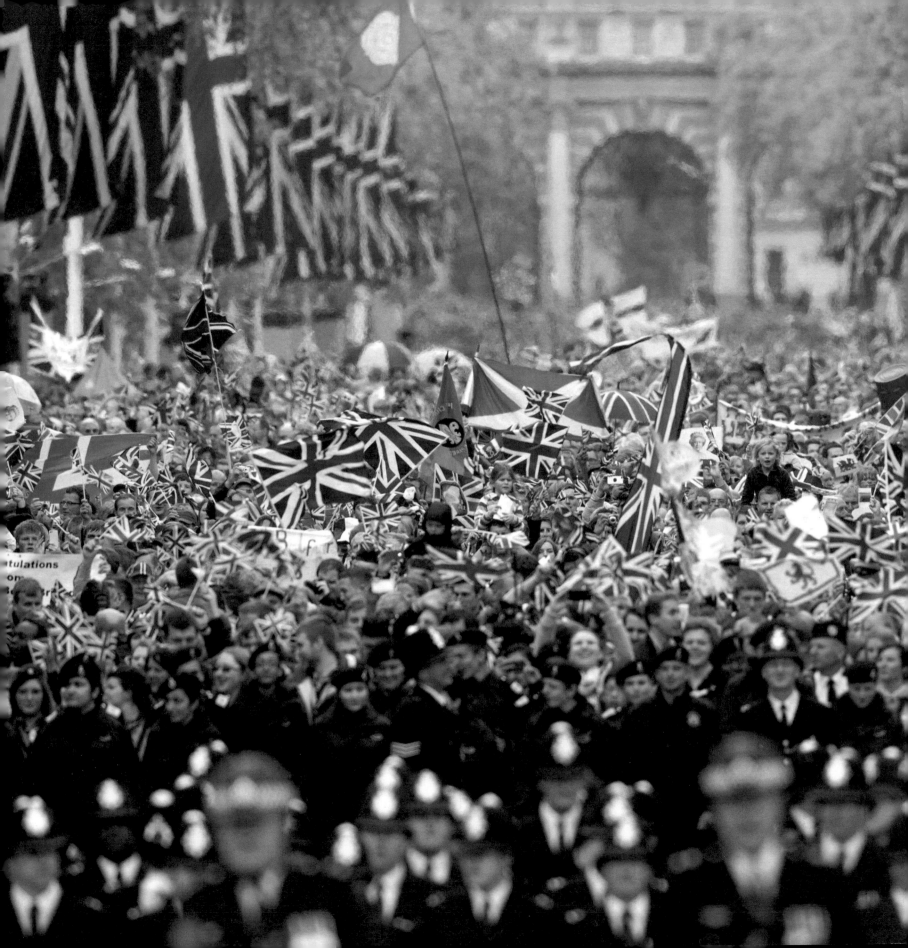

LEFT: Thousands line the Mall to see the Royal Family on the Buckingham Palace balcony.

BELOW: Prince Edward, Sophie and their children Lady Louise and James, Viscount Severn, leave London's King Edward VII Hospital after visiting Prince Philip, 5th June 2012.

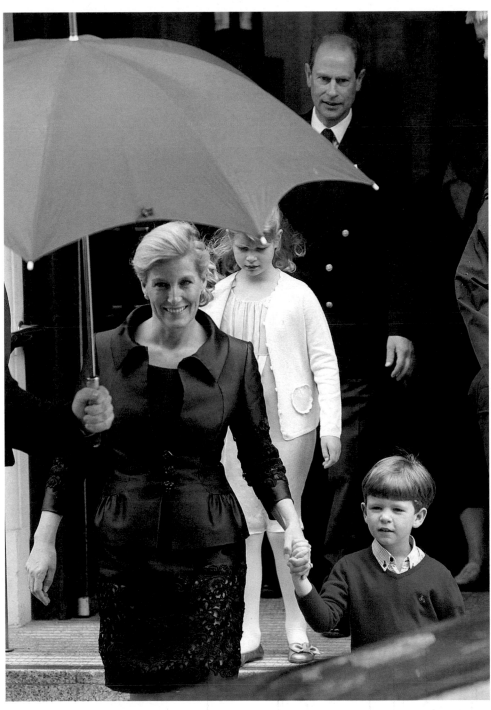

CHAPTER FIVE

THE HEART OF THE FAMILY

"During these years as your Queen, the support of my family has, across the generations, been beyond measure."

Queen Elizabeth II Diamond Jubilee address to Parliament, 20th March 2012

RIGHT: The Queen processes out of St Paul's Cathedral following the Diamond Jubilee Service of Thanksgiving. Her family follows behind in order of precedence, 5th June 2012.

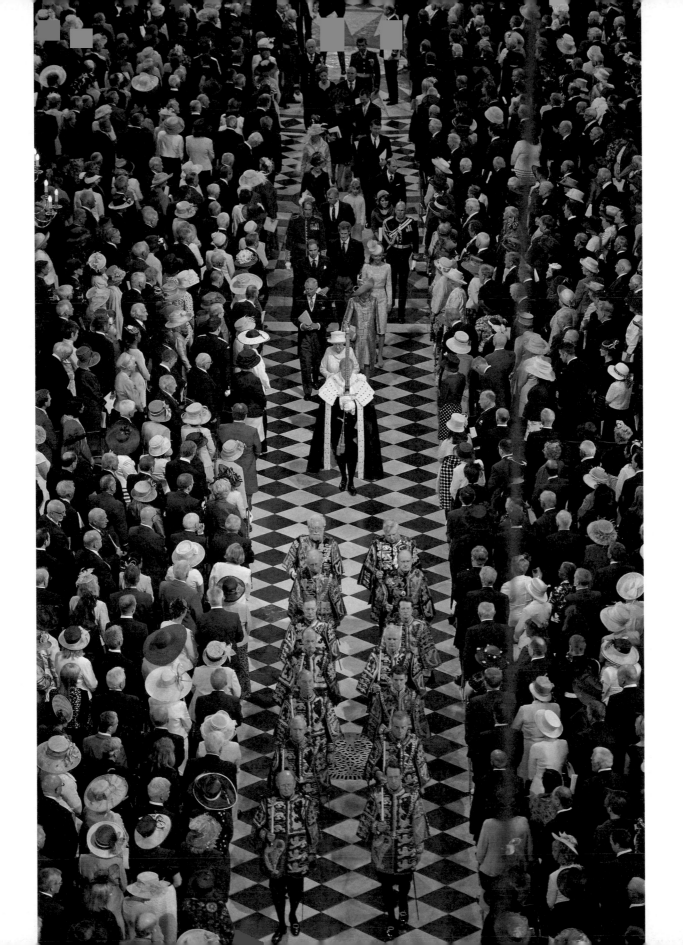

MAGNIFICENT SEVEN

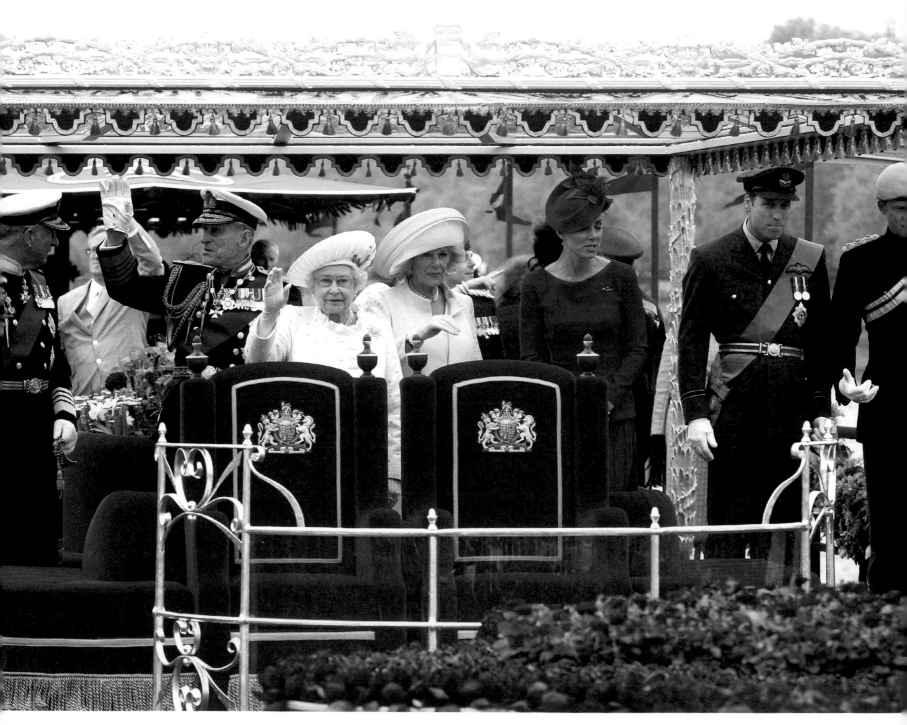

The Diamond Jubilee celebrations put the Royal Family in the spotlight for hours each day as a worldwide audience watched their every move. One theme that quickly emerged throughout the extended weekend was the constant prominence of the seven most senior royals – the Queen, Prince Philip, Prince Charles, Camilla, Prince William, Kate and Prince Harry. These were the only royals to travel on the Royal Barge during the river pageant, the only royals to process down the aisle of St Paul's Cathedral at the opening of the Service of Thanksgiving and the only ones to take part in the carriage procession and appear on the Buckingham Palace balcony.

The theme was so apparent that they were quickly dubbed the "Magnificent Seven", even though in reality they were six for most of the weekend after Prince Philip was taken to hospital on Monday morning.

"Is this a sign from the Queen: No more hangers on?", historian Kate Williams asked in the *Daily Mirror*.

"A new, streamlined royalty for straightened times?"

Palace courtiers confirmed that the decision had been carefully thought through.

An aide said: "The carriage procession is designed to carry the three generations – the Queen, Prince of Wales, Duke of Cambridge, their spouses and Prince Henry – and this demonstration of the continuity of monarchy is also reflected at the balcony appearance."

The vision for the future gave a big thumbs up to one of the Royal Family's newest additions – the Duchess of Cambridge. Just over a year earlier she had been plain Kate Middleton, Prince William's girlfriend who was very much in the background. Yet here she was standing alongside the Queen, very much a key player as the Monarchy moves further into the 21st century.

And this vision for the future of the Royal Family also marked a significant turn-around for another female royal, Camilla. Once reviled by the public as the woman who destroyed the "fairytale" marriage of Prince Charles and Diana, Camilla's key position at the Diamond Jubilee celebrations proved that those difficult days were well and truly behind her. In the absence of Prince Philip, she and Charles sat alongside the Queen in the carriage procession from Westminster Hall to Buckingham Palace on the final day of the Jubilee celebrations, and the night before she had enjoyed a front row seat for the Buckingham Palace concert. "For years she was the 'other woman' but Camilla's increased prominence demonstrated she has been truly accepted as part of the Windsor's future", the *Daily Mirror* observed.

The cheers on the Mall when the royals emerged onto the Buckingham Palace balcony showed that the slimmed down Royal Family was more than enough to excite and enthuse the public.

LEFT: The seven most senior members of the Royal Family on board the Royal Barge the *Spirit of Chartwell* during the Thames Diamond Jubilee Pageant. Other royals followed behind on different vessels. Kate's family, the Middletons, were also invited onboard a vessel as part of the royal section of the pageant, 3rd June 2012.

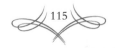

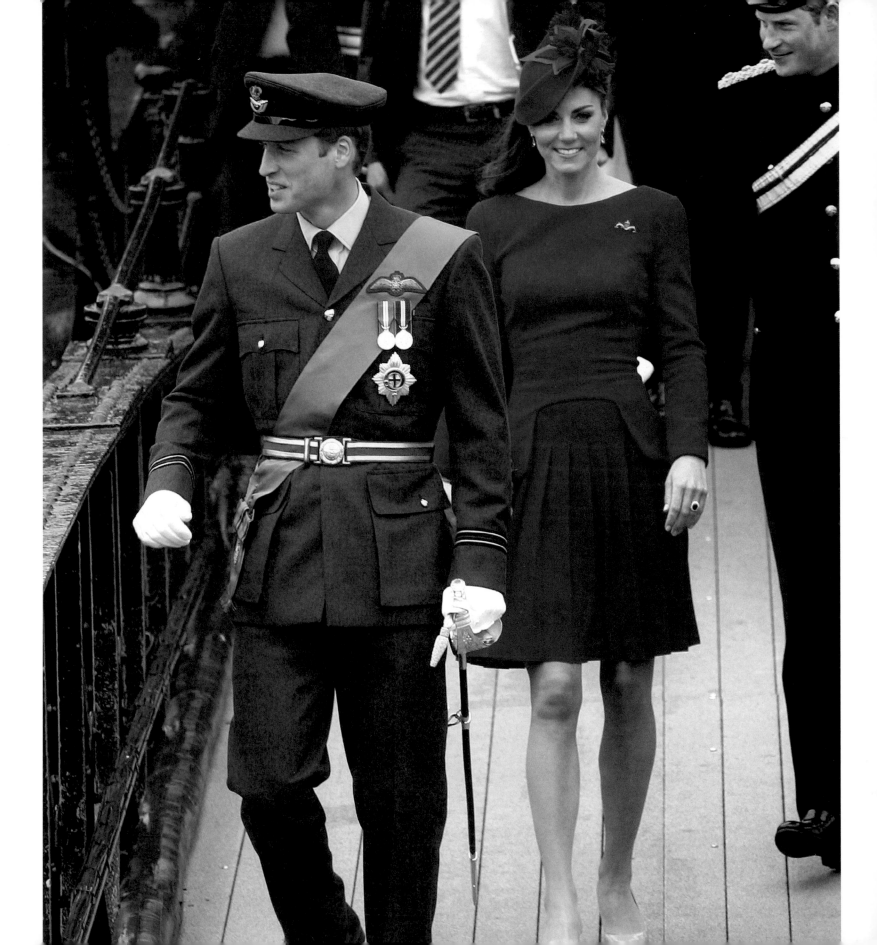

LEFT: Prince William, Kate and Prince Harry prepare to board the *Spirit of Chartwell* before the Thames Diamond Jubilee Pageant, 3rd June 2012.

BELOW: The Queen and Camilla, Duchess of Cornwall, share an animated conversation during the Thames Diamond Jubilee Pageant.

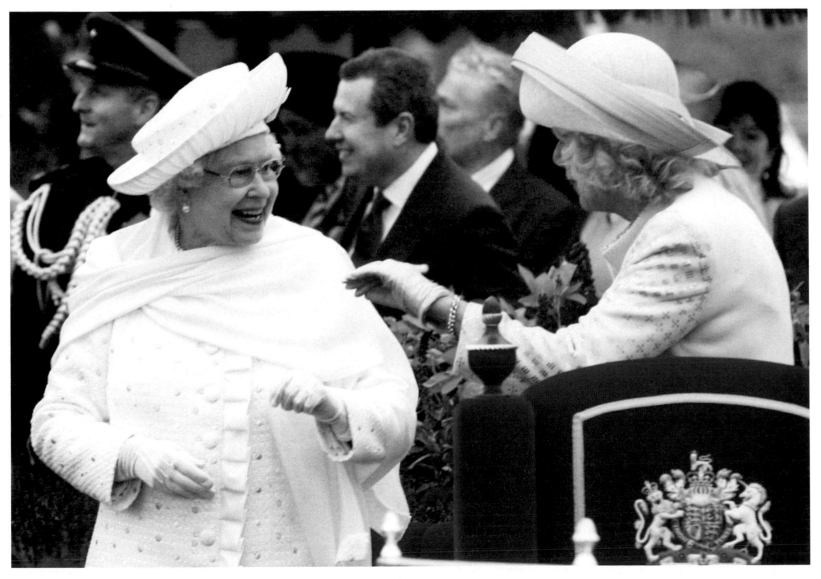

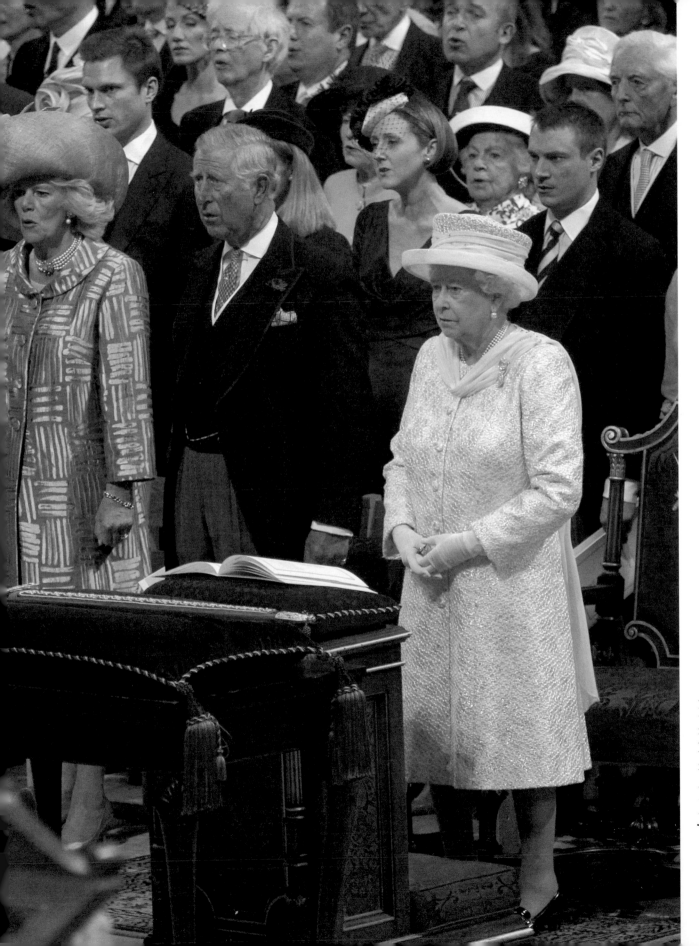

LEFT: **Senior members of the Royal Family stand for the National Anthem during the Diamond Jubilee Service of Thanksgiving in St Paul's Cathedral, 5th June 2012.**

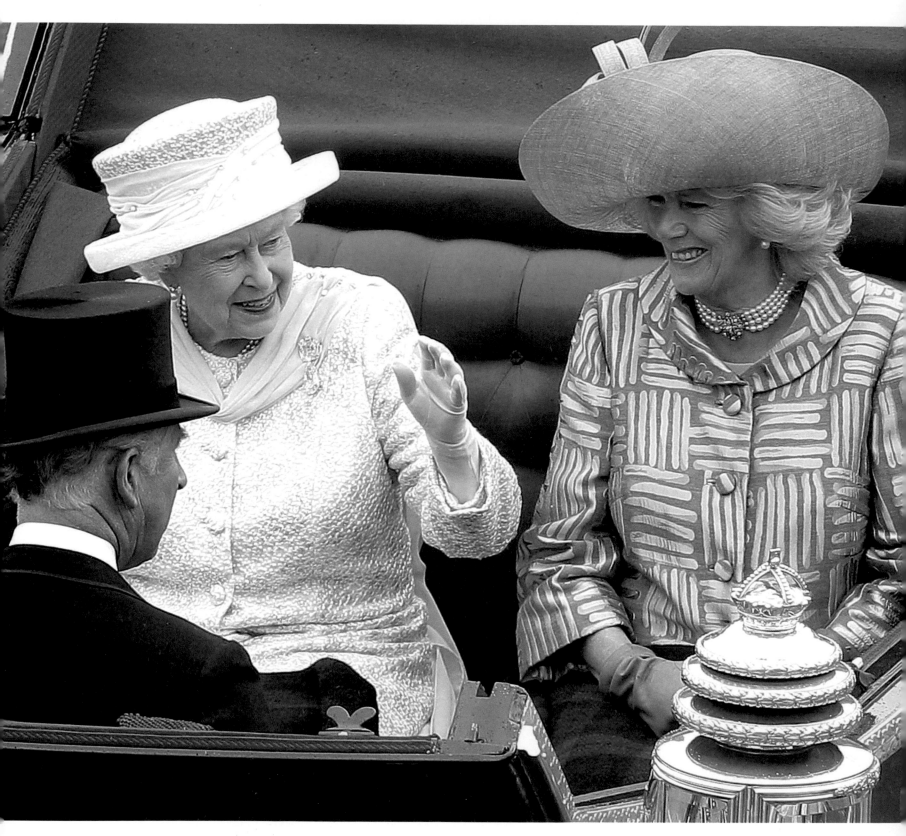

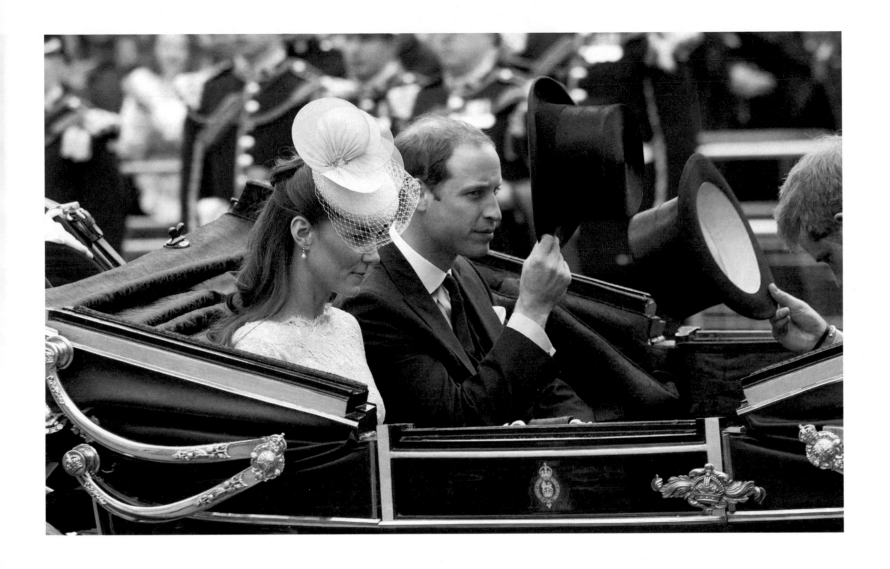

LEFT: **The Queen, Prince Charles and Camilla travel in the 1902 State Landau to Buckingham Palace following the lunch at Westminster Hall on the final day of the Diamond Jubilee weekend, 5ᵗʰ June 2012.**

ABOVE: **Prince William, Kate and Prince Harry travel in a carriage from Westminster Hall to Buckingham Palace following the lunch.**

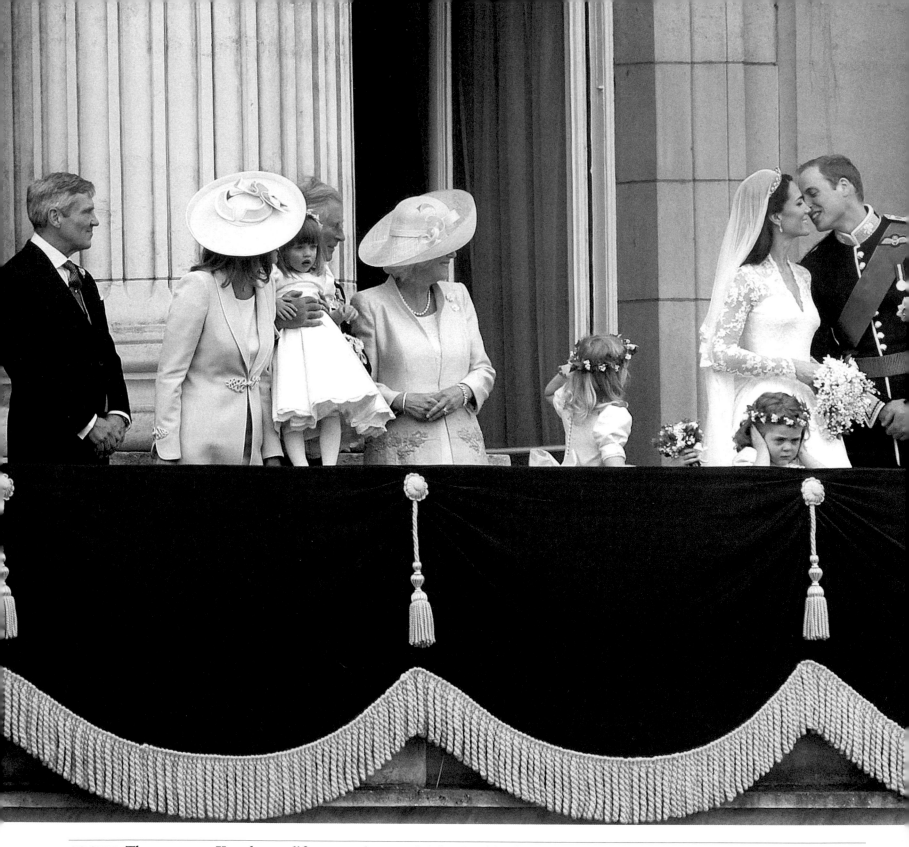

ABOVE: **The moment Kate began life as a senior royal. The Buckingham Palace balcony scene following the wedding of Prince William to Kate Middleton, now the Duke and Duchess of Cambridge, 29th April 2011.**

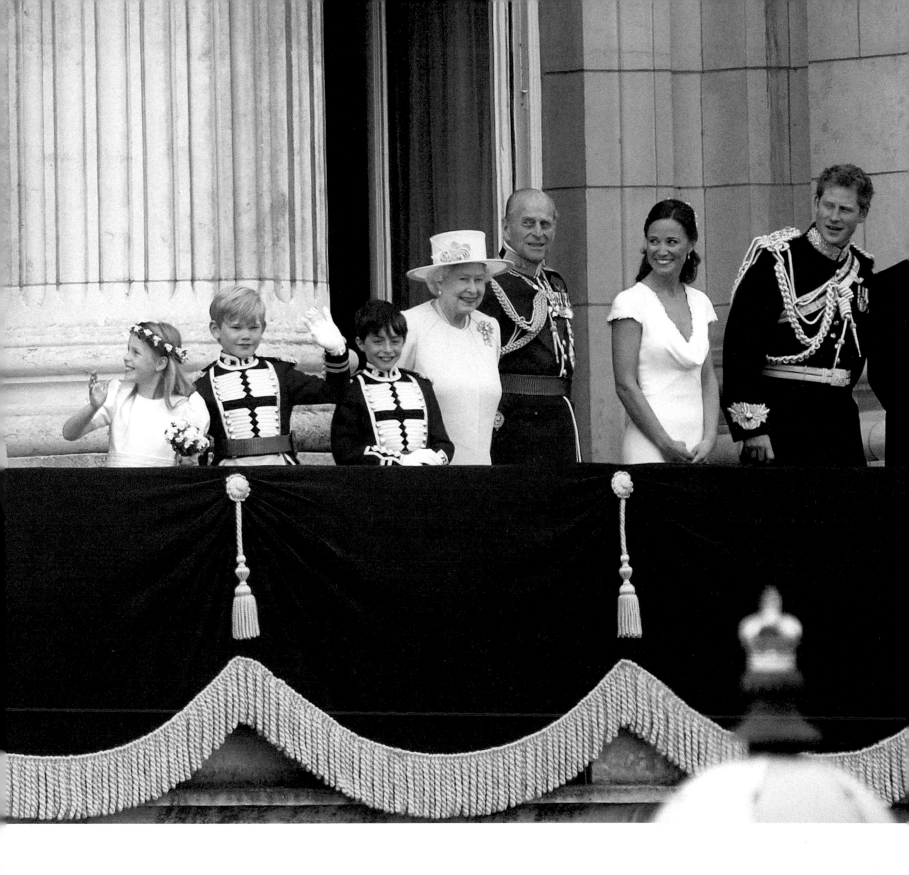

THE QUEEN'S ROCK

"Prince Philip is, I believe, well known for declining compliments of any kind. But throughout he has been a constant strength and guide."

Queen Elizabeth II Diamond Jubilee address to Parliament, 20th March 2012

It is impossible to look back on the Queen's glorious 60-year reign without thinking instantly of the man who has been by her side through each and every step.

Prince Philip is one of the only constants of the Queen's long reign, always present, usually walking just a few paces behind. They first met in 1934 at a wedding, and then again in 1939 when Princess Elizabeth was 13 – and from that moment she was smitten.

From the day they were married, on 20th November 1947, in Westminster Abbey, to almost 65 years later at her Diamond Jubilee celebrations, they have barely parted.

"In Prince Philip she found her true love and the Queen has often acknowledged the tremendous support he has given to her – her 'rock'," explained the Queen's cousin Margaret Rhodes, who was a bridesmaid at their wedding.

Over the years Prince Philip has become famed for his no-nonsense attitude and his infamous witty comments or "gaffes", and the Diamond Jubilee year was no exception. On a visit to Redbridge, north London, in March he asked a man on a mobility scooter: "How many people have you knocked over this morning on that thing?", and in May he told a woman in a red dress in Bromley, south London: "I'd get arrested if I unzipped that dress."

Those closest to the Queen and Prince Philip are full of praise for the way he has supported her unfailingly, with Prince Harry declaring: "Without him she would be slightly lost."

ABOVE: The Queen and Prince Philip on a visit to Salford Quays during their Diamond Jubilee UK tour, 23rd March 2012.

In an interview with US TV channel ABC, aired in May 2012 to mark the Queen's Diamond Jubilee, Prince William spoke of Philip's sacrifices to let his wife shine.

He said: "My grandfather had a very successful career in the military, in the Navy.

"He gave it all up to do his job to be there to support the Queen. It must have been quite difficult for him being in the shadows and being the support. But he does it fantastically well."

The Queen has paid many personal tributes to her husband and the life they have made together throughout her reign. In her Golden Wedding anniversary speech on 20th November 1997 she said: "He is someone who doesn't take easily to compliments but he has, quite simply, been my strength and stay all these years, and I, and his whole family, and this and many other countries, owe him a debt greater than he would ever claim, or we shall ever know."

And the Queen did not let her Diamond Jubilee pass without paying him another tribute.

In her address to Parliament in March 2012 she said: "Prince Philip is, I believe, well known for declining compliments of any kind. But throughout he has been a constant strength and guide."

His long-standing support for the Queen made it particularly unfortunate that he wasn't able to share in her Diamond Jubilee celebrations, instead spending most of the June weekend in hospital.

But the resilient Duke was out just in time to celebrate his 91st birthday on 10th June.

And, true to his no-nonsense form, when asked "Are you feeling better sir?" he replied: "Well I wouldn't be coming out if I wasn't."

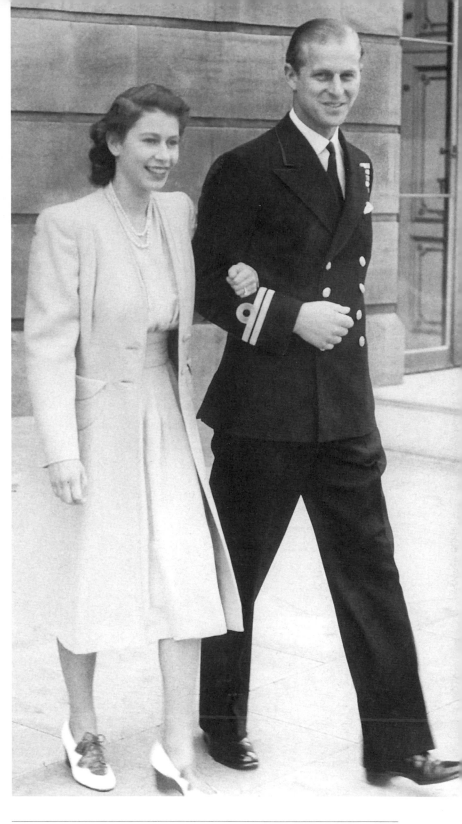

ABOVE: **Princess Elizabeth and Philip Mountbatten, arm in arm, announce their engagement at Buckingham Palace, 9th July 1947.**

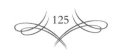

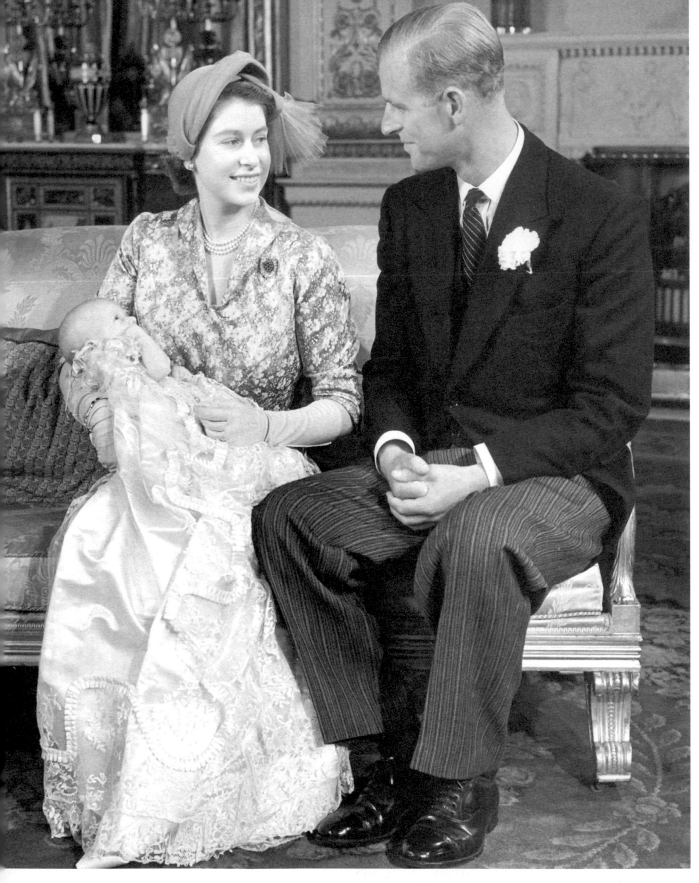

LEFT: **Princess Elizabeth and husband Philip with their second child, Princess Anne, after her christening, 21st October 1950.**

RIGHT: **Philip, the Duke of Edinburgh, pays homage to his wife the Queen at her Coronation in Westminster Abbey, 2nd June 1953.**

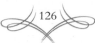

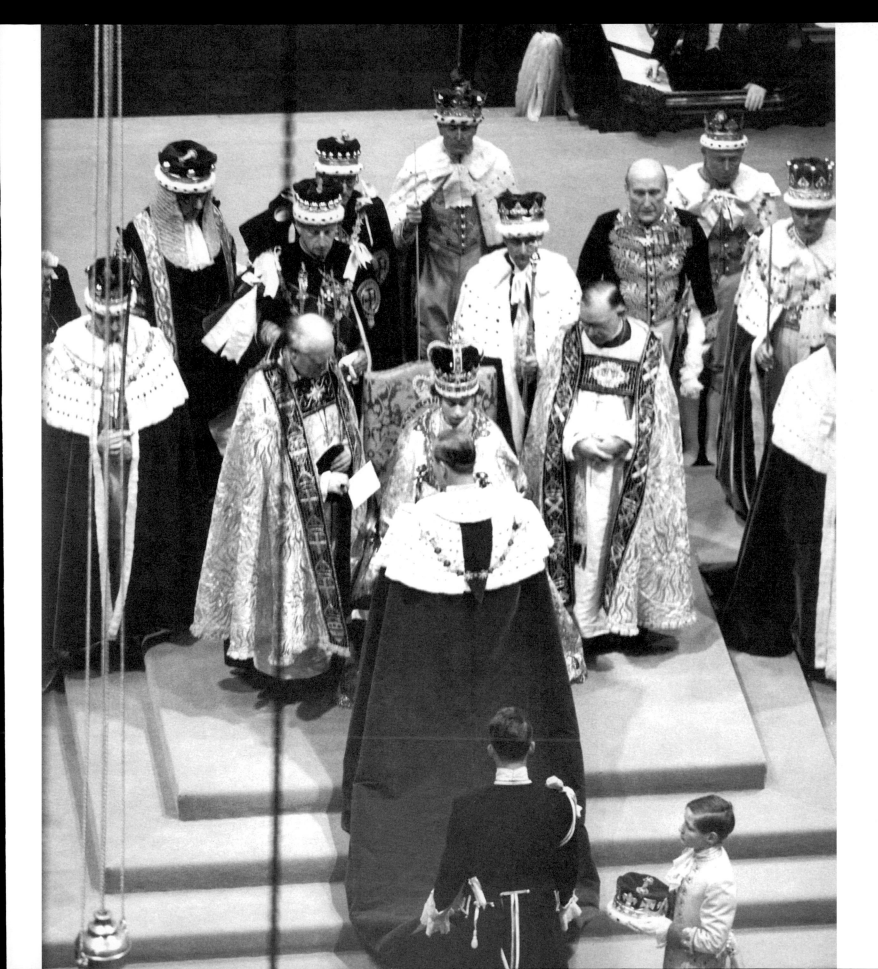

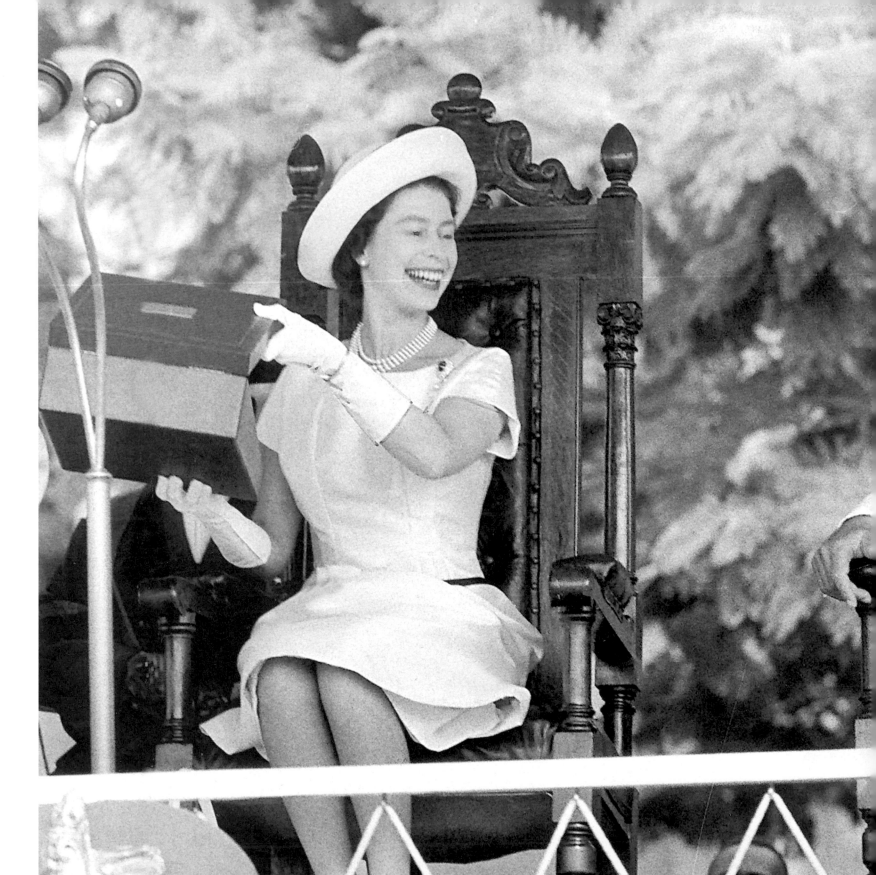

LEFT: **The Queen and Prince Philip share a joke during their visit to Bathurst in Gambia, 5th December 1961.**

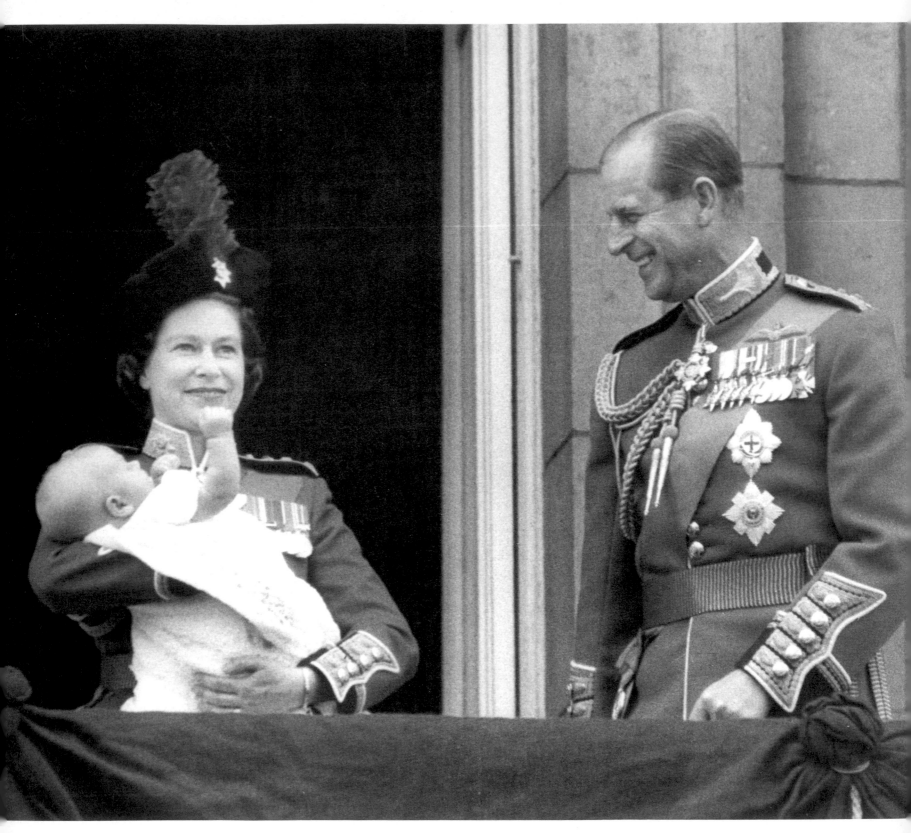

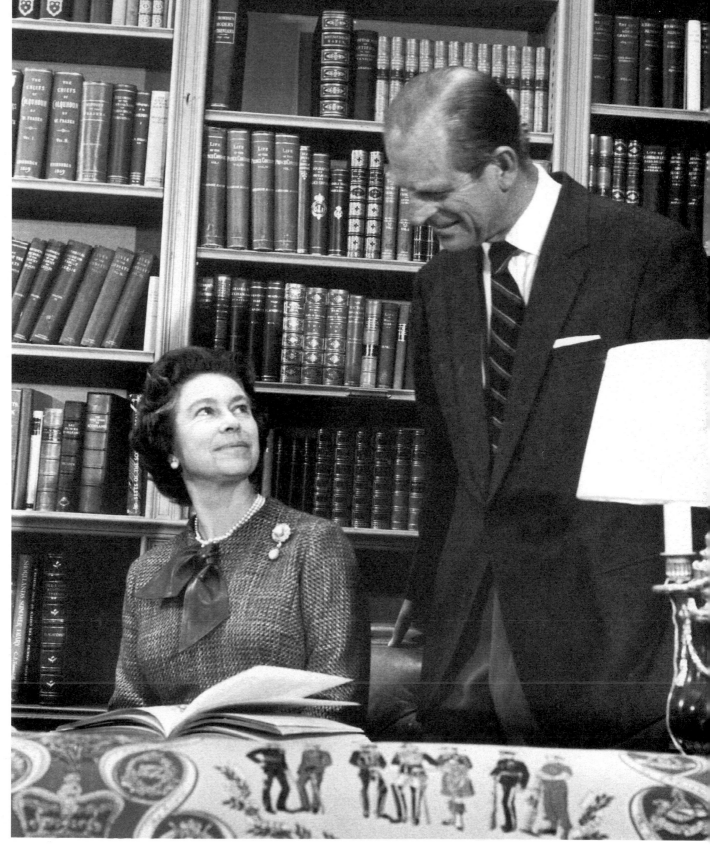

LEFT: Prince Philip looks lovingly at the Queen as she holds their youngest child, Prince Edward, on the balcony of Buckingham Palace during the Trooping of the Colour ceremony, 13th June 1964.

RIGHT: The Queen and Prince Philip look lovingly at each other in the library at Balmoral, 1970s.

RIGHT: **Prince Philip helps the Queen from her car as she arrives at Royal Ascot, June 2009.**

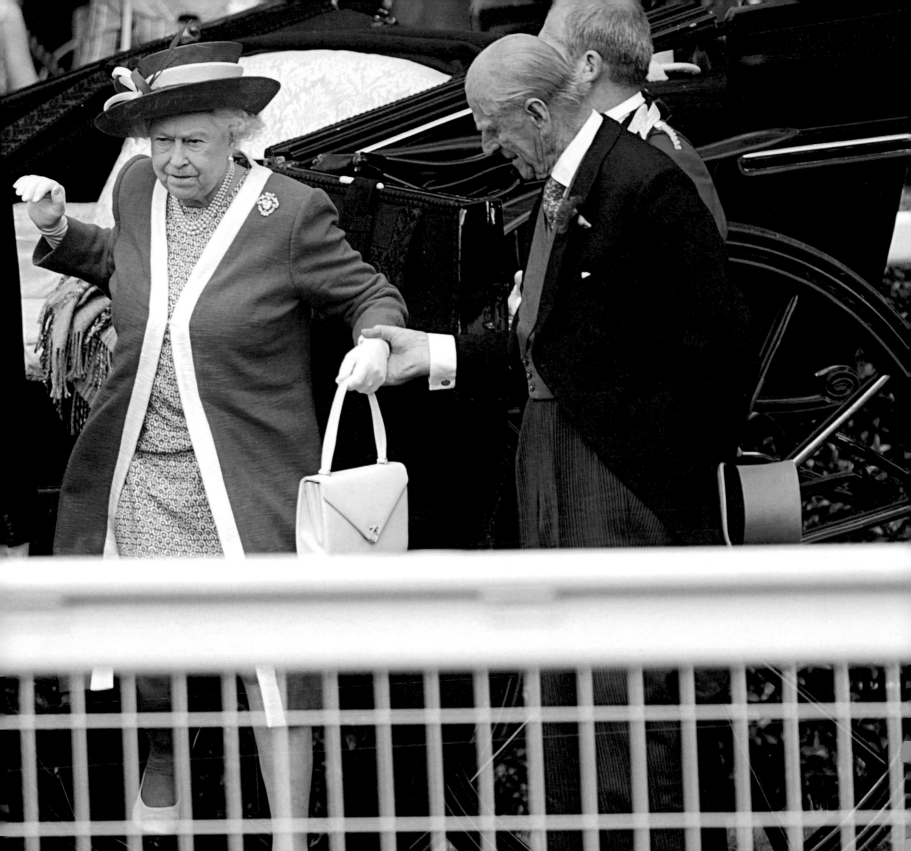

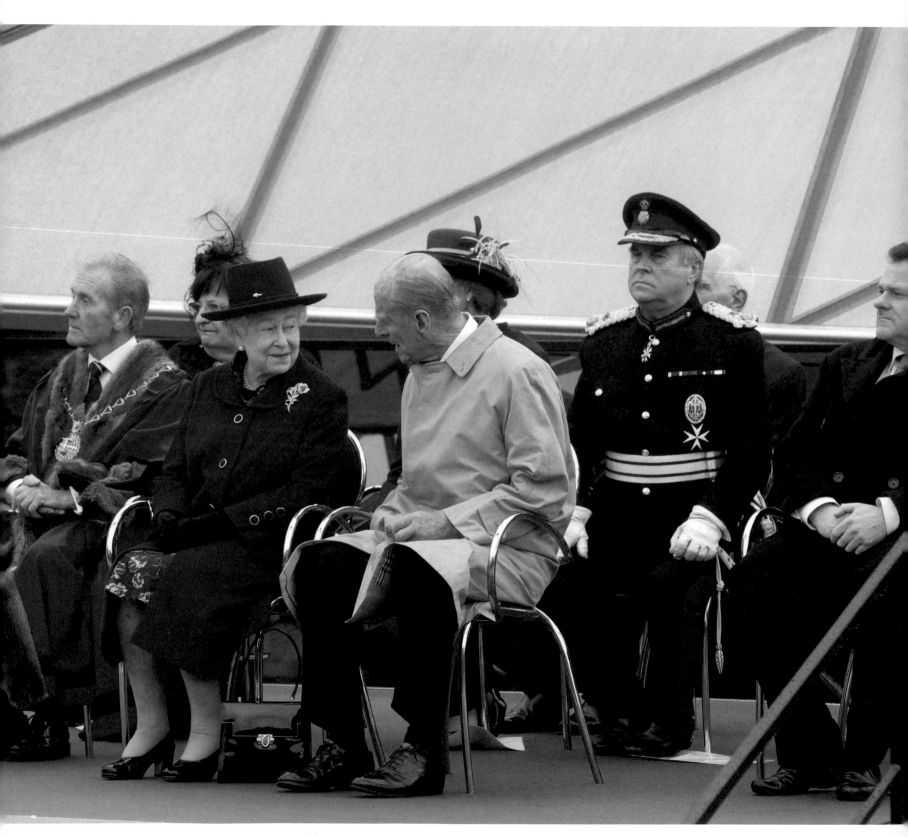

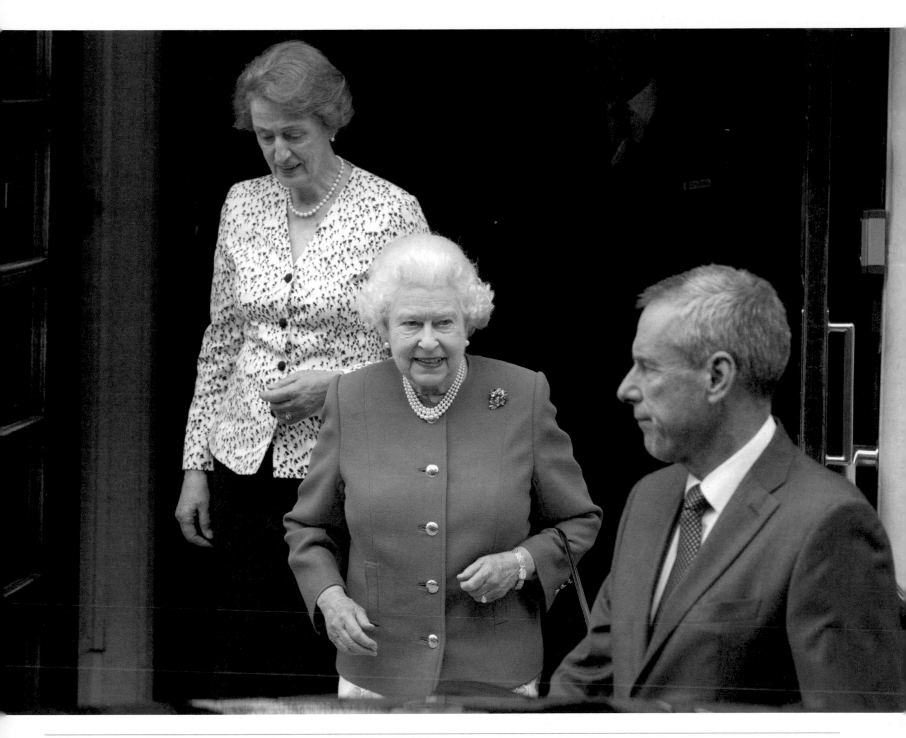

ABOVE: **The Queen leaves King Edward VII Hospital looking relieved after visiting Prince Philip following the Diamond Jubilee weekend. Philip had been rushed to hospital two days earlier where he was diagnosed with a bladder infection, 6ᵗʰ June 2012.**

LEFT: **The Queen turns to Prince Philip as he talks to her during a visit to the *Cutty Sark* in Greenwich, London, 26ᵗʰ April 2012.**

CHAPTER SIX

A PARTY IN EVERY STREET

"It is my sincere hope that the Diamond Jubilee will be an opportunity for people to come together in a spirit of neighbourliness and celebration of their own communities."

Queen Elizabeth II Diamond Jubilee address to Parliament, 20th March 2012

RIGHT: **Families decorate their street for a Diamond Jubilee street party in Ealing Park Gardens, Ealing, London, 5th June 2012.**

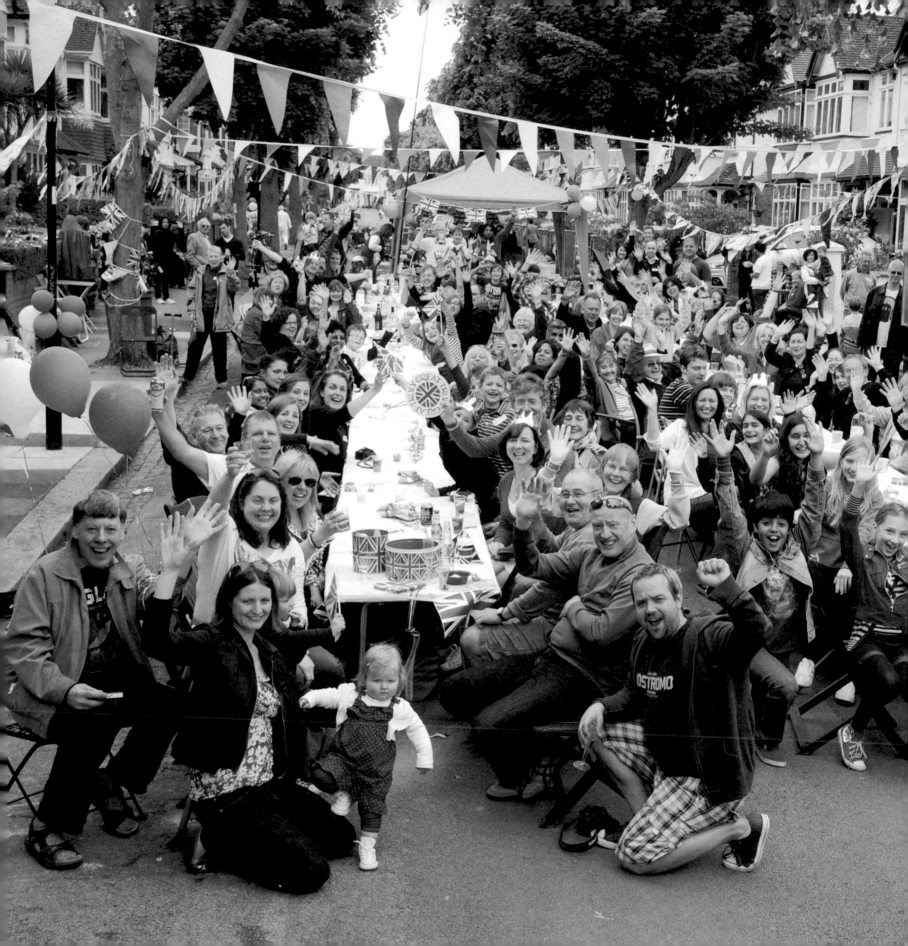

A NATIONAL PARTY

All eyes may have been on London as it hosted the breathtaking river pageant, concert and thanksgiving service, but communities up and down the land held their own celebrations during the Diamond Jubilee weekend.

From the 550 tables stretched along the promenade in Morecambe, Lancashire, for families to enjoy a feast, to the landlord in Goring-on-Thames, south Oxfordshire, who handed out 400 free scones to customers, each party, big or small, had its own unique feel.

Almost 9,500 roads were shut across England and Wales and an estimated 6 million people throughout the UK joined family, friends and neighbours to raise a toast to their Queen.

Despite the miserable weather, village greens, streets and gardens were a riot of red, white and blue as party-goers enjoyed food and entertainment ranging from a frozen sausage-tossing competition in Blyth, Northumberland, ping-pong ball racing in Denbigshire, North Wales, to a world-record-breaking kilt race in Perth.

"A bit of rain can't stop us!" was the overriding message as people kept dry under red, white and blue ponchos, umbrellas and even tents.

Prince Charles and Camilla also joined in with the fun, making a surprise appearance at a Piccadilly street party near their London home on Sunday 3rd June. Camilla arrived with a large white box containing an enormous and exquisitely-decorated Union Jack sponge cake, joking "I've been up all night making this." Spying some sausage rolls she said: "Ah, sausage rolls, you can't beat a sausage roll can you?" Prince Charles told the revellers: "What a wonderful day, let's hope the weather holds off."

And Prime Minister David Cameron hosted a Downing Street party, held indoors because of the rain. He said: "We had elderly people, we had Scouts, we had Girl Guides and Brownies. The oldest was 96, the youngest was four or five. Everyone is celebrating in their own way and it is bringing people together, bringing people out into our communities, helping us to get to know our neighbours better."

Deputy Prime Minister Nick Clegg and his wife Miriam brought a Victoria sponge to a party in Sheffield.

Margaret Jenkins, 69, summed up the mood at Birmingham's Big Lunch, which was moved inside the city's cathedral. She said: "Let's be honest, in Britain if we let a bit of rain stop us doing things we'd never get anything done here, would we?"

Parties were also held in the sunshine in popular holiday destination Benidorm, and on the beach at Port Stanley in British Overseas Territory the Falklands. In Gibraltar a Royal Gun Salute got festivities under way at midday. There were even celebrations in the Mess Hall at Camp Bastion in Afghanistan, with the Band of Royal Engineers providing the music.

RIGHT: Children dress up for a Diamond Jubilee party at Thornhill Primary School in Cardiff. The party was one of the first of more than 160 that took place in the region across the June bank holiday weekend, 1st June 2012.

The Diamond Jubilee street party initiative was spearheaded by project The Big Jubilee Lunch, which encouraged as many people as possible to get together across the weekend.

Project ambassador, actress Barbara Windsor, joined 100 revellers in Ealing, west London, for a 1950s themed lunch. "Today took me back years in my life – all that red, white and blue", she said afterwards. "It was marvellous. I was 15 when the Queen came to the throne and I remember it vividly. Today felt just like that, it took me back and my heart skipped a beat."

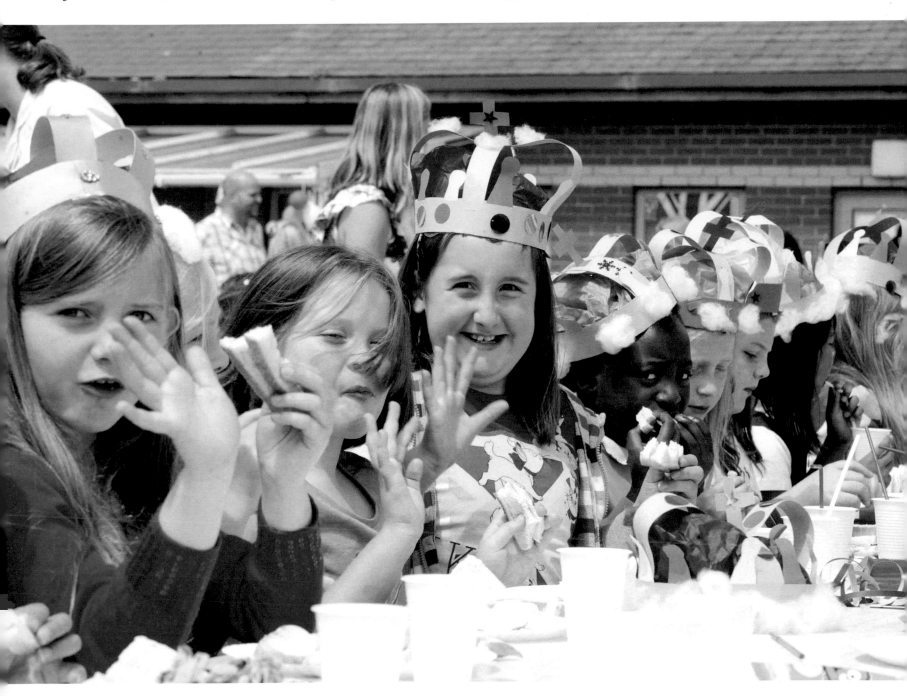

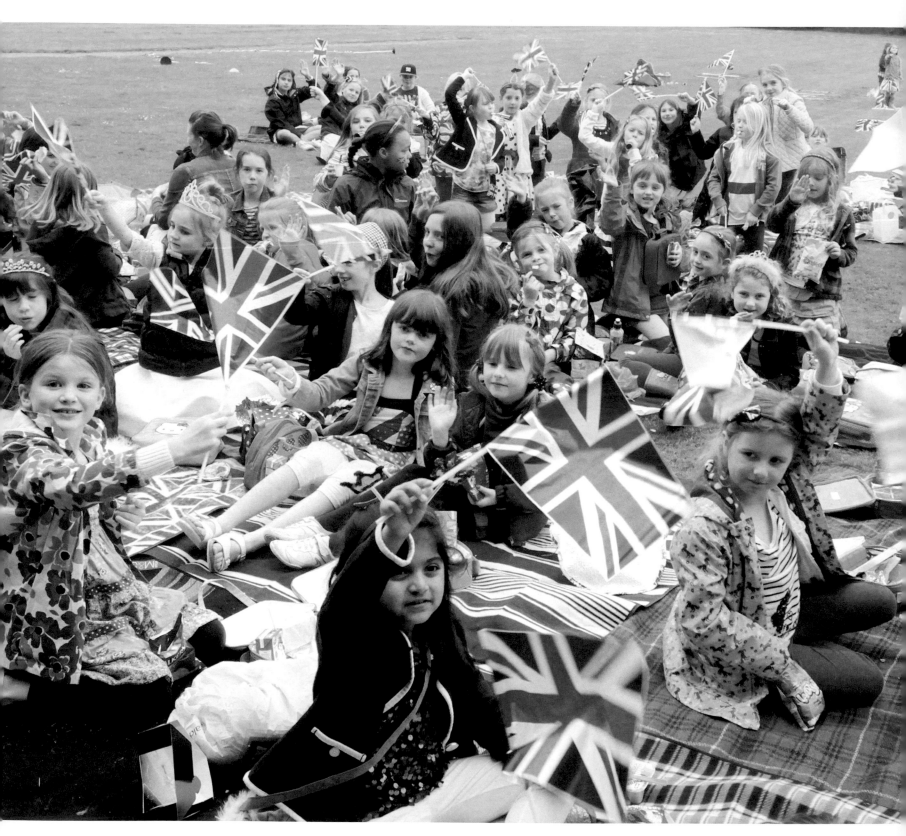

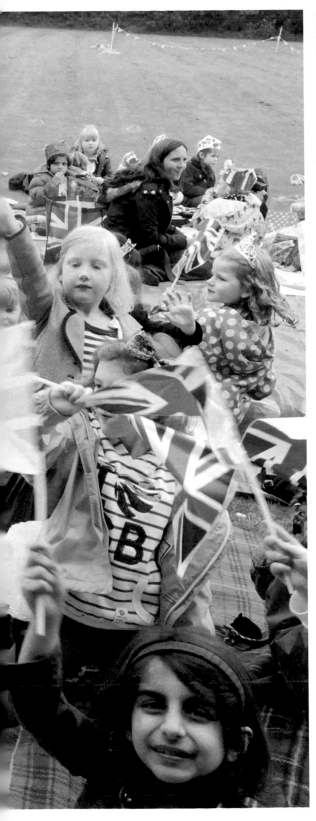

ABOVE & LEFT: **Children celebrate during a Diamond Jubilee street party at Church High School, Jesmond, Newcastle, 1st June 2012.**

RIGHT: Prince Charles and Camilla sit down at a Diamond Jubilee street party in London's Piccadilly. The party stretched from Piccadilly Circus to St James' Street, with a table for 500 people, 3rd June 2012.

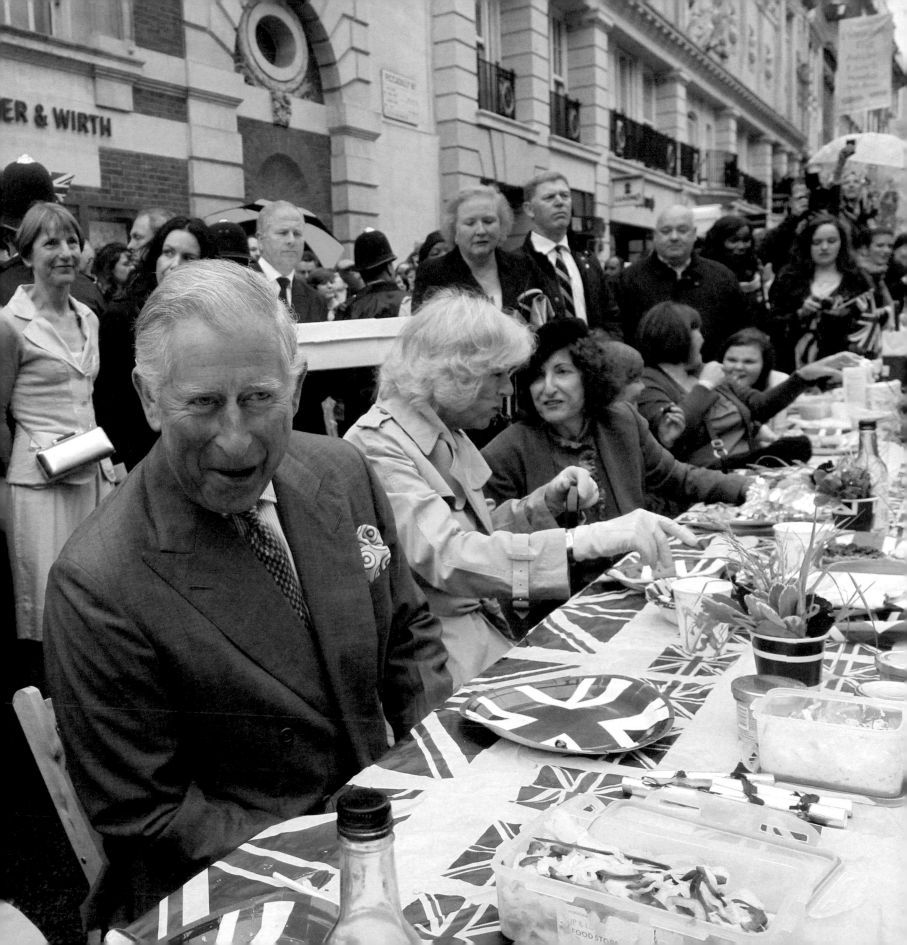

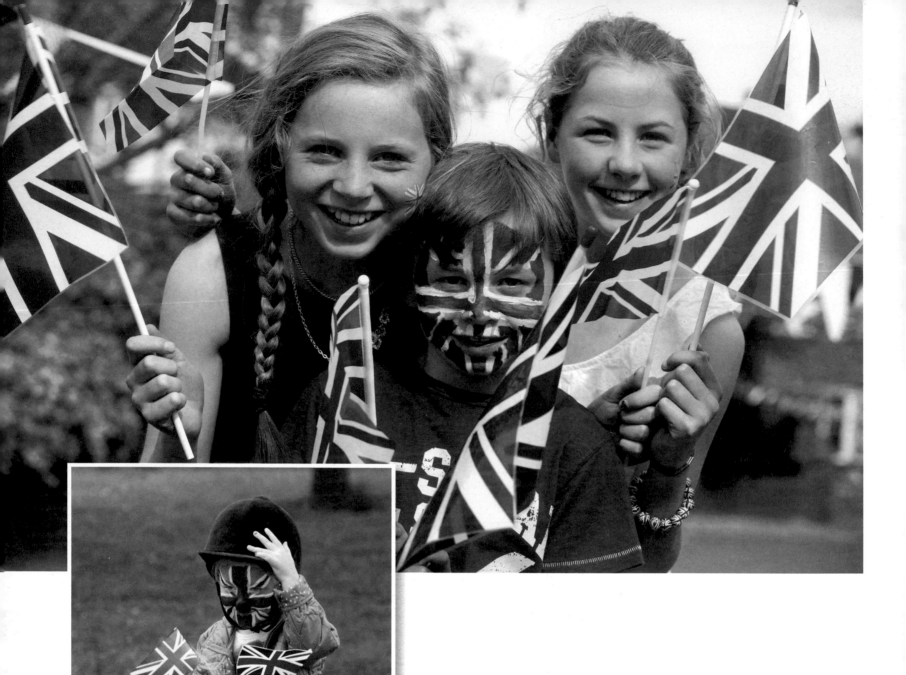

ABOVE: **Children wear facepaint and wave flags during a Diamond Jubilee street party in Crossway, Jesmond, Newcastle, 3rd June 2012.**

LEFT: **A girl enjoys a pony ride during a Diamond Jubilee street party at the Diamond Inn in Ponteland, Newcastle, 3rd June 2012.**

RIGHT: **A lively celebration in Esplanade Avenue, Porthcawl, South Wales, 4th June 2012.**

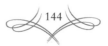

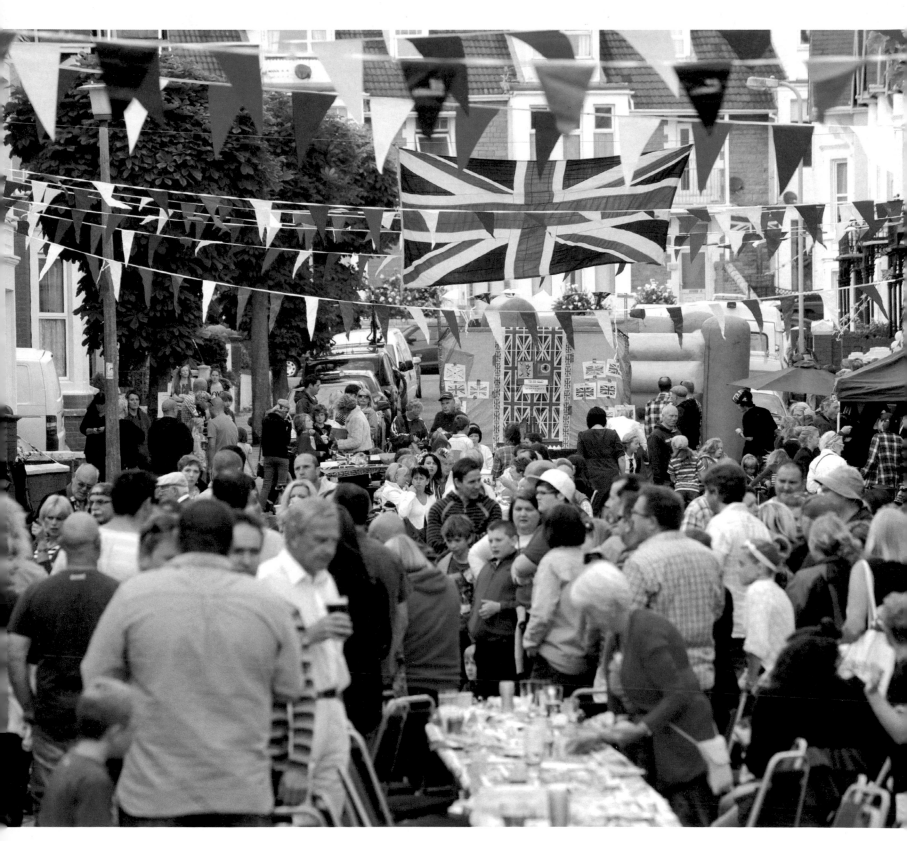

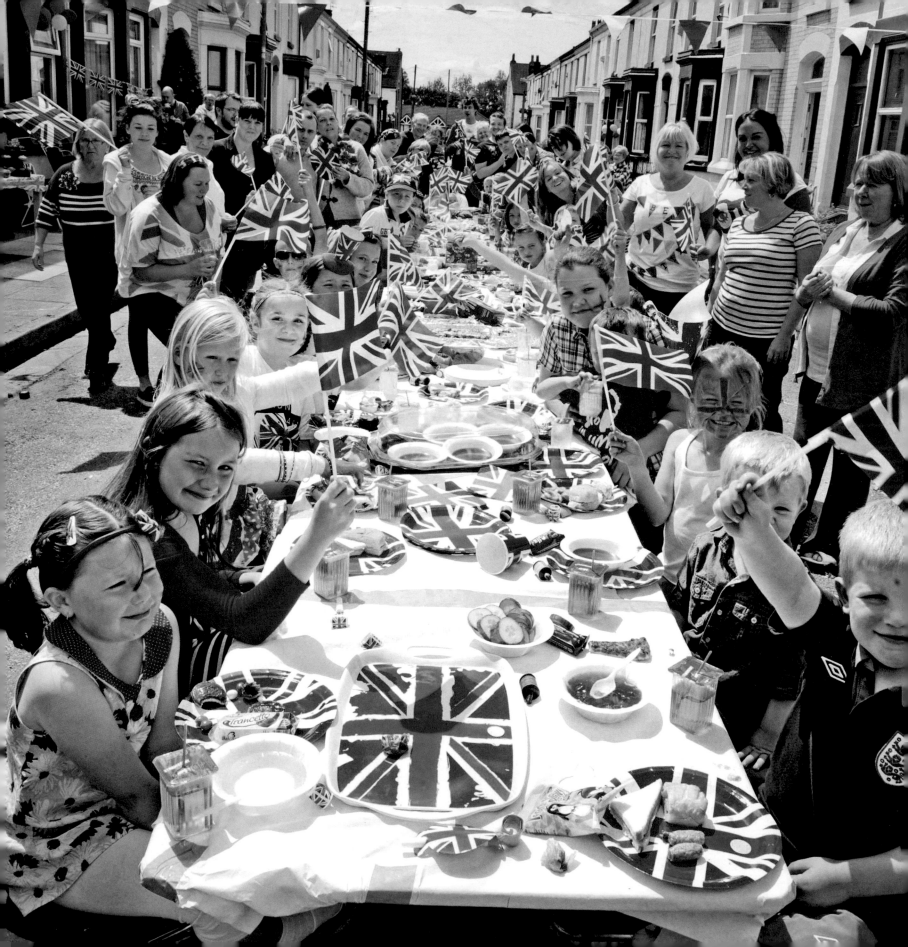

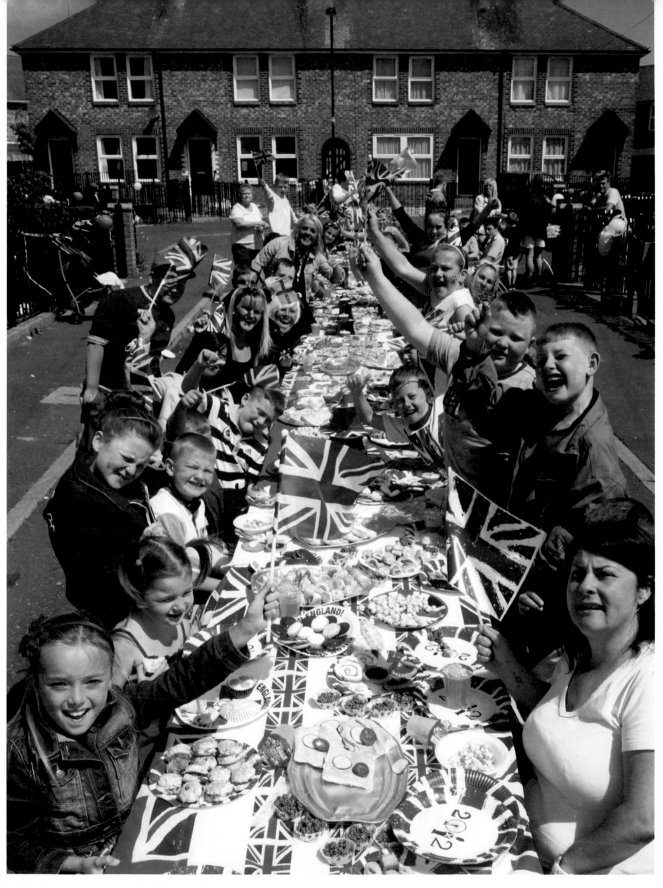

OPPOSITE:
Families join together for a Diamond Jubilee street party in Allington Street, Aigburth, Merseyside, 4th June 2012.

LEFT: **A Diamond Jubilee street party in Seaton Place, Walker, Newcastle, 4th June 2012.**

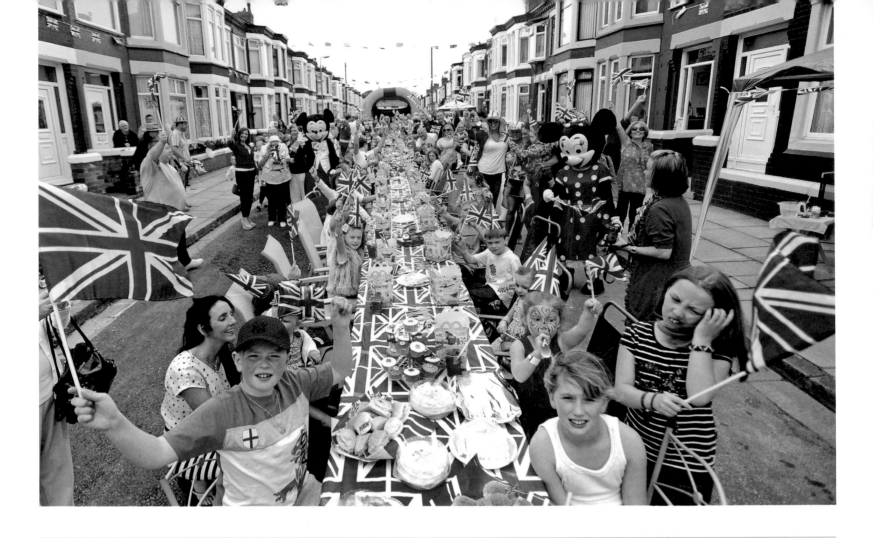

ABOVE: Jubilee celebrations on Selby Road, Walton, Liverpool, 4th June 2012.

BELOW: Families wave flags during their street party on Cromwell Road, Feltham, Middlesex, 4th June 2012.

BELOW RIGHT: A girl enjoys a Diamond Jubilee street party in Danygraig Street, Pontypridd, South Wales, 5th June 2012.

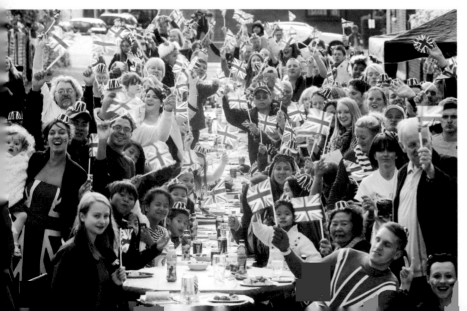

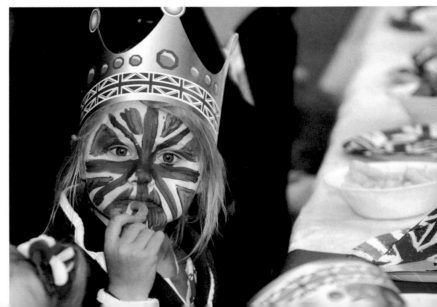

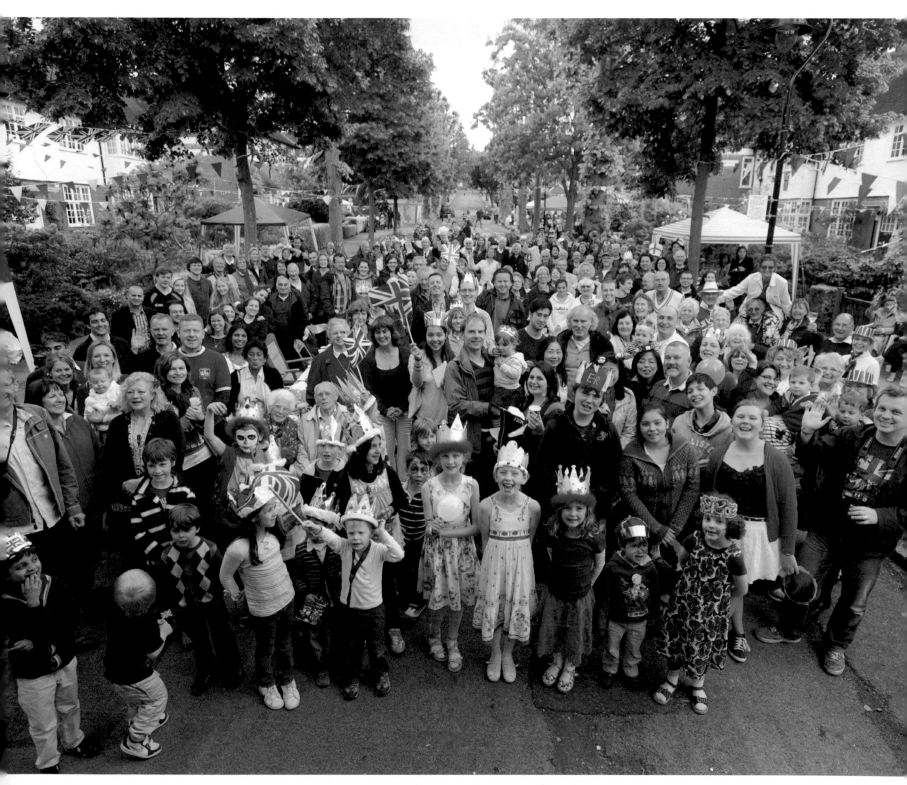

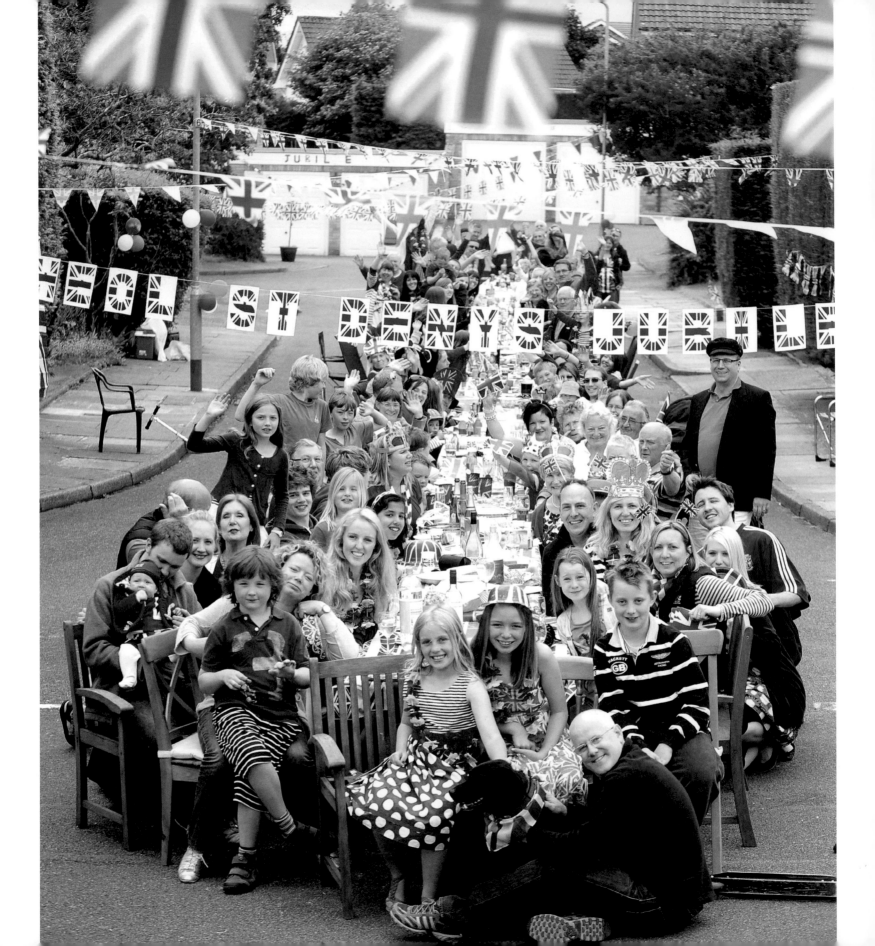

LEFT: Neighbours join together for a Diamond Jubilee street party in St Denys Road, Lisvane, Cardiff, 5th June 2012.

RIGHT: Enjoying the Union flag-themed cakes at a Diamond Jubilee party in St Andrews Road, Penycoedcae, Pontypridd, South Wales, 5th June 2012.

BELOW: More cakes at a Diamond Jubilee street party in Heddon-on-the-Wall, Northumberland, 5th June 2012.

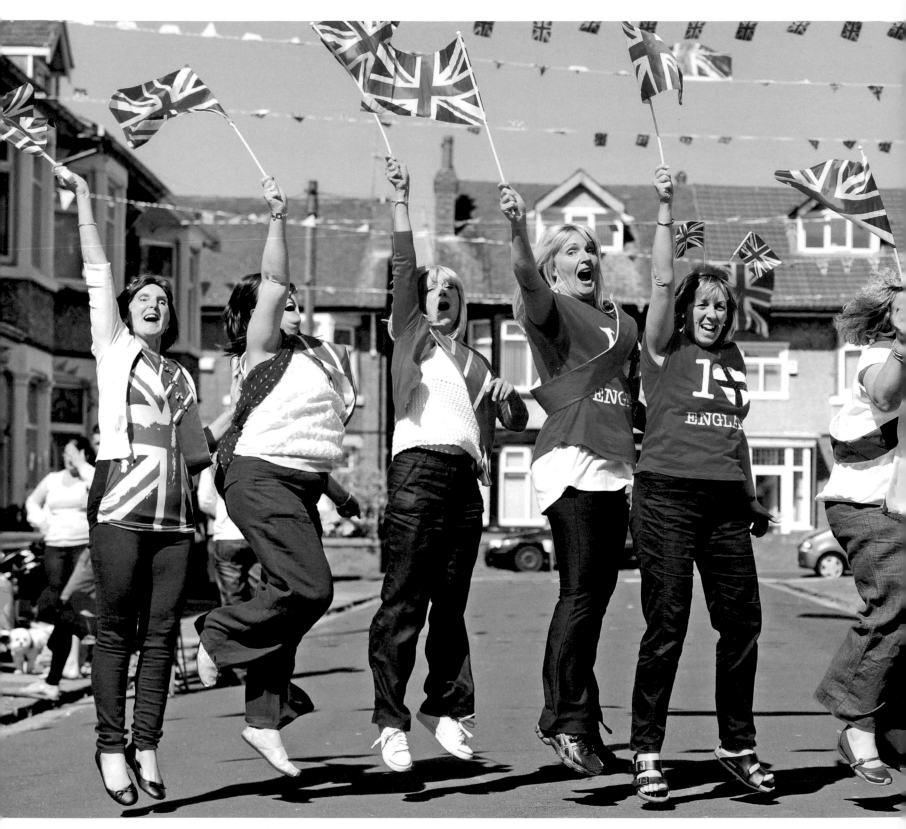

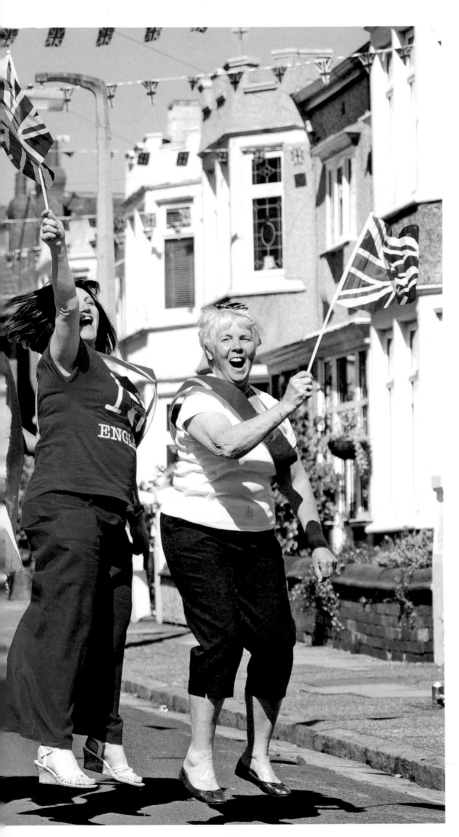

LEFT: Community spirit could be found in leaps and bounds in Tilston Road, Wallasey, Merseyside.

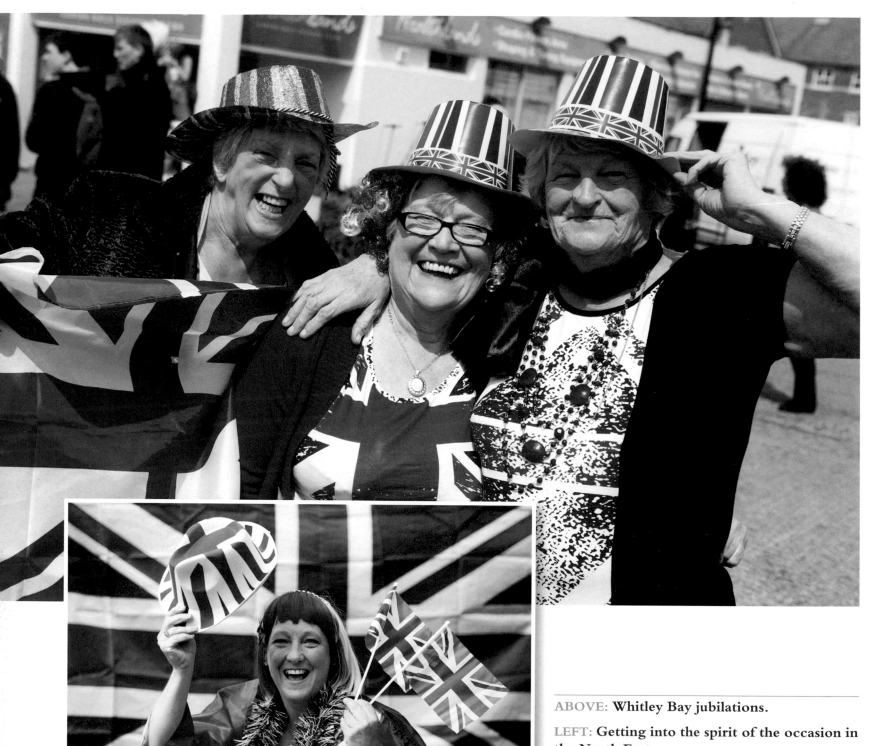

ABOVE: **Whitley Bay jubilations.**

LEFT: **Getting into the spirit of the occasion in the North East.**

RIGHT: **A father and son show off their face paint at Jubilee celebrations in Porthcawl, South Wales, 4th June 2012.**

THE CORONATION

"Throughout all my life and with all my heart I shall strive to be worthy of your trust."

Queen Elizabeth II radio broadcast on the evening of her Coronation, 2nd June 1953

More than 60 years had passed since the Queen came to the throne and exactly 59 since she was crowned, yet the Diamond Jubilee celebrations bore a striking resemblance to the Queen's Coronation all those years ago.

For the Coronation, millions had decorated their homes and streets with bunting and joined their neighbours and friends for parties. Even the weather during the Coronation mirrored that of the Diamond Jubilee, with rain and chilly temperatures threatening to dampen both events. On Coronation day the temperature failed to get above 12°C all day, with early morning rain mirroring the downpours that shrouded the bank holiday in 2012, particularly the Thames Diamond Jubilee Pageant on 3rd June.

On 2nd June 1953 millions of people watched TV for the first time, crowding into their friends' homes to catch a glimpse of the televised Coronation ceremony. An estimated 3 million people lined the streets as the Queen made her way from Buckingham Palace to Westminster Abbey in the Golden State Coach. Then, in front of 8,000 invited guests, including prime ministers and heads of state from round the Commonwealth, the 27-year-old Queen took her Coronation oath. Later in the day she and her family appeared on the Buckingham Palace balcony before a fireworks display lit up the sky.

RIGHT: Pinnington Road in Gorton, Manchester, decorated for the Queen's Coronation, June 1953.

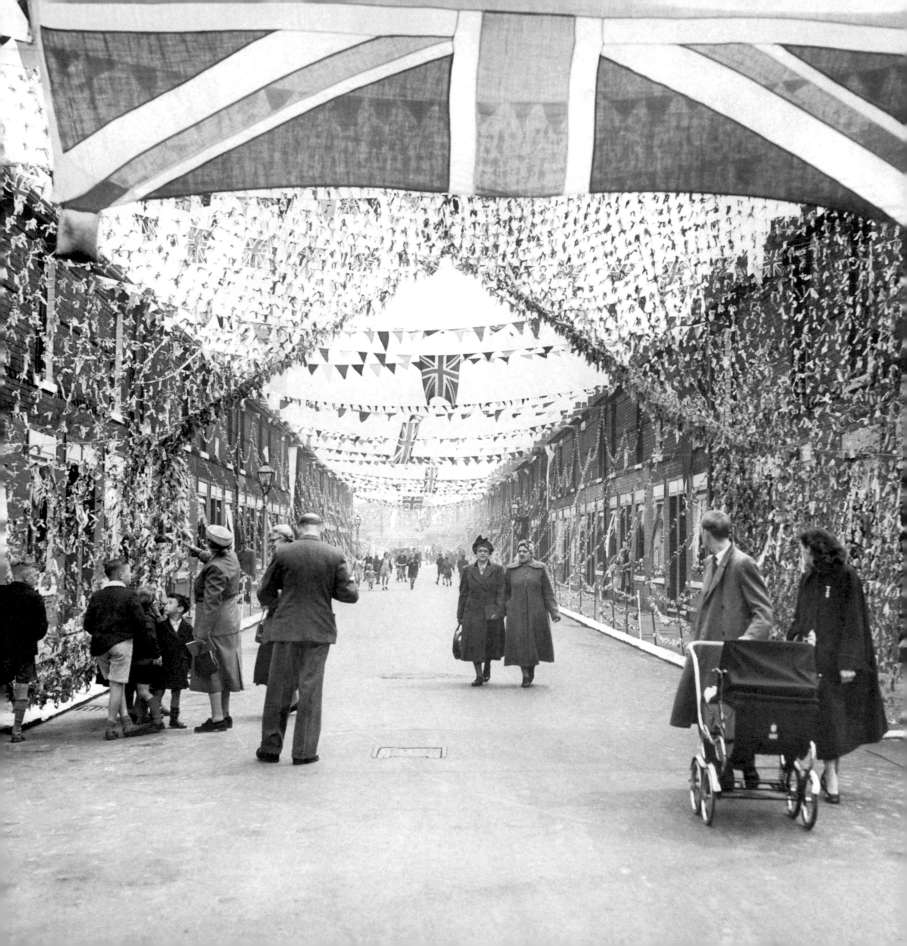

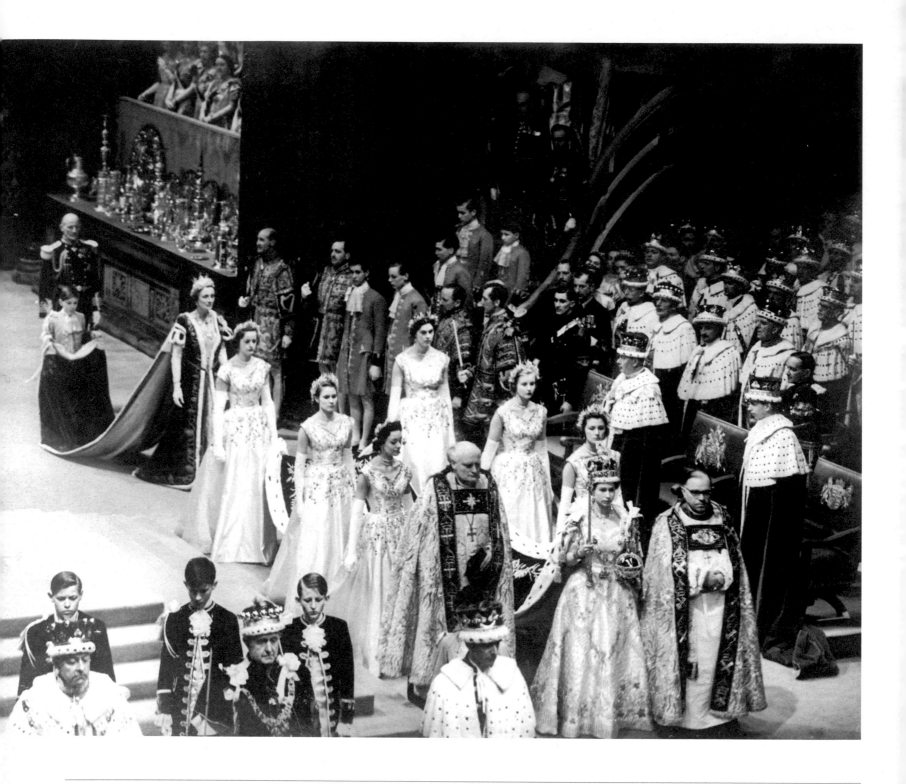

ABOVE: **Queen Elizabeth II walks down the aisle of Westminster Abbey after being crowned, 2ⁿᵈ June 1953.**

RIGHT: **Queen Elizabeth II Coronation procession travels down Cockspur Road from Trafalgar Square as crowds look on, 2ⁿᵈ June 1953.**

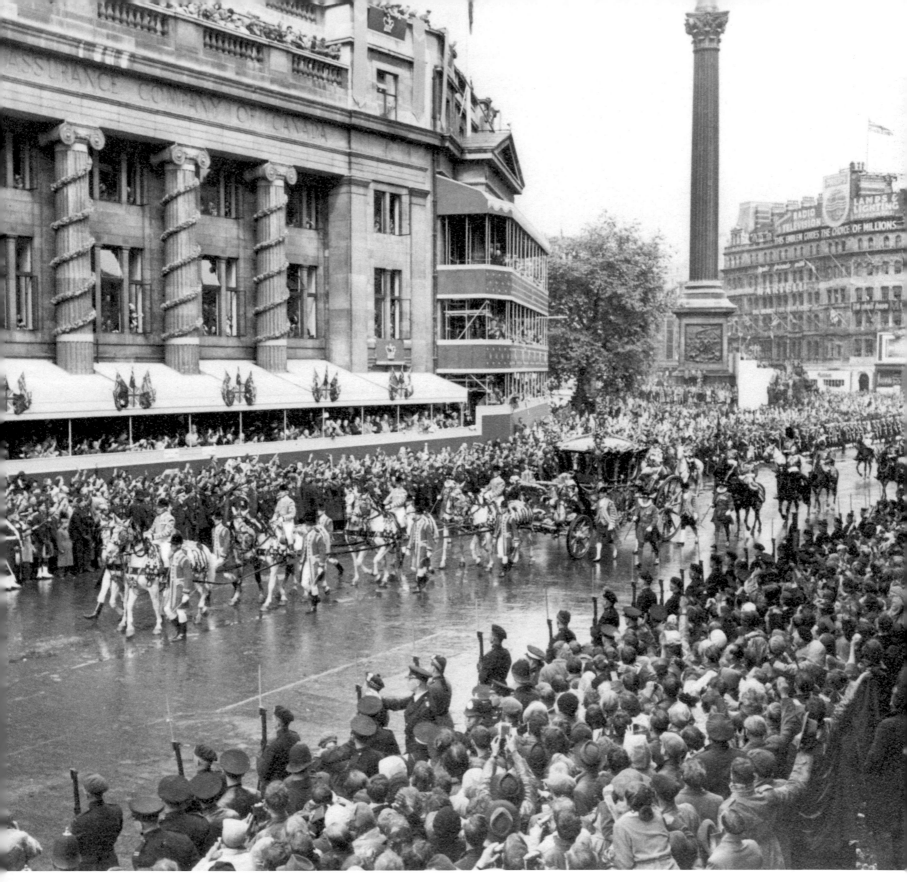

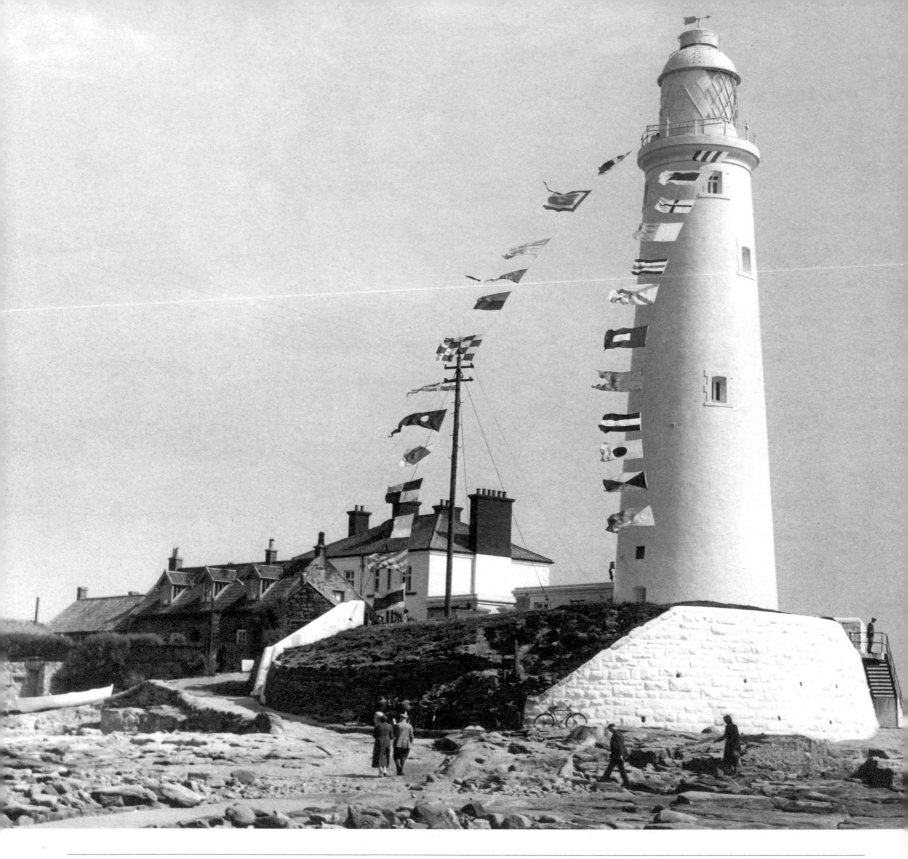

ABOVE: St Mary's Lighthouse at Whitley Bay, Tyne and Wear, is decorated for the Queen's Coronation, 2nd June 1953.

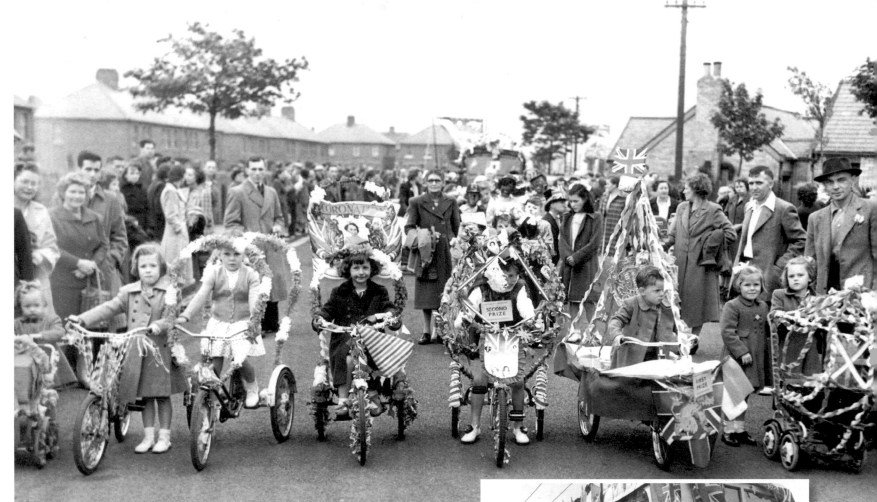

ABOVE: Children enjoy a bicycle race at a Coronation street party, location unknown, 2nd June 1953.

RIGHT: Families take part in a party on a bus decorated for the Queen's Coronation at Pier Head, South Shields, 2nd June 1953.

LEFT: Residents in a street in Byker, Newcastle, decorate their street in preparation for the Queen's Coronation, June 1953.

ABOVE: A workman puts the finishing touches to the Coronation decorations in Town Hall Square, Carlisle, June 1953.

RIGHT: Residents in Hawes Street, Byker, Newcastle, putting up decorations to mark the Queen's Coronation, June 1953.

ABOVE: **A street party in Saville Road, Blackpool, on the day of the Queen's Coronation, 2nd June 1953.**

PREVIOUS
CORONATIONS

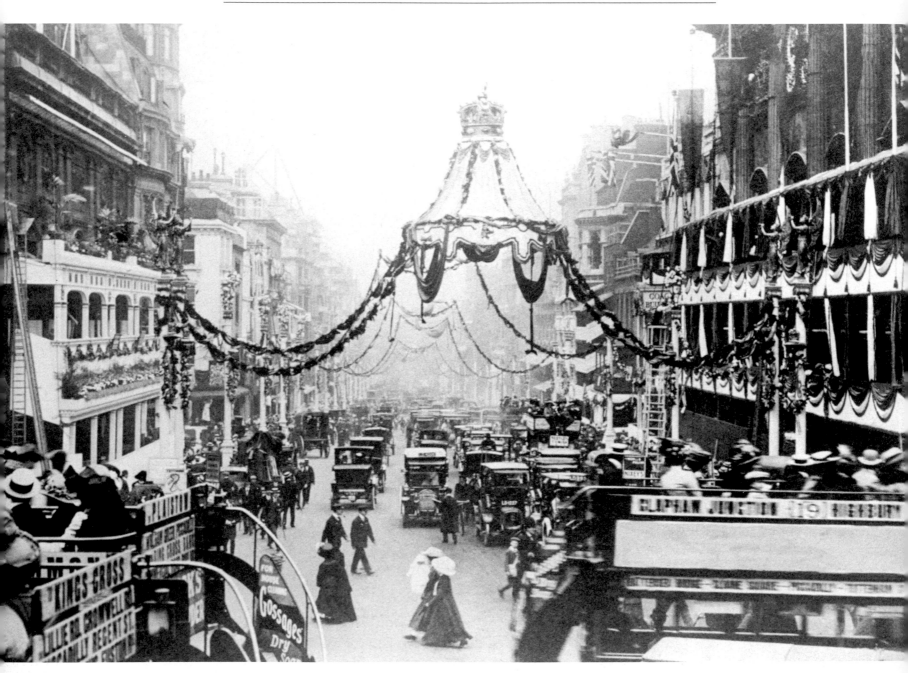

LEFT: St James' Street in London decorated for the Coronation of King George V and Queen Mary, 22nd June 1911.

RIGHT: Residents in Rolland Street, Glasgow, decorate their street for King George VI's Coronation, May 1937.

BELOW: The Coronation procession of King George VI, 12th May 1937.

CHAPTER SEVEN

SILVER AND GOLDEN JUBILEES

"As today, it was my privilege to address you during my Silver and Golden Jubilees. Many of you were present ten years ago and some of you will recall the occasion in 1977."

Queen Elizabeth II Diamond Jubilee address to Parliament, 20th March 2012

RIGHT: **Crowds in the Mall for the Queen's Golden Jubilee, 4th June 2002.**

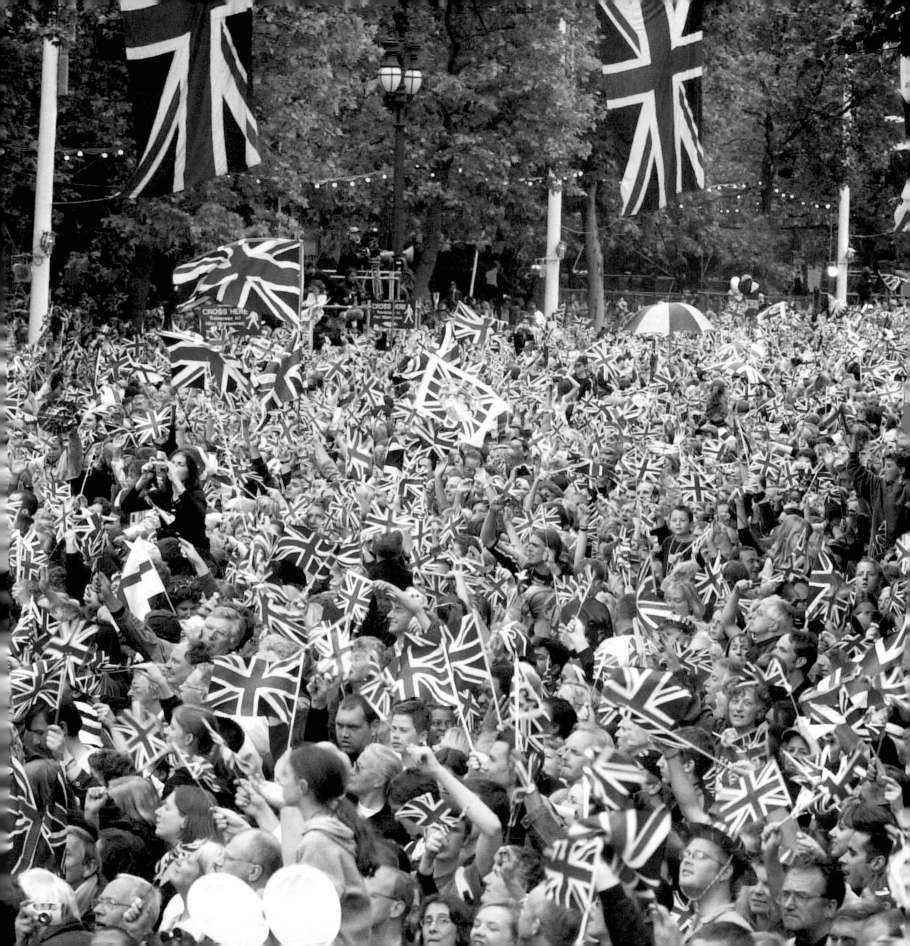

A Silver, Golden and Diamond Queen

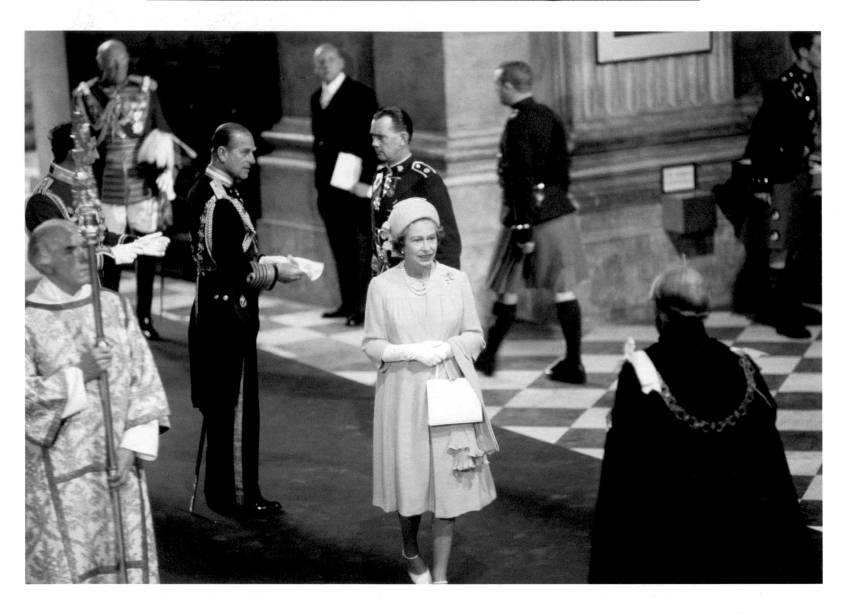

ABOVE: **The Queen and Prince Philip arrive at St Paul's Cathedral, for the Silver Jubilee Service of Thanksgiving, 7th June 1977.**

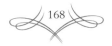

The Diamond Jubilee celebrations were unique in many ways, but they also closely echoed the festivities held 10 and 35 years earlier for the Queen's Silver and Golden Jubilees. Then, as in 2012, thousands lined the streets, holding their own street parties, and there were also spectacular central festivities held during June 1977 and June 2002.

Mirroring the Diamond Jubilee, there were Thanksgiving Services, Buckingham Palace balcony appearances with fly-pasts and beacons lit across the country.

The Queen also addressed both houses of Parliament in her Silver and Golden Jubilee years. As she pointed out in her Diamond Jubilee address to MPs and Peers, she has "had the pleasurable duty of treating with twelve Prime Ministers" throughout her reign.

Over so many years politicians have come and gone, but in the six decades of change there has only been one Queen.

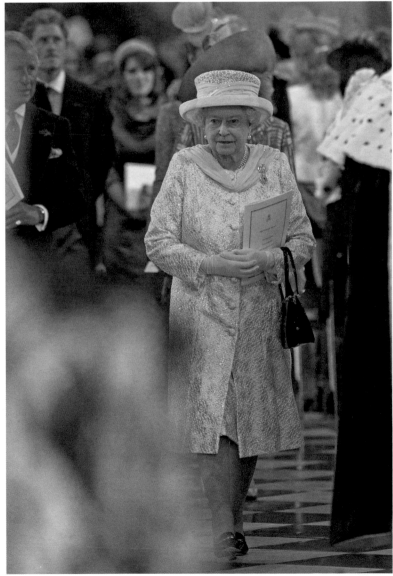

ABOVE: **Along with members of the Royal Family the Queen leads the Golden Jubilee Service of Thanksgiving at St Paul's Cathedral in London, 4th June 2002.**

RIGHT: **The Queen leaves the Diamond Jubilee Service of Thanksgiving at St Paul's Cathedral, 5th June 2012.**

SILVER JUBILEE 1977

"When I was 21 I pledged my life to the service of our people and I asked for God's help to make good that vow. Although that vow was made in my salad days, when I was green in judgement, I do not regret nor retract one word of it."

Queen Elizabeth II Silver Jubilee speech, 7th June 1977

Britain was fired up to celebrate the Queen's Silver Jubilee, the first milestone Jubilee in her reign. The actual anniversary of her accession to the throne, 6th February 1977, was marked by a low-key church service at St George's Chapel, Windsor.

But the main celebrations, in June of that year, saw Britain come to a standstill. Preparations for the parties started as early as March. On 6th June the Queen lit a bonfire beacon at Windsor Castle; after this a chain of beacons was lit up across the country.

The following day, in glorious sunshine, more than a million people lined the streets of London, and another 500 million watched on TV, as the Royal Family made their way to a Service of Thanksgiving at St Paul's Cathedral. Crowds cheered as the royals passed in the Golden State Coach on their way to join world leaders, including Prime Minister James Callaghan and US President Jimmy Carter, for the service.

Afterwards, the Queen attended a lunch in the Guildhall hosted by the Mayor of the City of London, Peter Vanneck, where she made her Silver Jubilee speech. She thanked the people of Britain and the Commonwealth for the "loyalty and friendship" that gave her "strength and encouragement during these last 25 years".

On 9th June the celebrations culminated in a procession down the River Thames from Greenwich to Lambeth, with a spectacular fireworks display as the finale.

That year the Queen and Philip also undertook an epic Jubilee tour round the UK and Commonwealth, travelling 56,000 miles in 12 months.

In February and March they visited Western Samoa, Australia, New Zealand, Tong, Fiji, Tasmania, Papua New Guinea, Bombay and Oman. From May until August the couple toured the whole of the UK and Northern Ireland, visiting 36 counties in just three months in a feat unmatched by any other sovereign. The year was finished off with visits to Canada and the Caribbean in October before the Queen headed back home to spend Christmas with her family.

It was in her Silver Jubilee year that the Queen became a grandmother for the first time, when Princess Anne gave birth to Peter Phillips on 15th November.

In her Christmas speech she summed up the happy events of 1977 by telling the country: "The street parties and village fêtes, the presents, the flowers from the children, the mile upon mile of decorated streets and houses; these things suggest that the real value and pleasure of the celebration was that we all shared in it together."

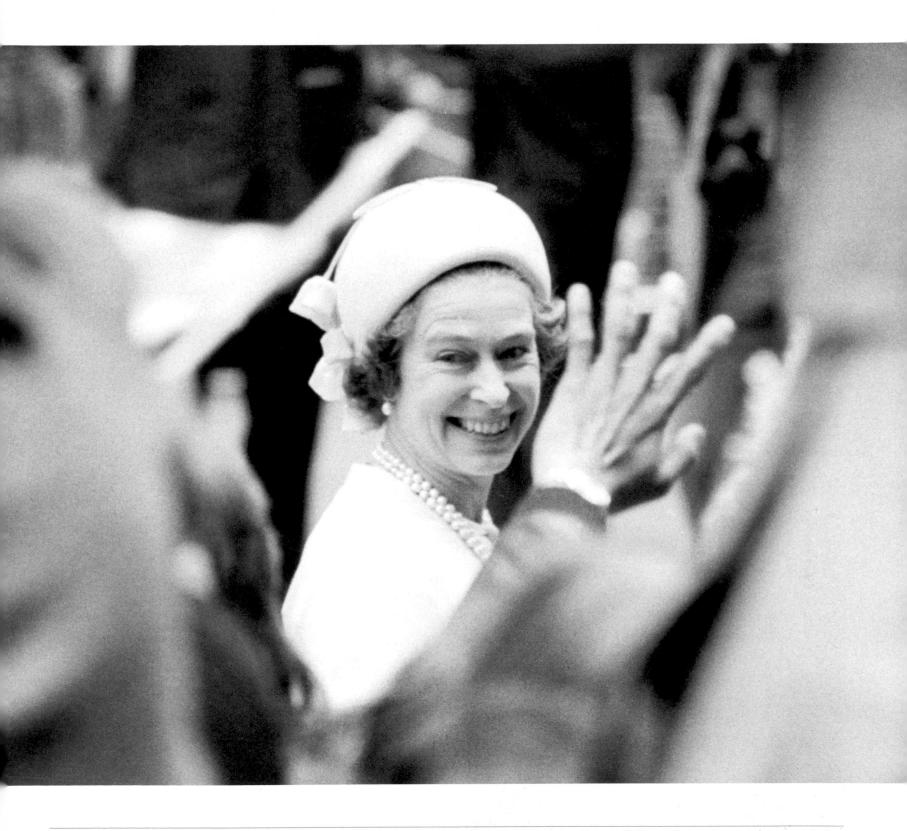

ABOVE: **The Queen is cheered by crowds on a walkabout in London during her Silver Jubilee celebrations, 7th June 1977.**

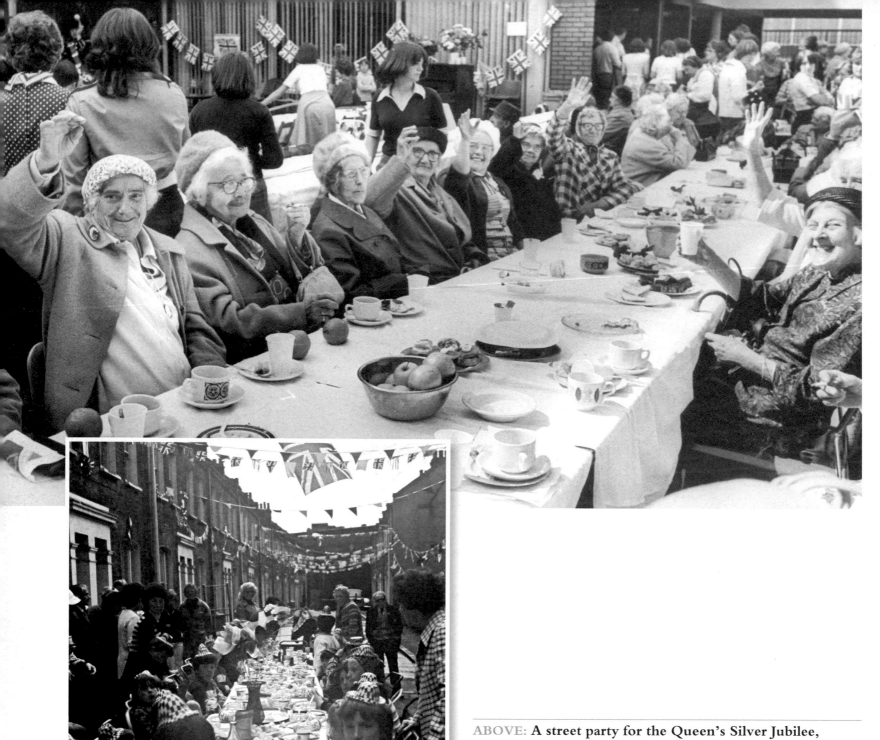

ABOVE: A street party for the Queen's Silver Jubilee, 6th June 1977.

LEFT: Families enjoy a Silver Jubilee street party in Deptford, South East London, June 1977.

RIGHT: The Queen and Prince Philip, with Prince Charles and Prince Andrew, prepare to light the beacon at Windsor Castle to start a chain of Silver Jubilee beacons, 6th June 1977.

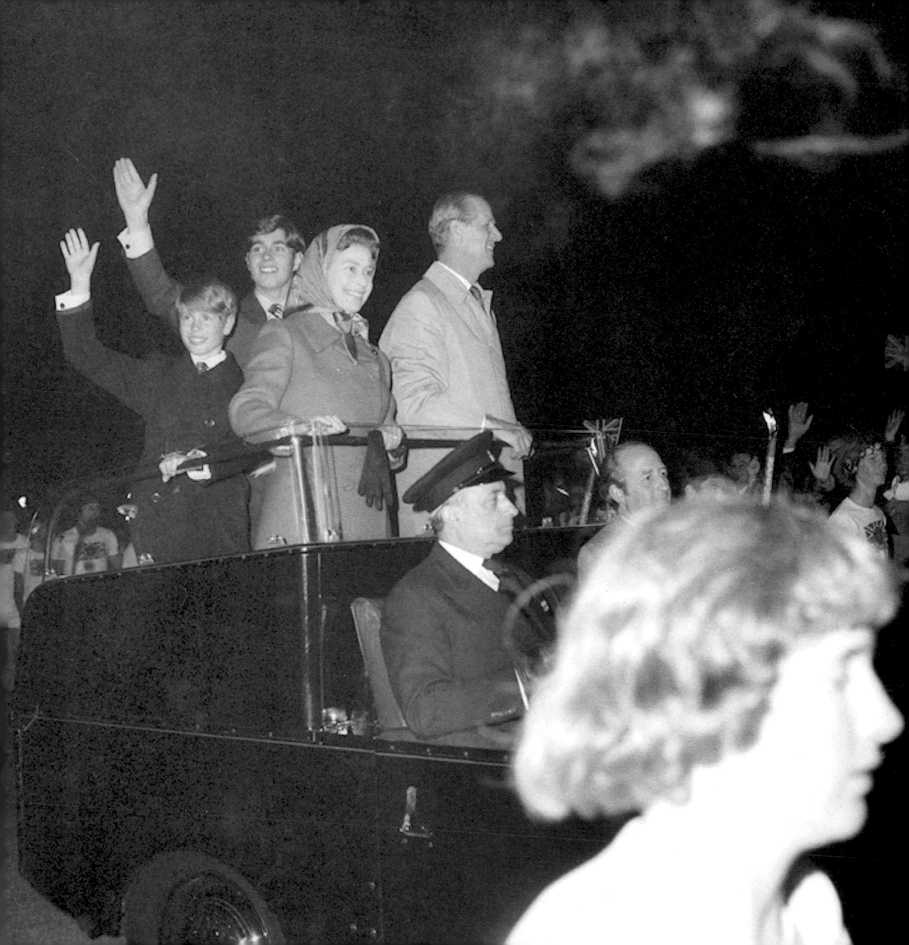

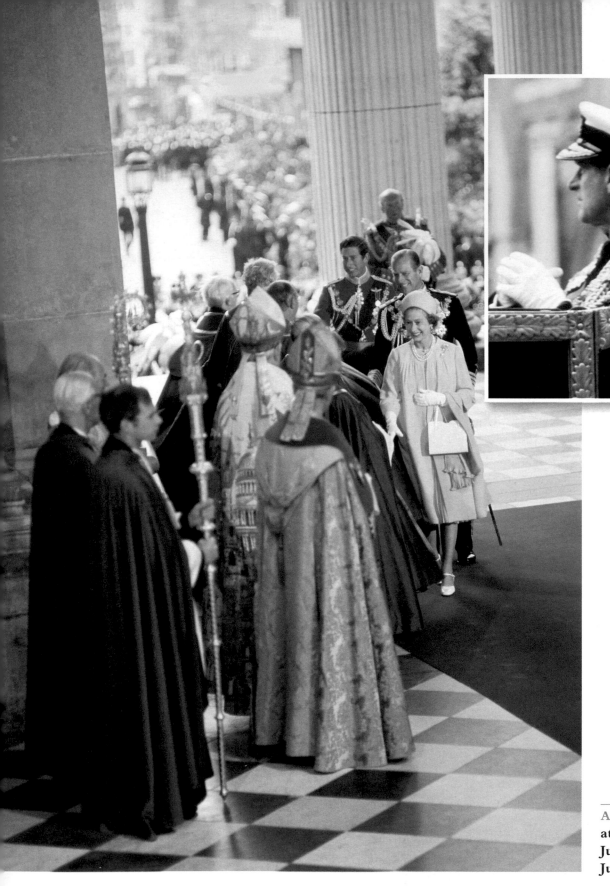

ABOVE & LEFT: **The Queen arrives at St Paul's Cathedral for her Silver Jubilee Service of Thanksgiving, 7th June 1977.**

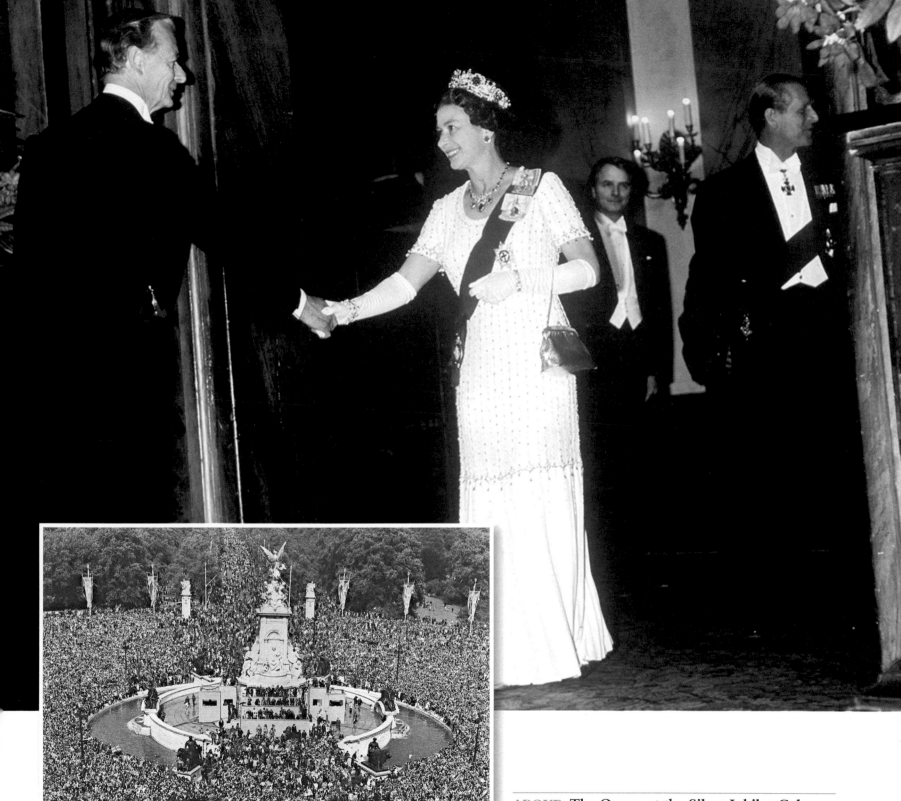

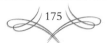

ABOVE: **The Queen at the Silver Jubilee Gala.**

LEFT: **Crowds flood the outside of Buckingham Palace waiting for the Royal Family to appear on the balcony, 7th June 1977.**

ABOVE: The Queen at County Hall after taking part in a river pageant for her Silver Jubilee, 9th June 1977.

RIGHT: The Queen on her Silver Jubilee tour, visiting New Zealand, February 1977.

GOLDEN JUBILEE 2002

"For if a Jubilee becomes a moment to define an age, then for me we must speak of change – its breadth and accelerating pace over these years."

Queen Elizabeth II Golden Jubilee address to Parliament, 30th April 2002

Although her Golden Jubilee was a time of celebration, the year began with tragedy for the Queen. Her sister, Princess Margaret, passed away on 9th February 2002, aged 71, after battling with a series of health problems and suffering strokes that had left her paralysed and her sight damaged.

The Princess was remembered by those close to her for her "vivaciousness" and "vitality", and despite her turbulent relationships, friends said she had a "happy" life and told how she adored her older sister. Lord St John of Fawsley, a friend, said: "I never in all my life heard Princess Margaret say a harsh or critical word about the Queen. She was totally devoted to her."

And the Queen had even more sadness to bear when, just six weeks later, her beloved mother died. Aged 101, the Queen Mother had led a long and fulfilling life. She passed away peacefully at the Royal Lodge, Windsor, on 30th March, with the Queen by her side.

One of the most loved members of the Royal Family, her death sparked a huge outpouring of grief from the British public. Thousands of bouquets were strewn across the railings of Clarence House and Buckingham Palace as Prime Minister Tony Blair led the tributes, describing how her "zest for life made her loved and admired by people of all ages and backgrounds, revered within our borders and beyond".

Losing two of the people closest to her during what should have been one of her most joyful years was devastating for the Queen. But, as always, she put her duty to her country before her personal troubles, and channelled her energies into making her Golden Jubilee a success.

She had spent the 50th anniversary of her accession to the throne on 6th February meeting cancer patients while opening the Macmillan Centre at the Queen Elizabeth Hospital in Norfolk. On the same day she issued a message to the nation saying: "I believe that, young or old, we have as much to look forward to with confidence and hope as we have to look back on with pride."

The message was posted on the new British monarchy website, a sign of the changing times that the crown was determined to embrace. And in her Golden Jubilee address to Parliament in April the Queen paid heed to the "transformation" of Britain since she came to the throne. She said: "Since 1952 I have witnessed the transformation of the international landscape through which this country must chart its course ... This has been matched by no less rapid developments at home, in the devolved shape of our nation, in the structure of society, in technology and communications, in our work and in the way we live."

In the run-up to the Golden Jubilee critics speculated the event would not be a success and that people were no longer

enthused by the Monarchy. But the main celebrations from 1st to 4th June proved them all wrong. More then 2 million people applied for tickets for the Saturday Night Prom in the Palace, and 12,500 were chosen to attend what was the largest event ever held on royal property.

Two days later the palace was home to another concert, this time a pop extravaganza, where performers included Paul McCartney, Eric Clapton, Cliff Richard and Queen guitarist Brian May performing on the roof of the palace. The evening culminated in a spectacular fireworks display as the Queen lit a beacon in the Mall, the last of more than 2,000 beacons across the world. About 12,000 people were invited to the concert, more than a million flooded into the Mall, and a further 2 million watched from their homes.

"The Golden Smile" was the *Daily Mirror*'s headline the next day.

The final day of the Jubilee weekend saw the Queen and Philip parade through London in the Golden State Coach to attend a National Service of Thanksgiving at St Paul's Cathedral, before watching a spectacular parade and fly-past over Buckingham Palace.

That day the Queen said: "Gratitude, respect and pride, these words sum up how I feel about the people of this country and the Commonwealth – and what this Golden Jubilee means to me."

That year, as with her Silver Jubilee, the Queen toured Britain and the world with Prince Philip, travelling more than 40,000 miles by air to countries including Jamaica, New Zealand, Australia and Canada. During their UK tour they visited 70 cities and towns.

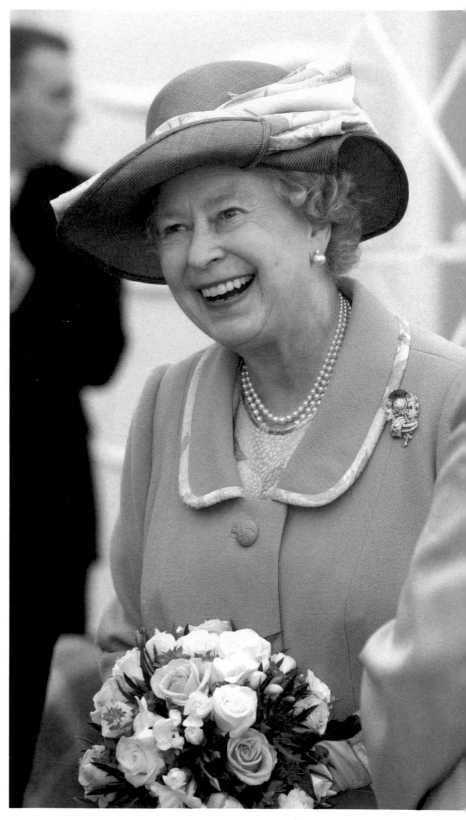

RIGHT: **The Queen smiles as she meets community leaders at St George Square, Glasgow, during her Golden Jubilee tour, 23rd May 2002.**

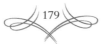

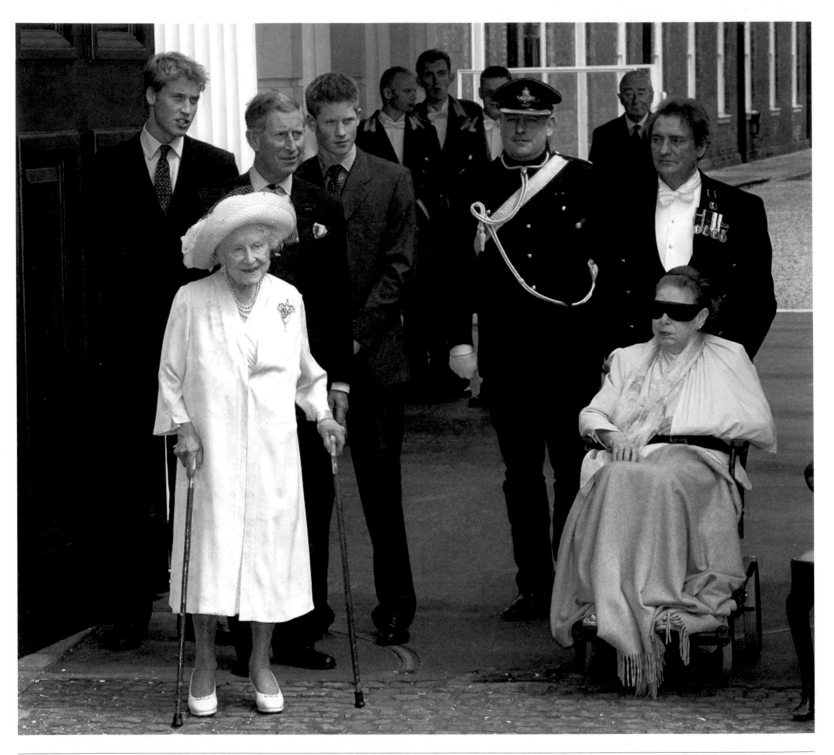

ABOVE: The Queen Mother on her 101st birthday, 4th August 2001. Despite having just been released from hospital, where she had a blood transfusion for anaemia, she insisted on coming out to meet the crowds who had gathered outside Clarence House. She was accompanied by Princess Margaret, who was also very frail after suffering a stroke in March 2001. This was Princess Margaret's second-last appearance in public before her death on 9th February 2002.

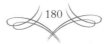

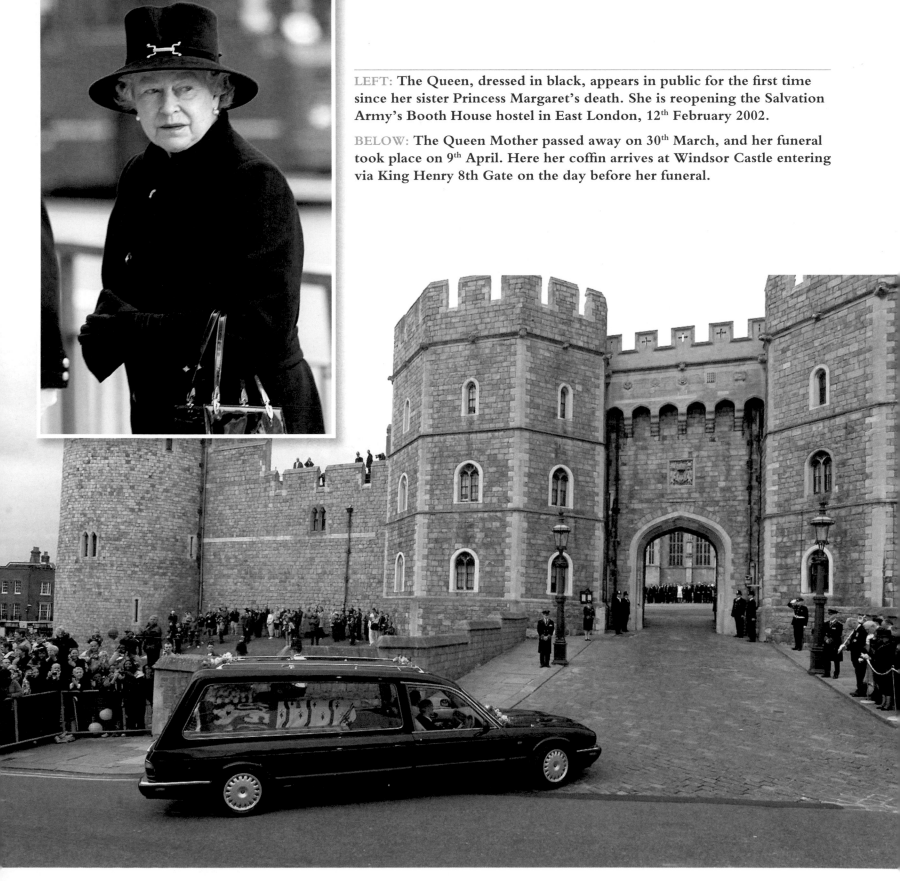

LEFT: The Queen, dressed in black, appears in public for the first time since her sister Princess Margaret's death. She is reopening the Salvation Army's Booth House hostel in East London, 12th February 2002.

BELOW: The Queen Mother passed away on 30th March, and her funeral took place on 9th April. Here her coffin arrives at Windsor Castle entering via King Henry 8th Gate on the day before her funeral.

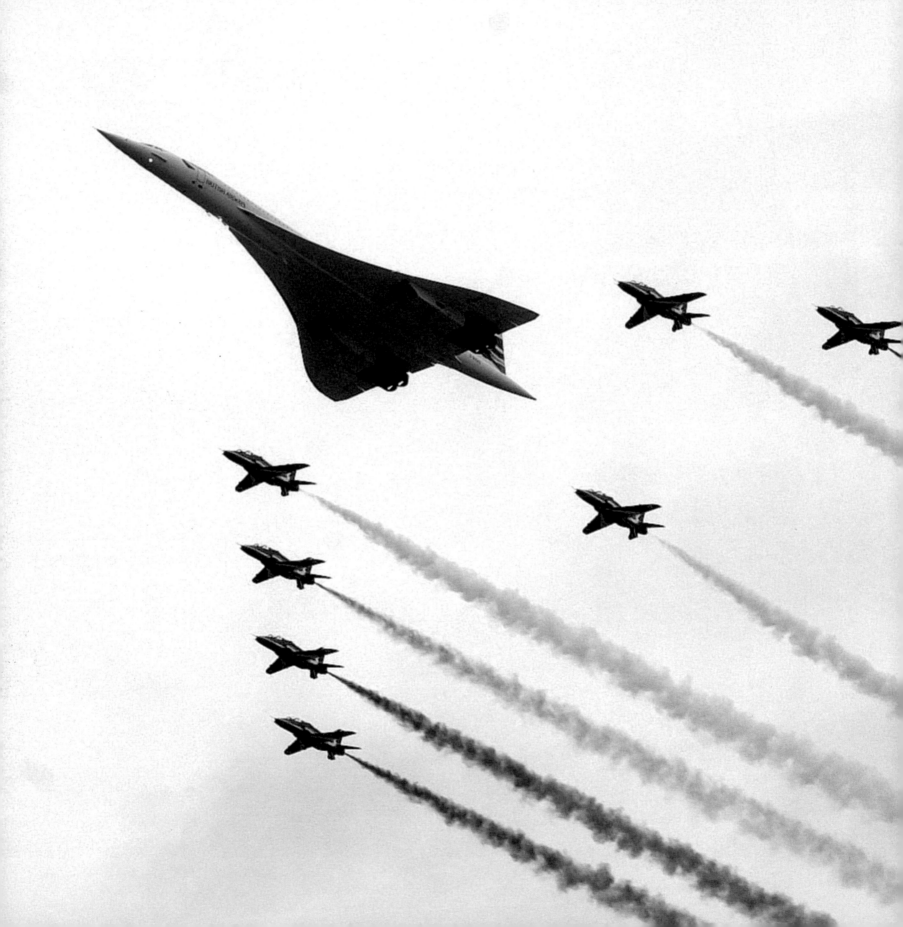

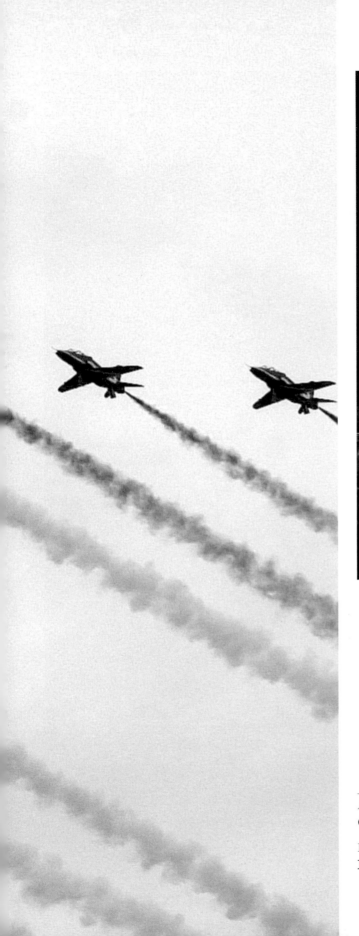

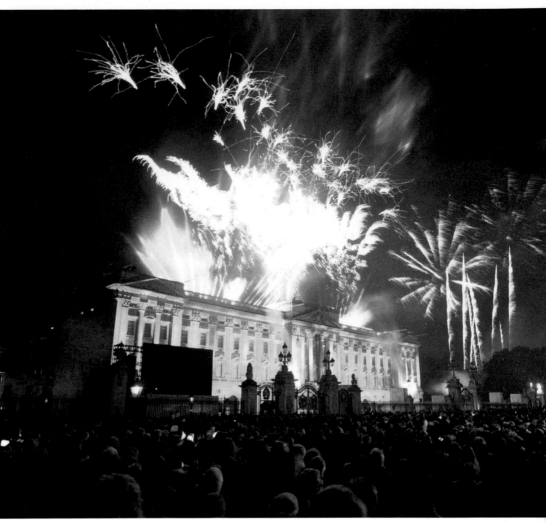

ABOVE: Fireworks explode over Buckingham Palace following the Golden Jubilee Party at the Palace, 3rd June 2002.

LEFT: Concorde and the Red Arrows on their Golden Jubilee fly-past over Buckingham Palace, 4th June 2002.

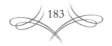

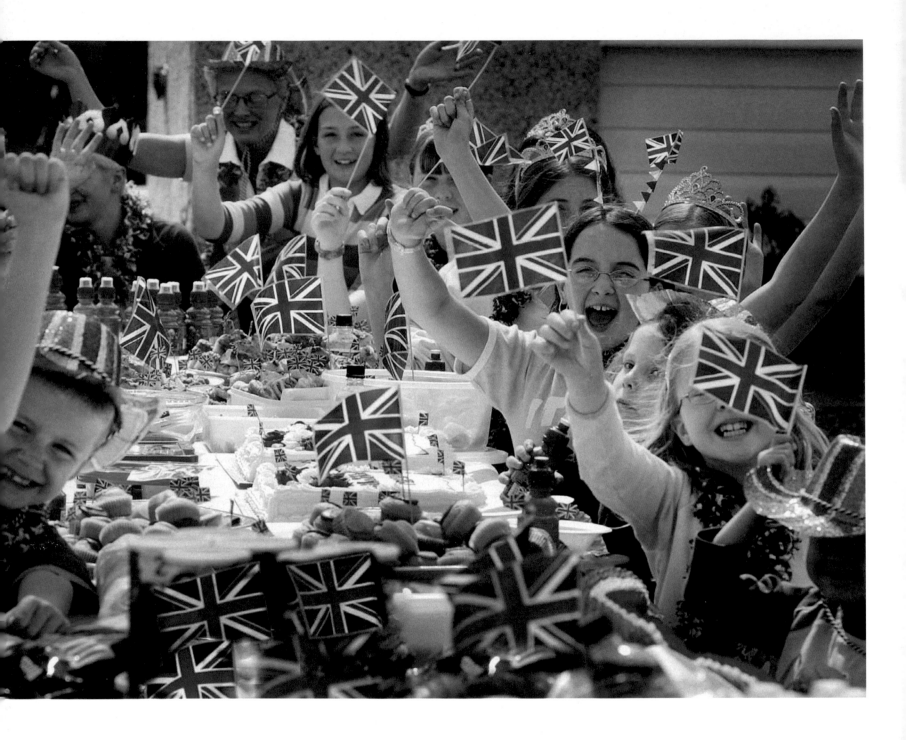

ABOVE: **A Golden Jubilee street party gets under way at Mountcastle Green in Edinburgh, June 2002.**

RIGHT: **The Queen leaves Buckingham Palace in the Golden State Coach to make her way to her Golden Jubilee Service of Thanksgiving in St Paul's Cathedral, 4th June 2002.**

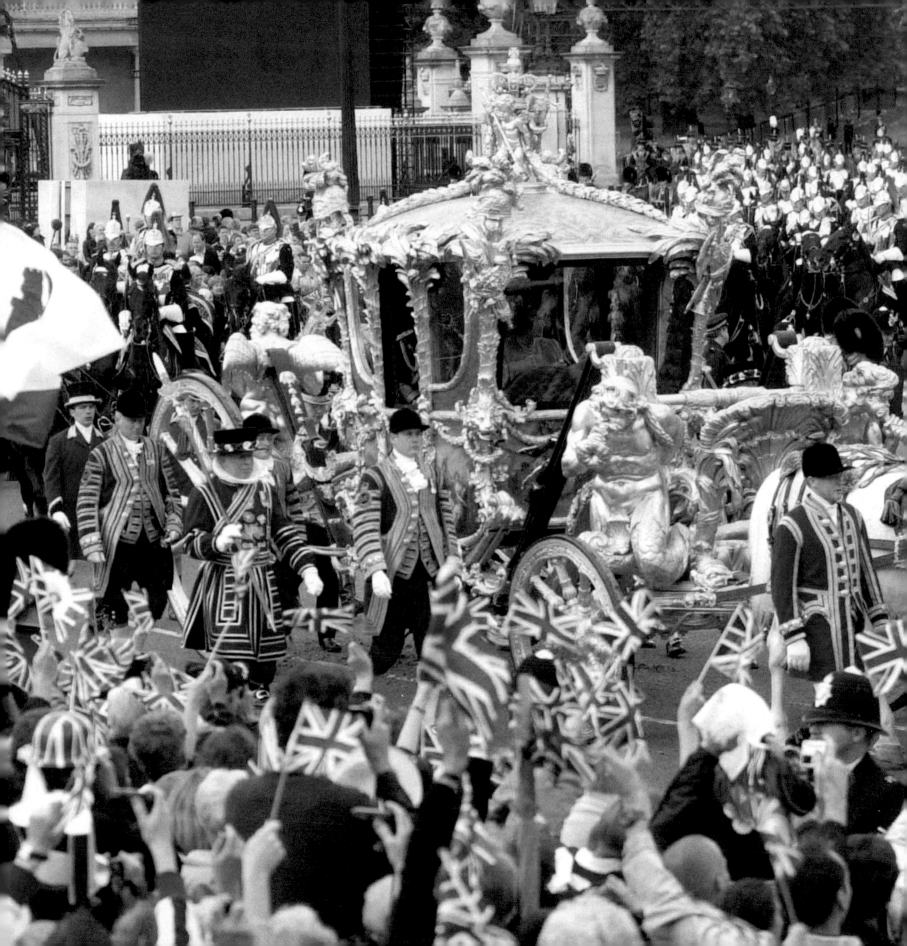

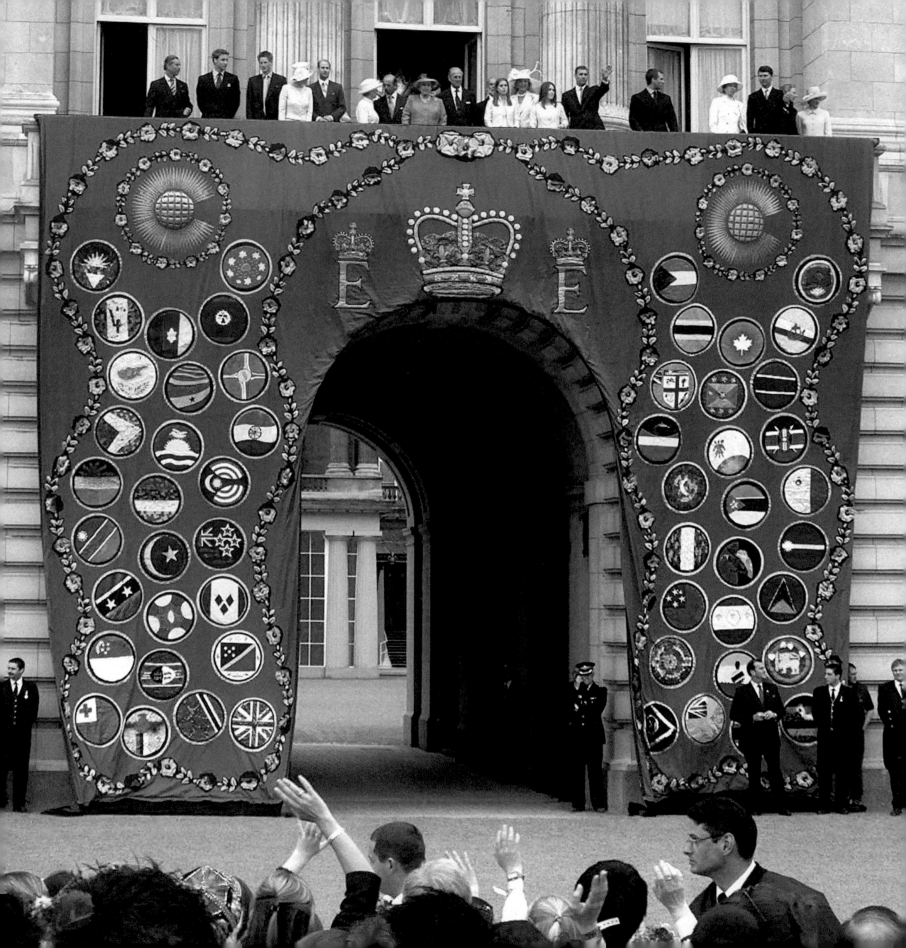

LEFT: The Royal Family, on the specially decorated Buckingham Palace balcony, during the Golden Jubilee celebrations, 4th June 2002.

RIGHT: The Queen visits the Murugan Hindu Temple in North London as part of her Golden Jubilee tour. It was the first time she had visited a Hindu temple, and she removed her shoes as a sign of respect, 6th June 2002.

CHAPTER EIGHT

A MILESTONE YEAR

"The Prince of Wales and other members of our family are travelling on my behalf in this Diamond Jubilee year to visit all the Commonwealth Realms and a number of other Commonwealth countries. At home, Prince Philip and I will be visiting towns and cities up and down the land."

Queen Elizabeth II Diamond Jubilee address to Parliament, 20th March 2012

RIGHT: The Queen shakes hands with former IRA commander Martin McGuinness during an historic meeting in Belfast as Northern Ireland's First Minister, Peter Robinson, looks on, 27th June 2012.

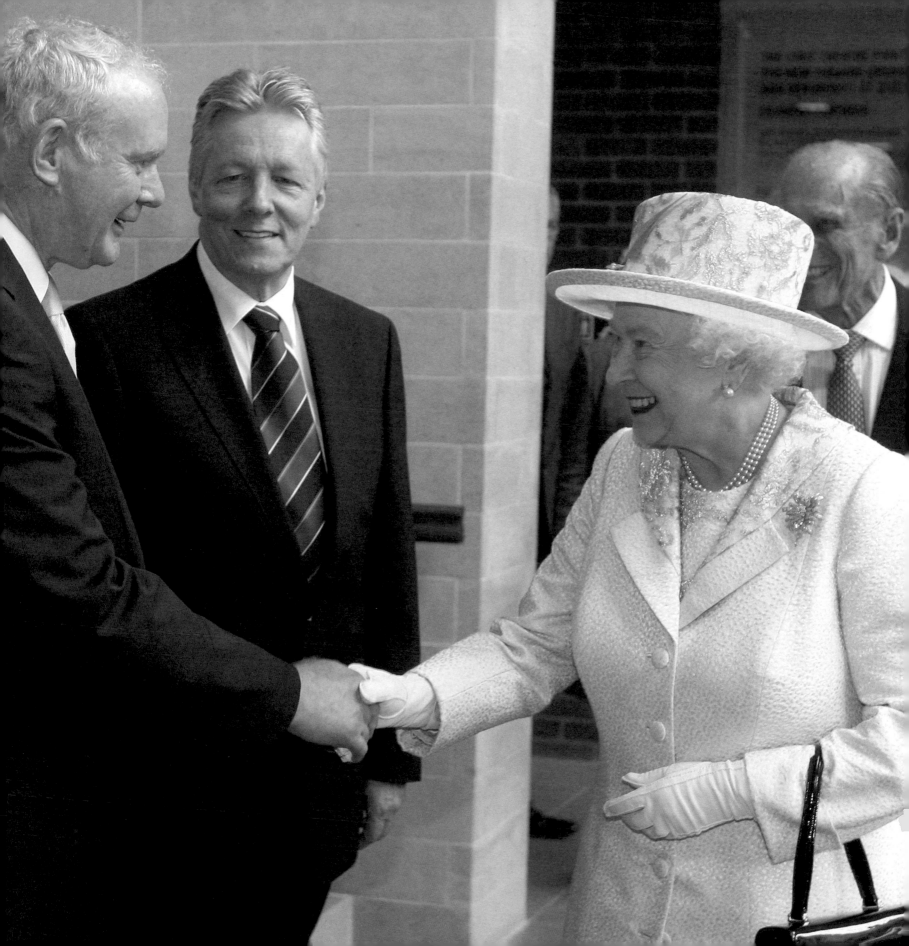

THE QUEEN AT HOME

Despite the fact she did not venture outside the UK for the whole of her Diamond Jubilee year, the Queen captivated the world with her visits. Her first major outing was on the anniversary of her accession, a bittersweet day because it is also the anniversary of the death of her father, King George VI, which is why she usually spends it in private. But, after issuing a message rededicating herself to her people 60 years after she came to the throne, the Queen chose to spend her Diamond Jubilee accession anniversary publicly, carrying out engagements in King's Lynn, Norfolk. After a brief stop in King's Lynn Town Hall, most of her morning was spent at Dersingham Infant and Nursery School, where children performed a play about her 60-year reign.

"The Queen is pretty. She was smiling, I could tell she enjoyed the play", said six-year-old pupil Ella Tuckwood.

The Queen toured the classrooms, where she came face to face with a display of knickers inspired by children's book *The Queen's Knickers* by Nicholas Allan.

"We were advised the children didn't need to be asking which pair she was wearing today," said teacher Carole Crane.

The Queen and Prince Philip embarked on their Diamond Jubilee UK tour in March, where they invited Kate, the Duchess of Cambridge, to their first stop at Leicester on 8th March.

Thousands packed into the city centre to see the royal ladies, one with 60 years of experience and one just starting out, as they arrived by train for their first stop at De Montfort University. After watching a fashion show and meeting staff and students they attended a service at Leicester's 14th-century cathedral then made a visit to the city centre Clock Tower, where they chatted to the crowds.

Crowd member Sam Brown said: "You just want to be able to tell your grandchildren you saw the Queen at her Diamond Jubilee."

The spectacle in Leicester was a template for scenes that unfolded round the country as the Queen and Philip made further stops in Manchester and Salford on 23rd March, North London on 29th March, cities across Wales from 26th to 27th April, southwest England from 1st to 2nd May, South London on 15th May, northwest England on 16th and 17th May, the East Midlands from 13th to 14th June, Henley-on-Thames on 25th June, Northern Ireland on 26th and 27th June, cities throughout Scotland from 2nd to 6th July, the West Midlands from 11th to 12th July, northeast England on 18th and 19th July and southeast England on 25th July. By the end of the tour Buckingham Palace said the Queen had carried out 83 public engagements.

With Prince Philip still recovering from his bladder infection, the Queen was joined by Prince William and Kate for her visit to Nottingham on 13th June during the East Midlands leg of the tour. An estimated 20,000 lined the streets and a huge cheer went up as the trio arrived at the city centre's Old Market Square.

But Philip was well enough to join the Queen a few days later when she made one of her most talked about trips of the year – a visit to Belfast, where she shook hands with former IRA commander and Deputy First Minister of Northern Ireland, Martin McGuinness.

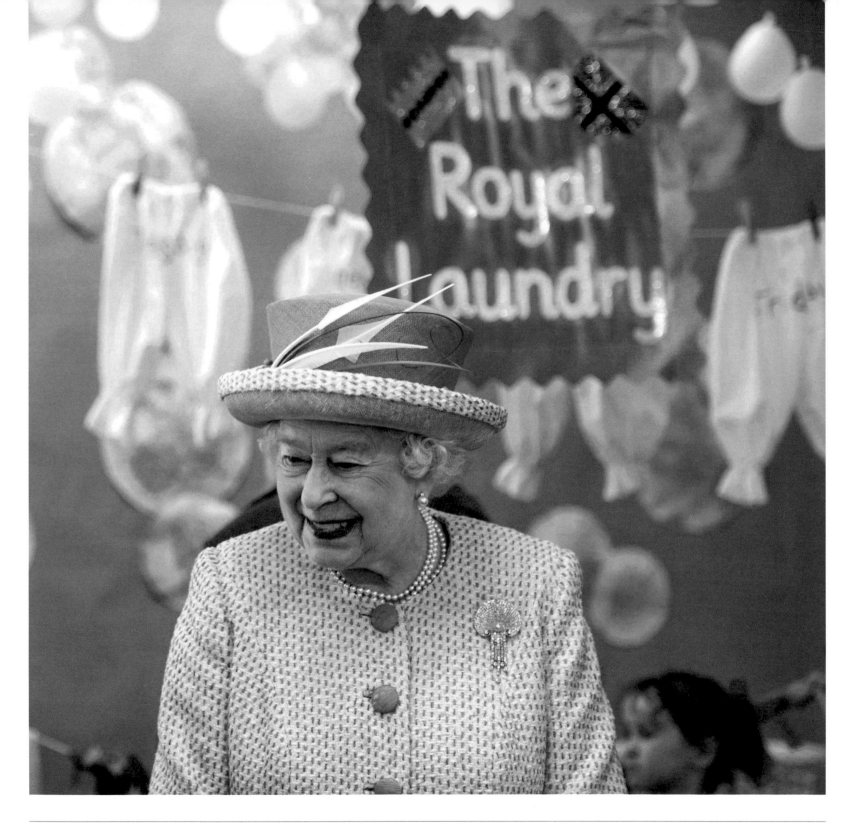

ABOVE: The Queen smiles as she looks round a classroom at Dersingham Infant and Nursery School on the 60th anniversary of her accession to the throne. The children had put up a Royal Laundry after studying children's book *The Queen's Knickers* by Nicholas Allan, 6th February 2012.

In an encounter that would have been unthinkable a little over 10 years earlier the Queen extended her white gloved hand to the man who was a senior member of the IRA when it killed her cousin Lord Mountbatten in a bomb blast in 1979.

McGuinness said to the Queen "Slan agus beannacht," which means "Goodbye and Godspeed" in Gaelic.

The image of the handshake was beamed round the world and the Queen was praised for her "magnificent gesture" by former Prime Minister Tony Blair, who oversaw the Good Friday Agreement.

As in her Golden and Silver Jubilee years, the Queen made an historic address to both Houses of Parliament in her Diamond Jubilee year.

On 20th March she arrived at the iconic 900-year-old Westminster Hall wearing buttercup yellow to address the crowd of MPs and peers past and present. She used her six-minute speech to pay tribute to British virtues of "resilience, ingenuity and tolerance" and gave a special mention to the armed forces and all Britain's volunteers. She raised a laugh by pointing out: "Since my accession I have been a regular visitor to the palace of Westminster and, at the last count, have had the pleasurable duty of treating with 12 Prime Ministers."

The Queen also made a moving tribute to Prince Philip, describing him as a "constant strength and guide" before finishing by announcing: "[I] rededicate myself to the service of our great country and its people now and in the years to come."

As well as the Diamond Jubilee tour and extended weekend of celebrations, the Queen also carried out scores of other engagements throughout the year, showing no sign of slowing down despite turning 86 on 21st April 2012.

She was the guest of honour at the annual Royal Windsor Horse Show in May, which hosted a special Diamond Jubilee pageant with a spectacular display of 550 horses, and 1,000 dancers and musicians from round the world. Highlights included singer Susan Boyle performing 'Mull of Kintyre' and narration from Dame Helen Mirren, who won an Oscar for her portrayal of Her Majesty in 2006 film *The Queen*.

The Queen also attended her annual official birthday parade Trooping the Colour in June, shortly followed by the annual Order of the Garter service. And she gave a special birthday present to her grandson Prince William, who celebrated his 30th birthday on 21st June 2012, by making him a Knight of the Thistle in a ceremony at Edinburgh's St Giles' Cathedral.

But one of her most spectacular appearances of the year came during the London Olympic Games in July. As 80,000 people in the stadium and millions more worldwide watched in disbelief the 86-year-old Queen appeared to skydive into director Danny Boyle's £27 million opening ceremony. In jaw-dropping scenes that had been pre-recorded in Buckingham Palace weeks earlier, James Bond – played by actor Daniel Craig – appeared behind the Queen as she sat at her desk. She turned round and said, "Good evening, Mr Bond," before appearing to follow him to a helicopter which flew over the Olympic Stadium. The crowds gasped as a a stuntman dressed as the Queen jumped out of the helicopter as the real Queen timed her entrance to coincide with his landing. "In a Diamond Jubilee year the Queen entered into the spirit of the Olympics to declare the Games open", the *Daily Mirror* said.

The following day, as the world hailed her ingenious appearance, the Queen told London Mayor Boris Johnson: "It was a bit of a laugh."

A few days later the Queen saw her family make history when granddaughter Zara Phillips became the first member of the Royal Family to win an Olympic medal, claiming silver in the Equestrian Team Eventing.

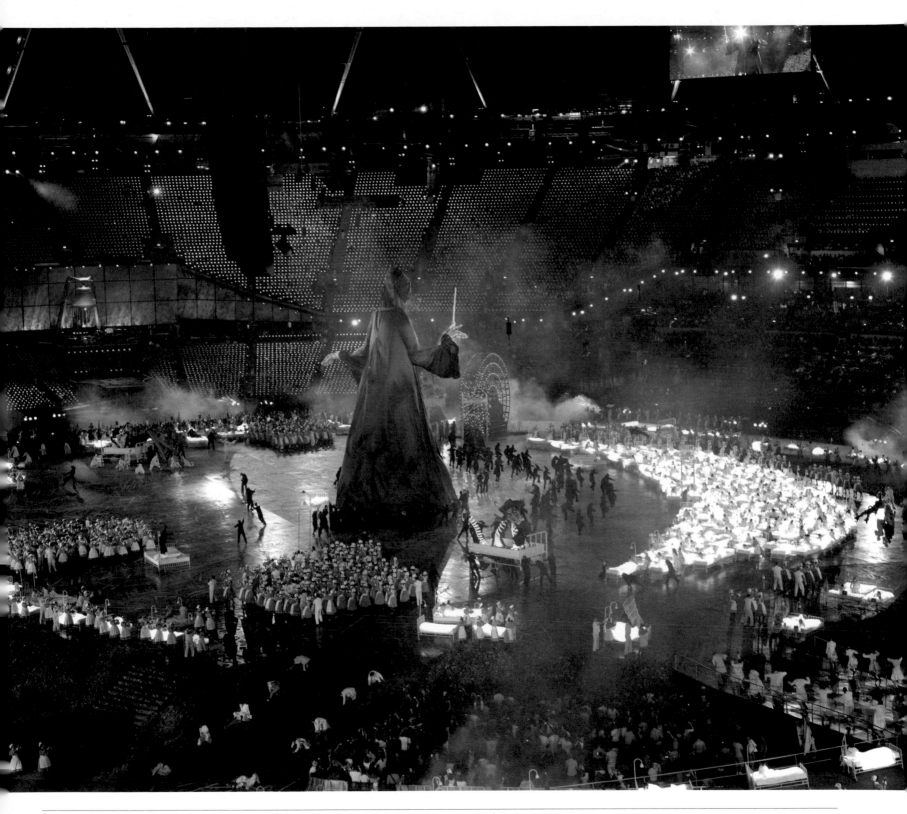

ABOVE: **The Opening Ceremony of the London Olympic Games, 27th July 2012.**

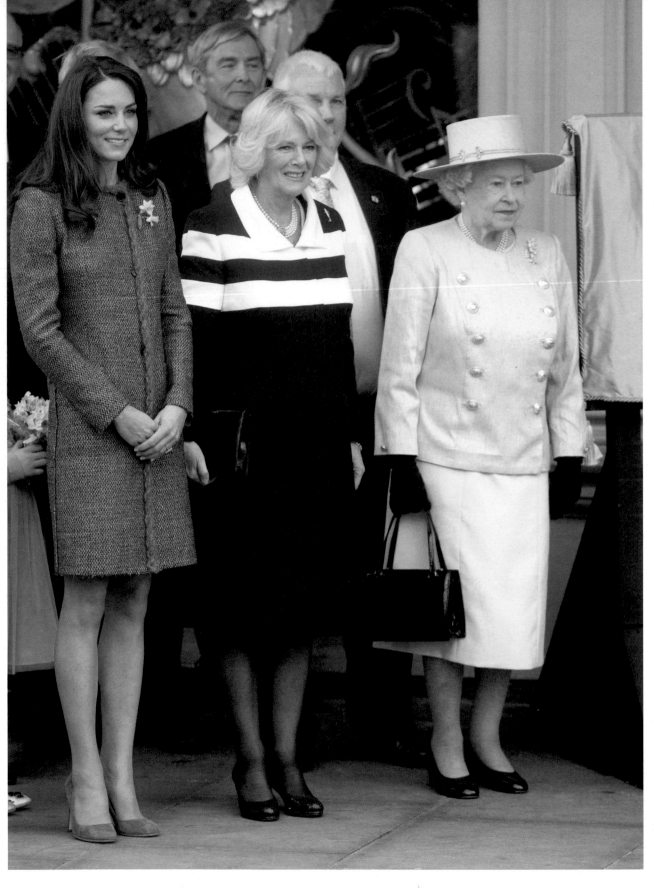

LEFT: **Three generations of royal ladies. The Queen, Camilla, Duchess of Cornwall, and Kate, Duchess of Cambridge, visit Piccadilly department store Fortnum & Mason in their first joint engagement. The Queen opened a Diamond Jubilee Tea Salon in the luxury store, 1ˢᵗ March 2012.**

RIGHT: **The Queen and Kate, Duchess of Cambridge, at Leicester's city centre Clock Tower for the launch of the Queen's Diamond Jubilee UK tour, 8ᵗʰ March 2012.**

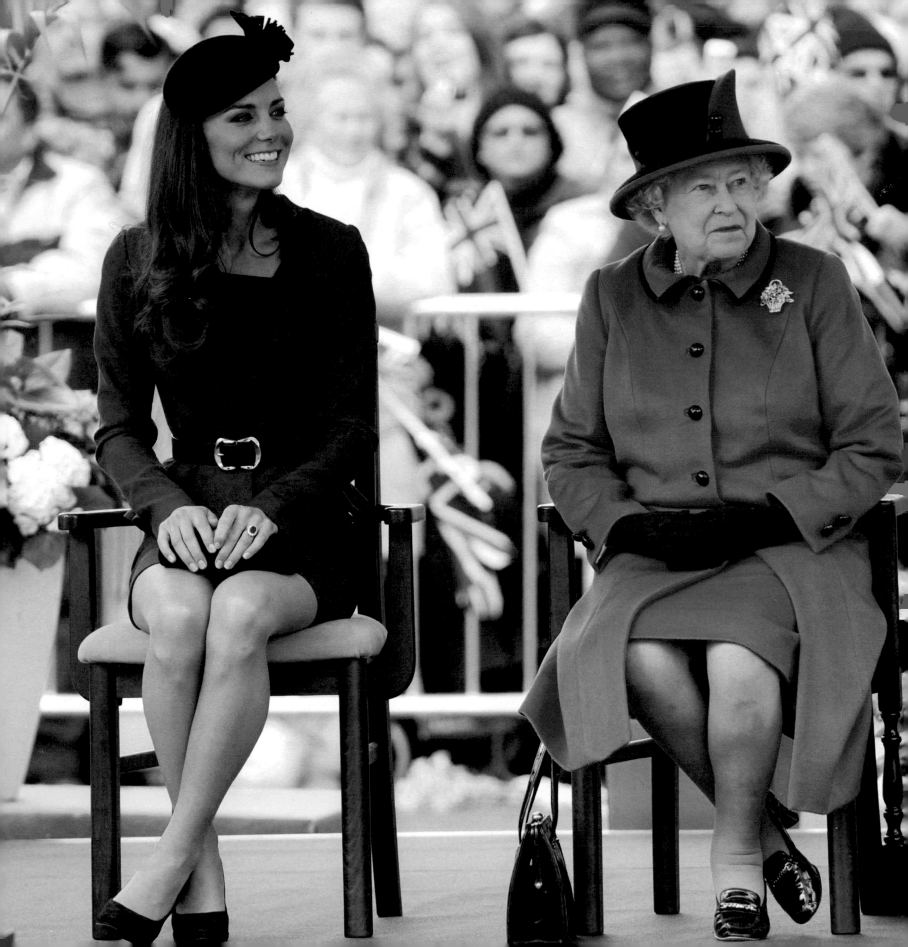

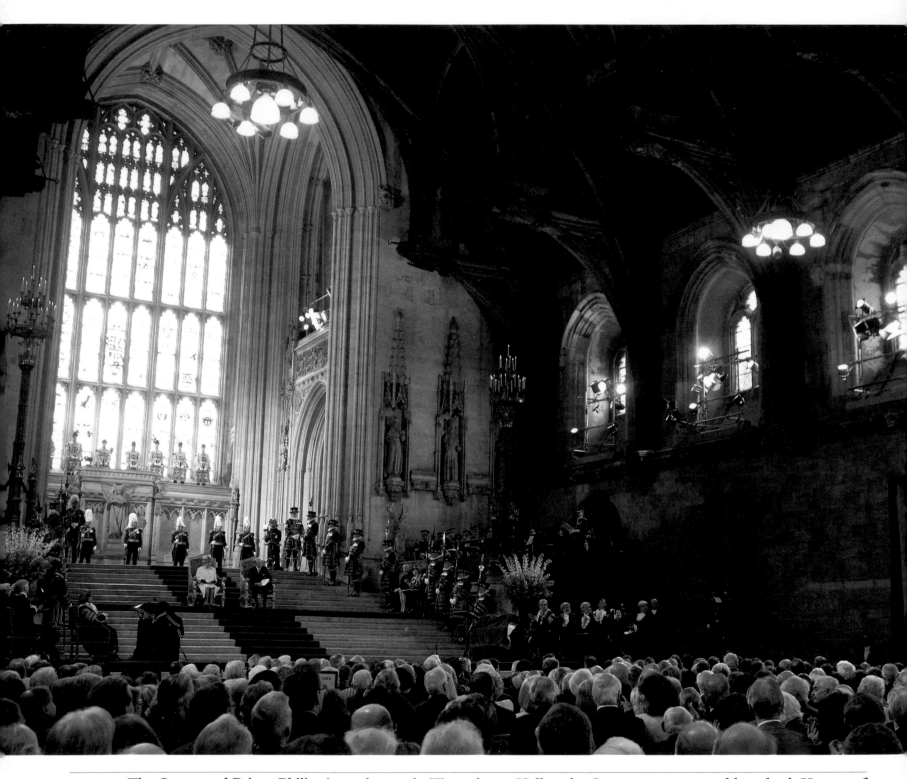

ABOVE: **The Queen and Prince Philip sit on thrones in Westminster Hall as the Queen prepares to address both Houses of Parliament. The stained glass window to the right is a Diamond Jubilee present from MPs and Peers which was unveiled before the address, 20th March 2012.**

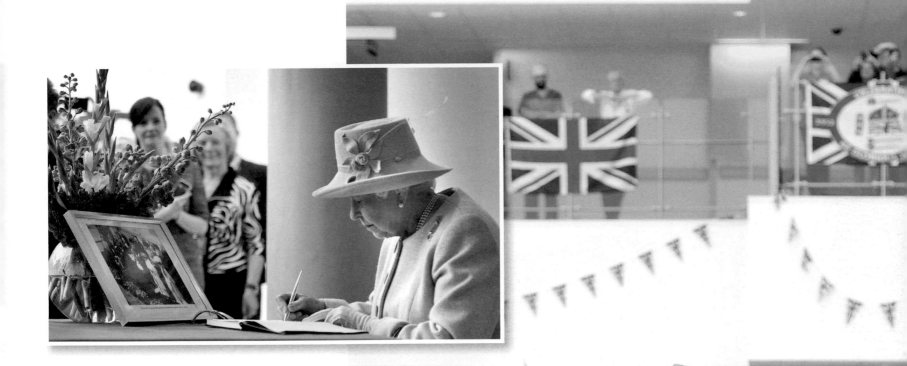

ABOVE: The Queen signs the visitors' book at the newly refurbished St Mary's Hospital in Manchester during her Diamond Jubilee UK tour, 23rd March 2012.

RIGHT: Staff and patients at St Mary's watch from above as the Queen looks round the newly refurbished hospital, 23rd March 2012.

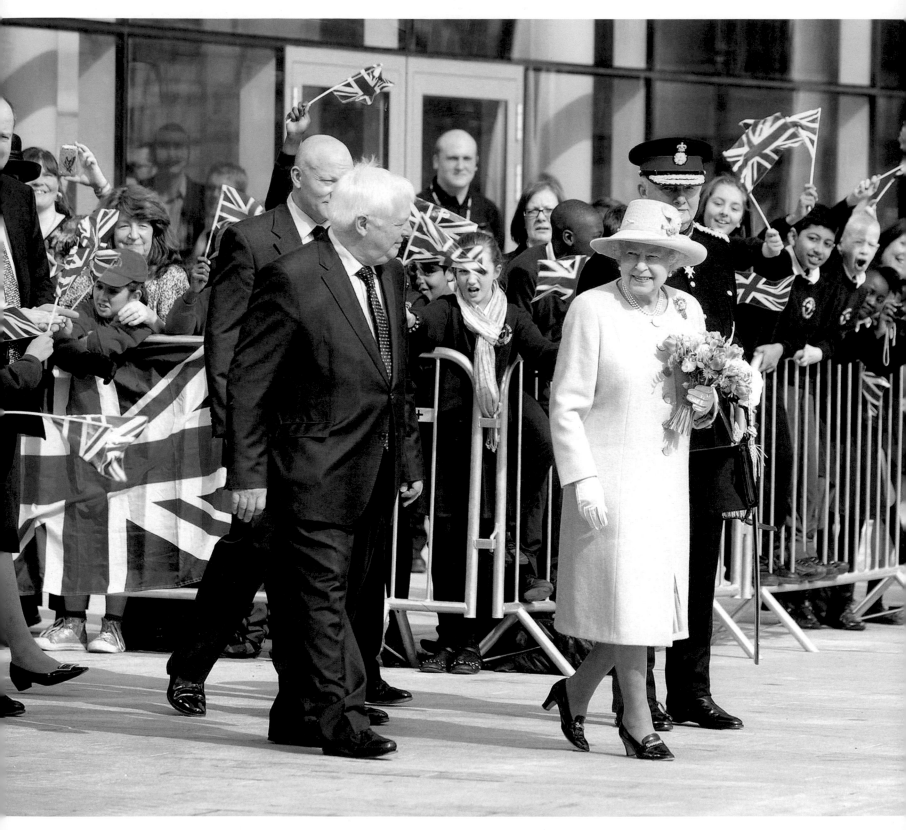

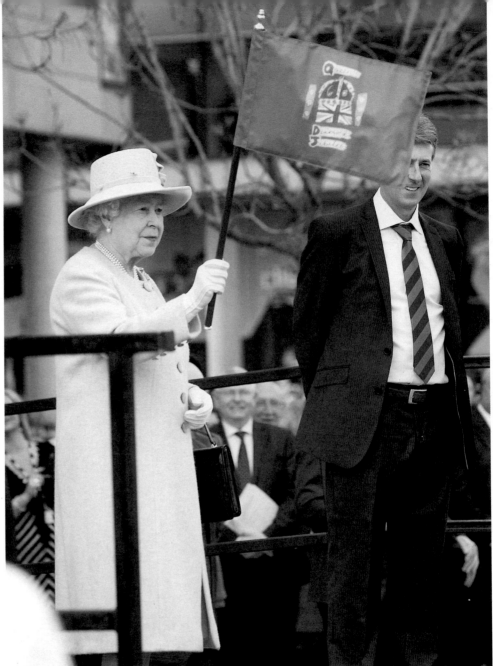

ABOVE: **The Queen waves the flag showing the official Diamond Jubilee emblem during her Diamond Jubilee UK tour visit to the BBC's Media City in Salford Quays. The emblem was designed by 10-year-old Katherine Dewar from Chester who was chosen from 35,000 entrants in a nationwide competition run by children's programme *Blue Peter*. The design was widely reproduced, on items ranging from posters to commemorative tea cups, 23rd March 2012.**

LEFT: **Crowds cheer and wave Union flags as the Queen leaves the BBC's Media City in Salford Quays during her Diamond Jubilee UK tour, 23rd March 2012.**

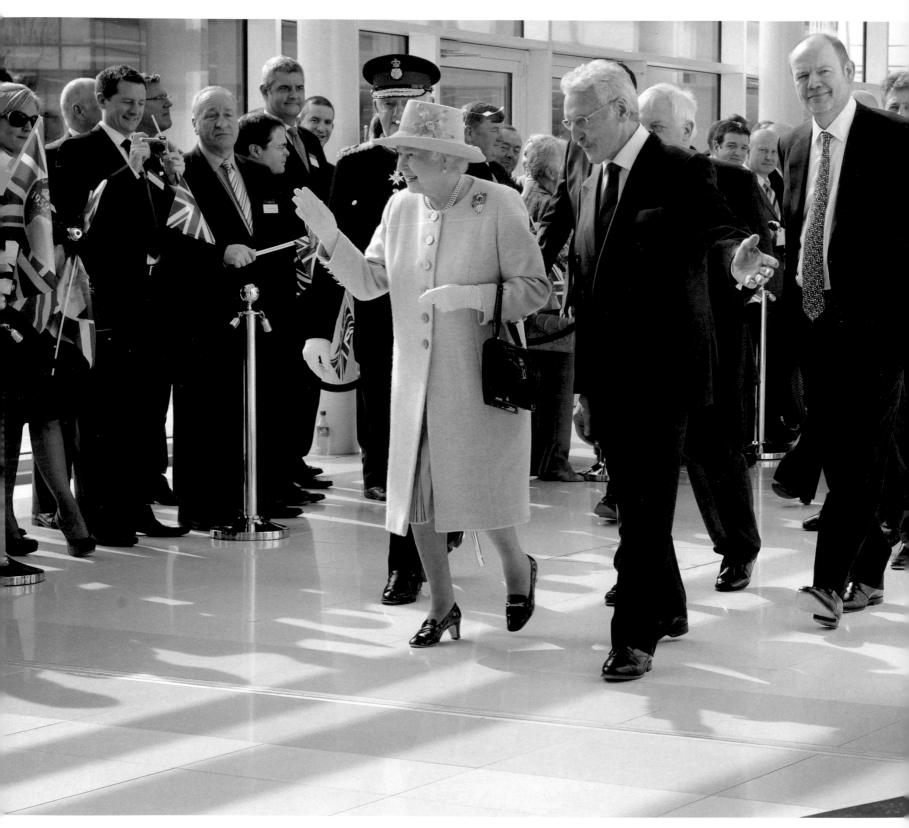

LEFT: On her visit to the BBC's Media City in Salford Quays the Queen comes within a few feet of a Dalek, 23rd March 2012.

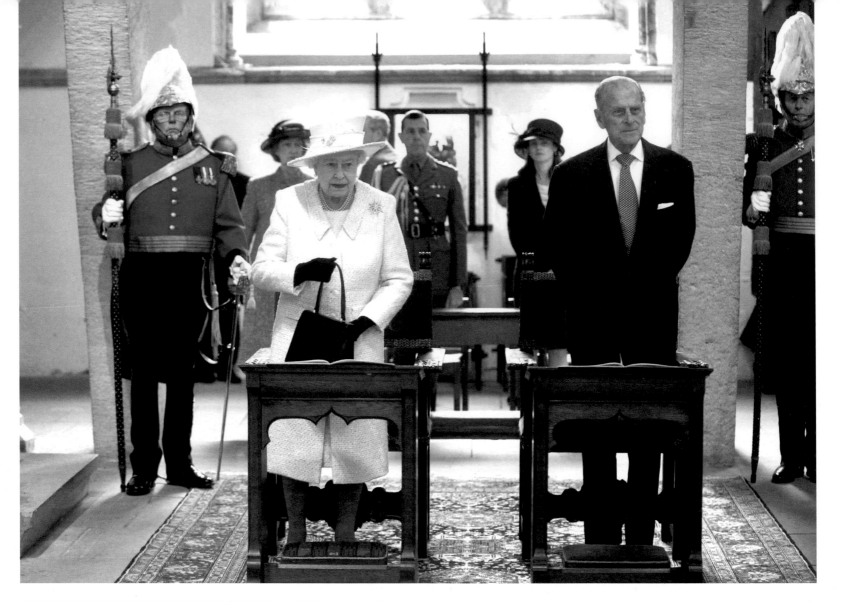

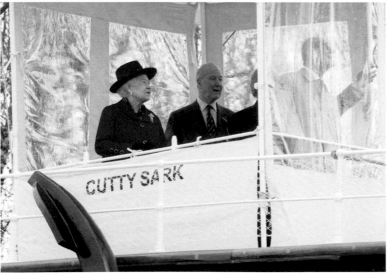

ABOVE: The Queen and Prince Philip attend a Thanksgiving Service in Cardiff's Llandaff Cathedral at the start of the Welsh leg of her Diamond Jubilee UK tour, 26th April 2012.

LEFT: The Queen officially reopens the *Cutty Sark* in Greenwich after a £50 million renovation programme following its near destruction by a fire in May 2007. She also unveiled a plaque to mark Greenwich becoming a royal borough, an honour bestowed to mark her Diamond Jubilee, 25th April 2012.

RIGHT: The Queen holds an umbrella to shield herself from the rain during a visit to Cyfarthfa High School and Cyfarthfa Castle Museum and art gallery in Merthyr Tydfil, South Wales, as part of her Diamond Jubilee UK tour, 26th April 2012.

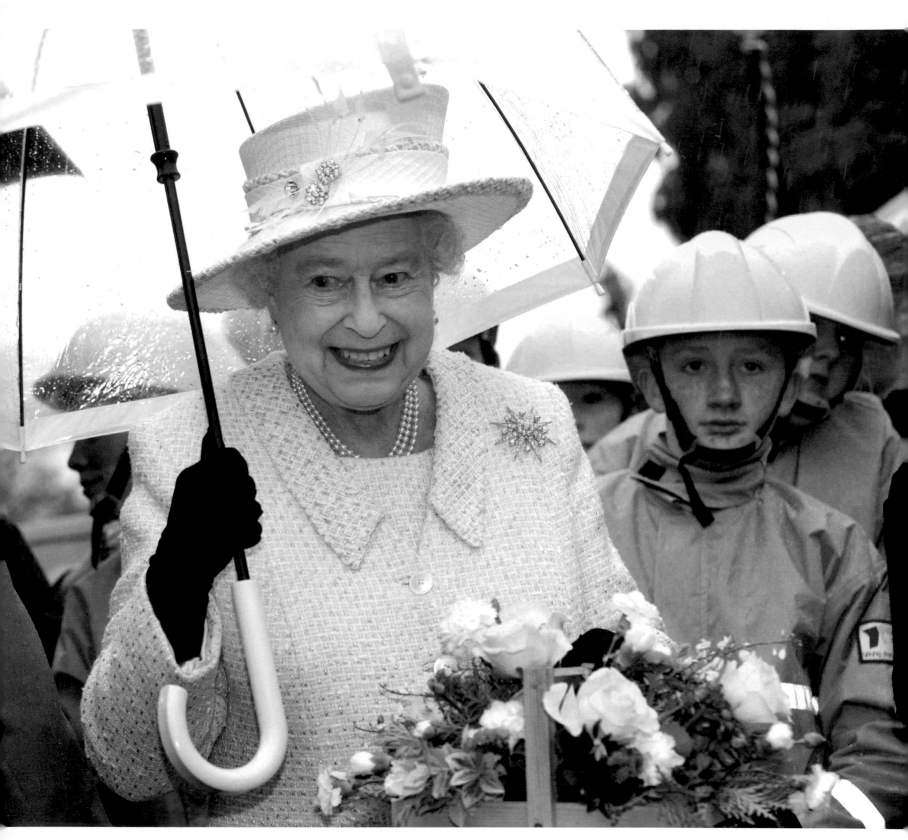

RIGHT: The Queen arrives in Aberfan to open Ynysowen Community Primary School on the second day of the Wales leg of her Diamond Jubilee tour. The visit was seen as a sign of her continued support for the city, which suffered a tragedy in 1966 when 144 people, including 116 children, died when a coal tip slid down a mountain, 27th April 2012.

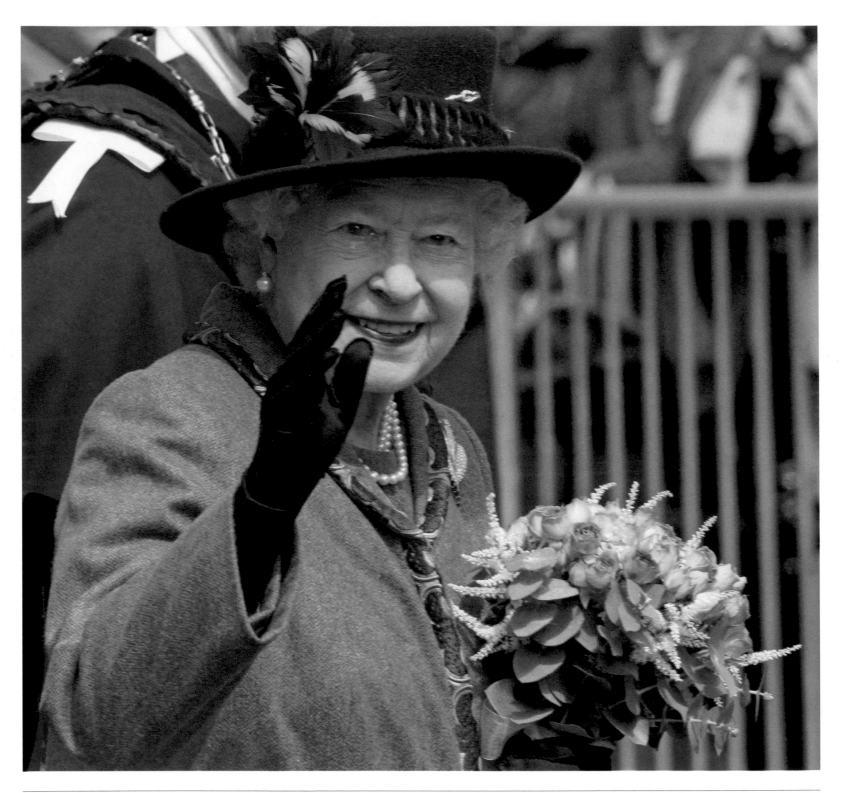

ABOVE: **The Queen on a walkabout from Windsor Castle to the Guildhall. The event was not part of the Diamond Jubilee UK tour but was billed as a "thank you" to the Royal Family's neighbours in the Berkshire town, 30ᵗʰ April 2012.**

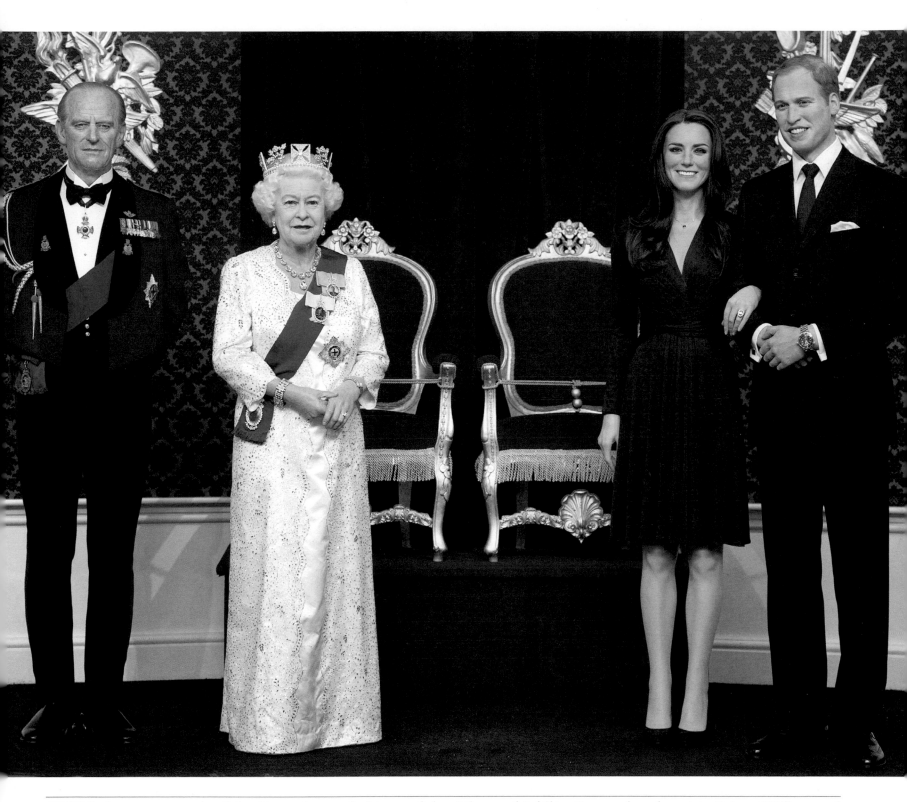

ABOVE: **A new waxwork of the Queen is unveiled to mark her Diamond Jubilee. It was placed next to Prince William and Kate's new waxworks which were unveiled in April 2012, in the royal section of the London attraction, 14th May 2012.**

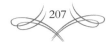

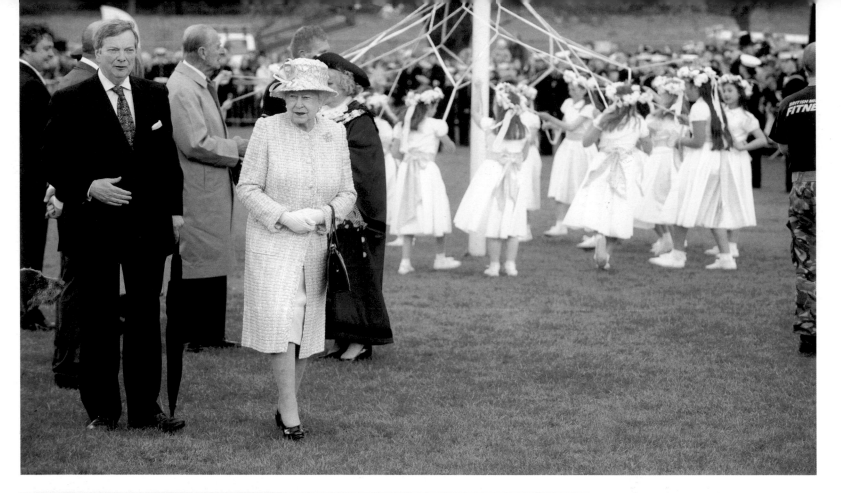

ABOVE: The Queen enjoys a display of maypole dancing on a visit to Richmond Park during the South London leg of her Diamond Jubilee UK tour, 15th May 2012.

LEFT: The Queen makes her way back to her car following a visit to Chester Zoo as part of the northwest England leg of her Diamond Jubilee UK tour, 17th May 2012.

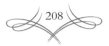

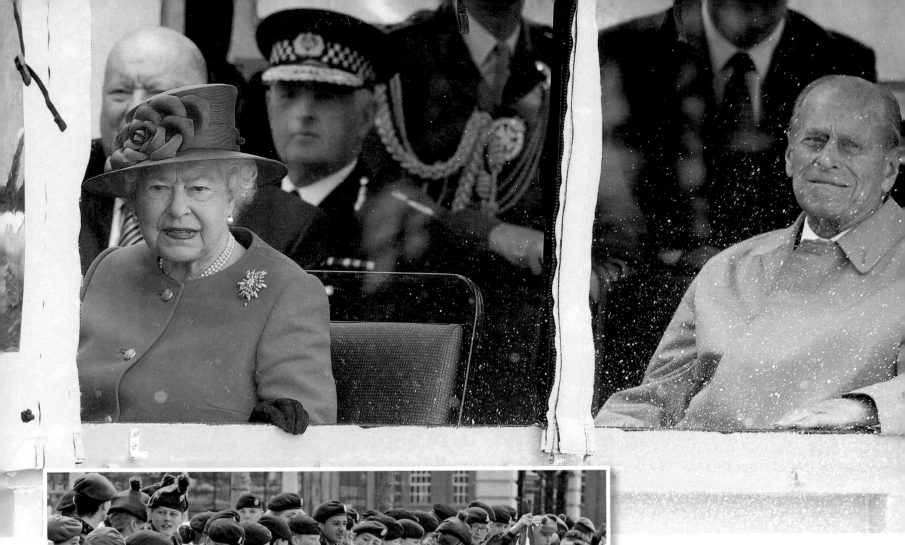

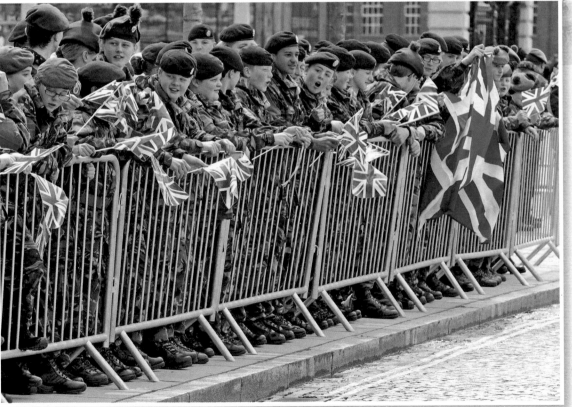

ABOVE: The Queen and Prince Philip aboard one of Liverpool's most popular tourist attractions, the Yellow Duck Marine, during the northwest England leg of their Diamond Jubilee UK tour, 17th May 2012.

LEFT: Cadets line the road in Liverpool's Colin Lane to welcome the Queen and Prince Philip, 17th May 2012.

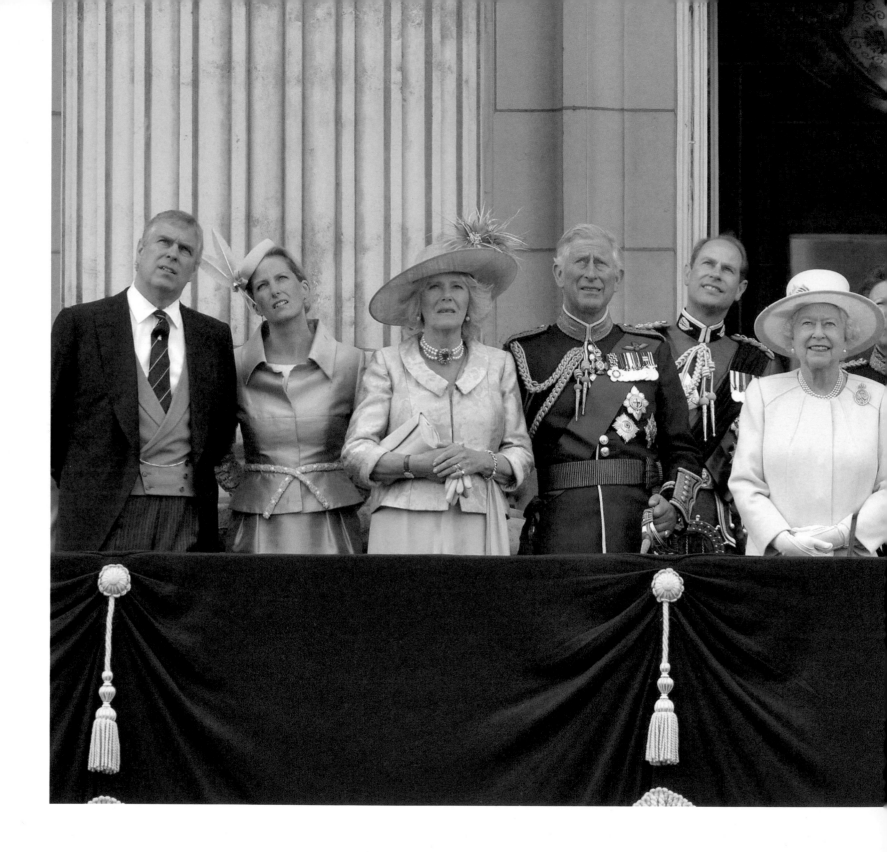

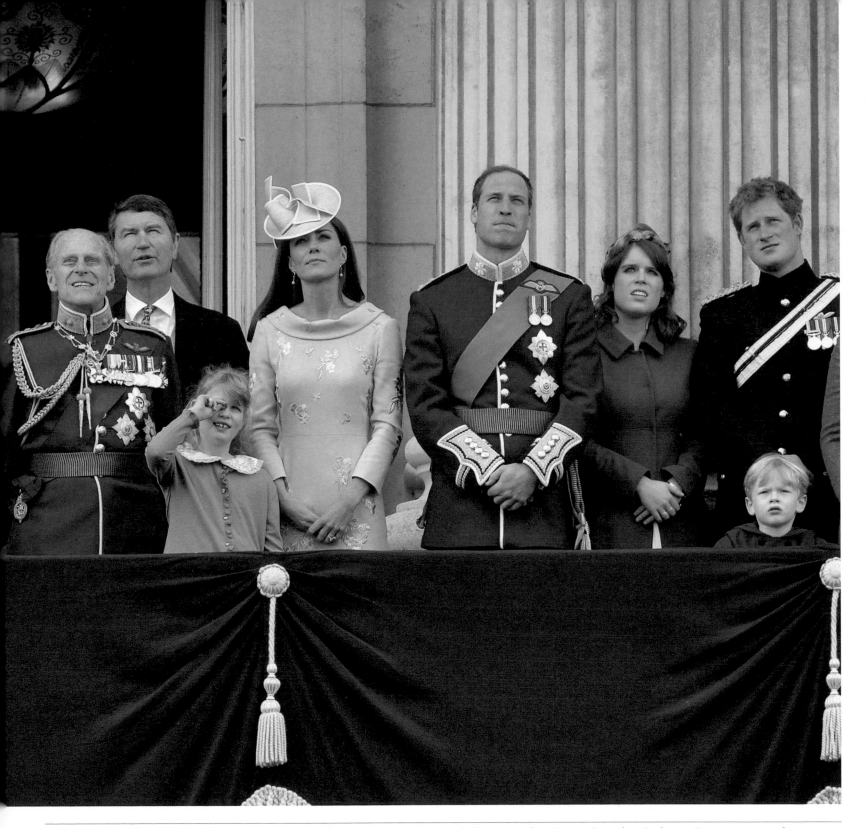

ABOVE: **The Royal Family on the Buckingham Palace balcony following the Trooping the Colour Ceremony to honour the Queen's official birthday. This was Prince Philip's first major appearance since leaving hospital on 9th June, having spent five nights being treated for a bladder infection, 16th June 2012.**

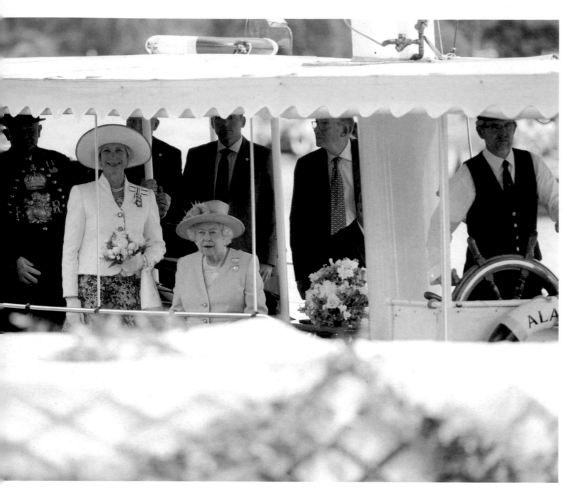

ABOVE: The Queen aboard 130-year-old steam launch *Alaska*, the oldest working passenger steamer on the Thames, during the Henley-on-Thames Jubilee river pageant. The visit was part of her Diamond Jubilee UK tour, 25th June 2012.

RIGHT: The Royal Family make their way to Edinburgh's St Giles' Cathedral where the Queen made Prince William a Knight of the Thistle, Scotland's highest honour, 6th July 2012.

OLYMPICS & PARALYMPICS

Ordinary life in Britain seemed to come to a standstill during the summer of 2012 when the world's most impressive athletes descended on London for the Olympic and Paralympic Games.

And the Queen was right at the heart of the action, with her mock skydive into the stadium at the Opening Ceremony of the Olympic Games on 27th July sending shockwaves of delight round the globe.

The show-stopping moment was even a surprise to her grandsons, Olympic and Paralympic ambassadors Princes William and Harry.

"To be honest, we were kept completely in the dark about it, that's how big the secret was. Harry got a sniff of a rumour on the night and we were talking about it and we were going 'No, this probably isn't happening'," Prince William told the BBC.

He added, joking: "But in fact she did such a good performance that she's now been asked to star in the next Bond film. So I'm thrilled for her, it's fantastic."

Following the stunt, the Queen officially declared the Olympic Games open.

In the two weeks that followed almost 11,000 athletes from 204 nations put on the most incredible sporting display that saw Great Britain come third with a staggering 65 medals – 29 gold, 17 silver and 19 bronze.

The United States of America won with 104 medals and the People's Republic of China came second with 88.

And just a few weeks later the stadiums were filled again as the world's most inspirational athletes competed in the Paralympics, which the Queen also declared open on 29th August.

LEFT: Stuntmen dressed as the Queen and James Bond parachute into the Olympic Stadium during the Opening Ceremony of the London 2012 Olympic Games at the Olympic Stadium, 27th July 2012.

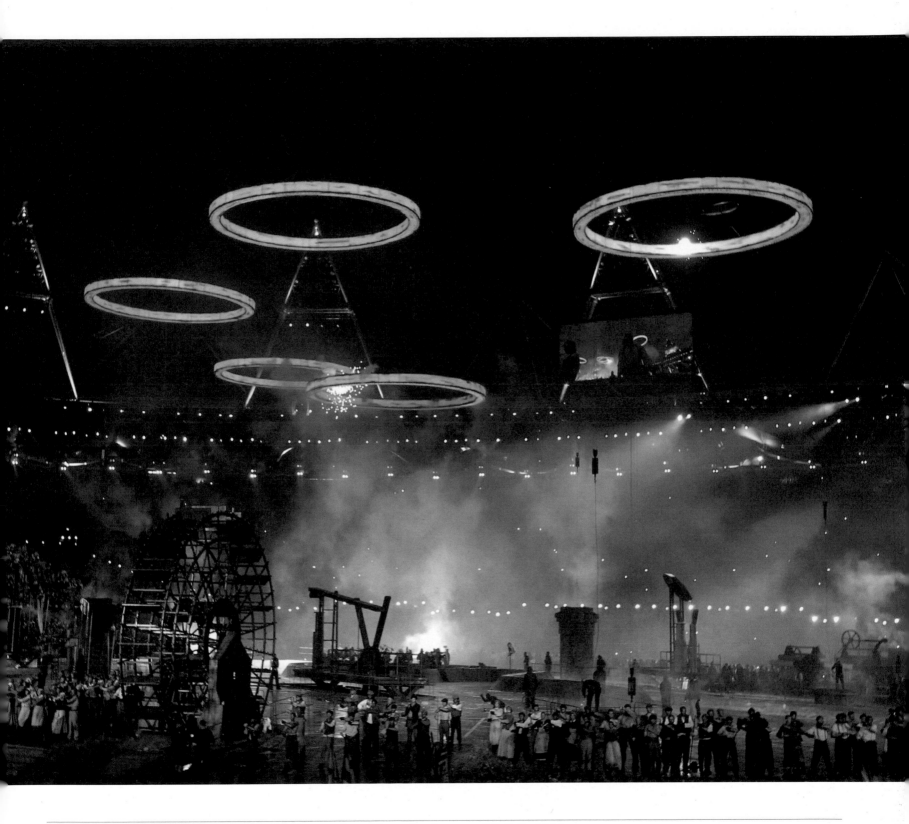

ABOVE: **The Opening Ceremony of the London Olympic Games, 27th July 2012.**

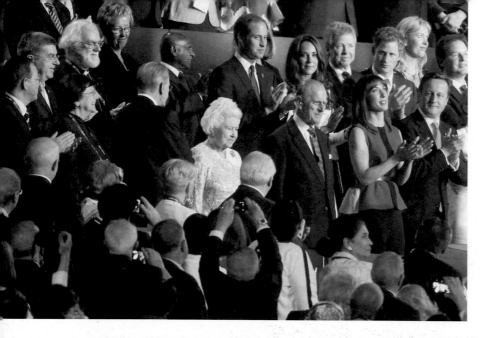

LEFT: The Queen and Prince Philip arrive at the Olympic Stadium during the Opening Ceremony of the London Olympic Games. They had timed their entrance to make it look as though the Queen had jumped out of a helicopter with James Bond, 27th July 2012.

BELOW: The Queen officially declares the London Olympic Games open. This was the second time in her reign she had opened the Olympics. The first was the Montreal Olympics in 1976, 27th July 2012.

RIGHT: The Queen's granddaughter Zara Phillips receives an Olympic silver medal from her mother, Princess Anne, at the Team Eventing, 31st July 2012.

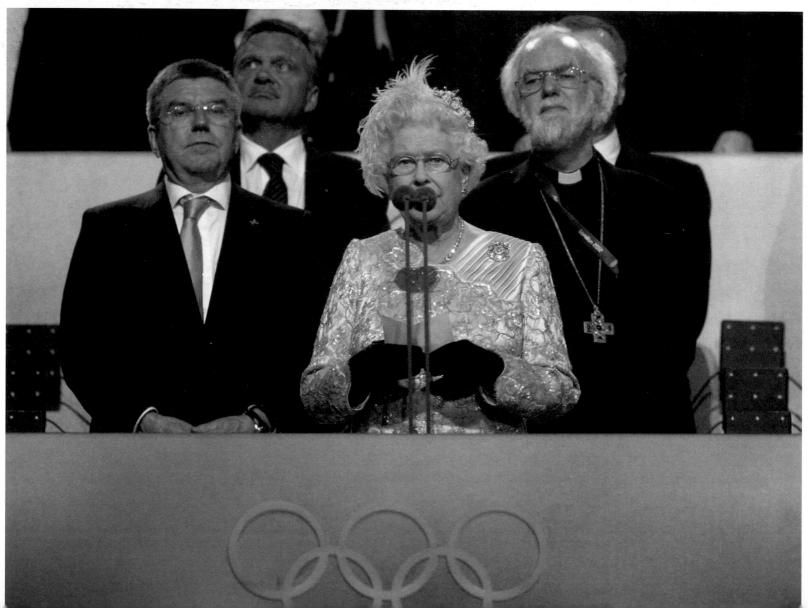

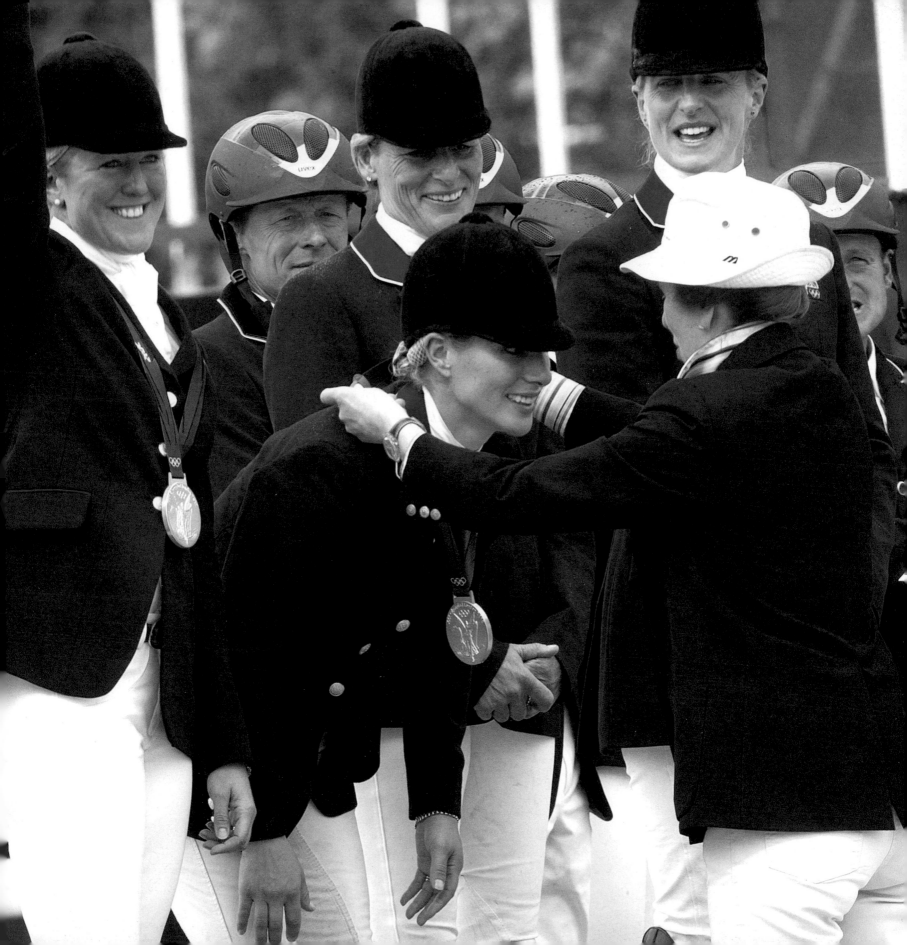

LEFT: **Members of the Royal Family and other dignitaries attend the Opening Ceremony of the London 2012 Paralympic Games at the Olympic Stadium, Stratford, London, 29th August 2012.**

BELOW: **Team GB athletes are introduced to the crowd at the Opening Ceremony of the London 2012 Paralympic Games at the Olympic Stadium, Stratford, London.**

THE ROYAL FAMILY ABROAD

While the Queen and Prince Philip stayed at home their family was dispatched round the world on tours of Commonwealth countries, Crown Dependencies and British Overseas Territories.

The first visit of the year was made by Prince Edward and Sophie, the Earl and Countess of Wessex, to the West Indies, from 21st February to 7th March, a visit that started off in sunny St Lucia, where the couple joined in

the Independence Day celebrations. They also stopped in Barbados, St Vincent and the Grenadines, Grenada, Trinidad and Tobago, St Kitts and Nevis, Anguilla, Antigua, Barbuda and Montserrat, where they saw the island's ongoing recovery from the devastating effects of volcanic eruptions.

In contrast to this relatively low-key tour, the next overseas visit by Prince Harry to the Caribbean and Latin America attracted an explosion of attention from all corners of the globe. Described as his "coming of age" tour, where 27-year-old Harry showed the world he had transformed from a fun-loving party prince into a mature ambassador for Queen and country, the 10-day visit, 2nd to 13th March, was a whirlwind of activity. Harry partied with Garifuna dancers at a street party in Belize, befriended inspirational blind girl Anna Albury in the Bahamas, charmed the republican Prime Minister Portia Simpson-Miller with hugs and jokes and raced the world's fastest man, Usain Bolt, in Jamaica, and lunged across the white sands of Brazil's famous Copacabana beach playing volleyball.

He said at the end: "It's been an emotional trip, I'm absolutely exhausted. I personally had no idea how much warmth there was towards the Queen ... I was actually quite choked up seeing the way that they are celebrating her 60 years ... I just hope that my grandmother is proud of what we've done."

LEFT: **Prince Harry charms the crowds in Belmopan, Belize, during his Diamond Jubilee tour of the Caribbean and Latin America, 4th March 2012.**

RIGHT: **Prince Harry meets republican Prime Minister Portia Simpson-Miller when she arrives for lunch in Kingston. Two months before Harry's visit Mrs Miller made a speech at her inauguration where she vowed to abandon the Queen as Jamaica's head of state and turn the country into a republic, 6th March 2012.**

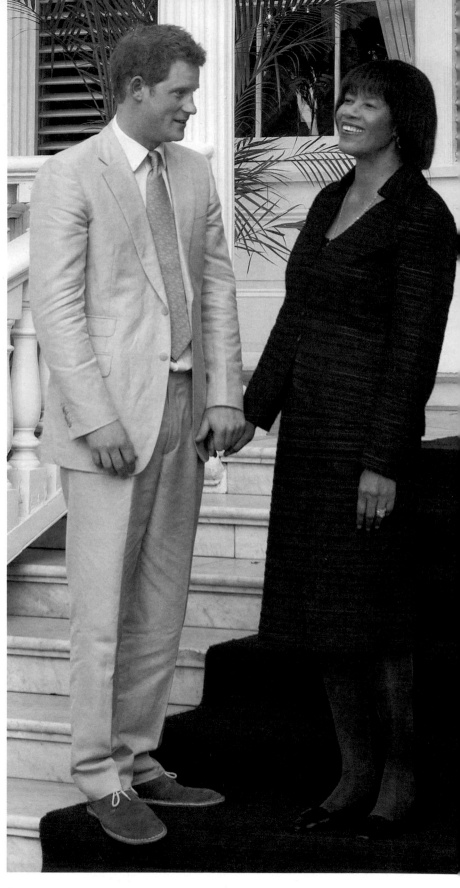

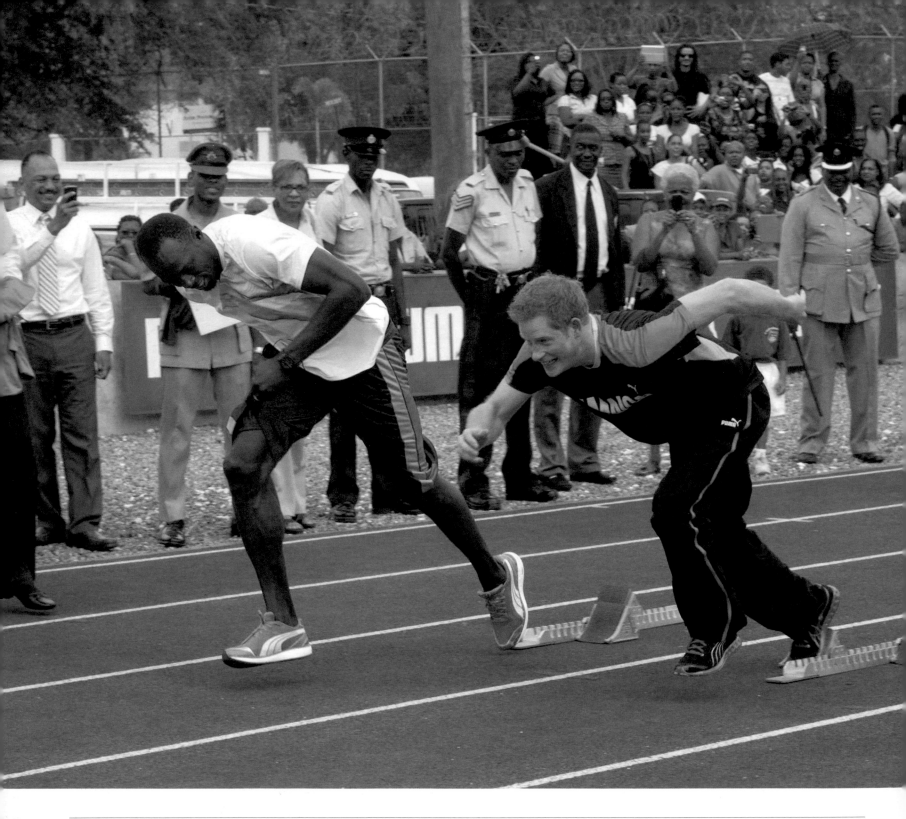

ABOVE: **Prince Harry races the world's fastest man, Usain Bolt, in Kingston, Jamaica, during his Diamond Jubilee tour of the Caribbean and Latin America. Harry secured an advantage in the race by starting early!, 6th March 2012.**

RIGHT: **Prince Edward and Sophie arrive in Gibraltar for their Diamond Jubilee visit, 11th June 2012.**

In an interview with US TV network CBS at the end of the tour Harry also opened up about his personal life, revealing that his royal status and duties can be a hindrance to finding love.

He said: "It's sort of, 'Oh my god, he's a prince'... I mean look at me I'm 27 years old ... I'm not so much searching for someone to fulfil the role, but obviously, you know, finding someone that would be willing to take it on."

Prince Charles and Camilla made a three-day visit to Canada, from 20th to 23rd May, where the prince presented Diamond Jubilee medals to Canadians who had excelled in community service. In a speech on the final day in Regina he said: "My wife and I take with us today your countless good wishes and congratulations to the Queen." Later in the year the couple visited the Channel Islands and the Isle of Man and also jetted across the globe to Australia, New Zealand and Papua New Guinea.

The Queen's daughter Princess Anne also carried out visits, to Mozambique and Zambia, while Prince Andrew spent a week in India where he took a trip to Mumbai's Dharavi slum, one of Asia's biggest slums. In June, Prince Edward and Sophie made a three-day visit to Gibraltar, despite diplomatic tensions between Britain and Spain over fishing rights in the surrounding waters.

Minor royals also carried out visits on behalf of the Queen. The Queen's cousin the Duke of Gloucester went to the British Virgin Islands Malta, and another cousin, the Duke of Kent, went to the Falkland Islands and Uganda.

But by far the most talked about tour of the year was the trip by Prince William and Kate to Singapore, Malaysia, the Solomon Islands and Tuvalu, 11th to 19th September. Only their second royal tour together, the couple were expected to take the Far East countries by storm and take the eyes of the world with them.

CHAPTER NINE

FASHIONING THE JUBILEE

"Should this beautiful window cause just a little extra colour to shine down upon this ancient place, I should gladly settle for that."

Queen Elizabeth II thanking Parliament for her Diamond Jubilee present of a stained-glass window during her Diamond Jubilee address to Parliament, 20th March 2012

RIGHT: **The Queen making her Diamond Jubilee address to Parliament in Westminster Hall, 20th March 2012.**

The Queen lit up Westminster Hall in a pale buttercup yellow outfit to address MPs and Lords in March. Her dress, designed by Karl Ludwig Rehse, was decorated with flower motifs in shades of olive, lavender and pale burgundy, while Angela Kelly created a hat to match.

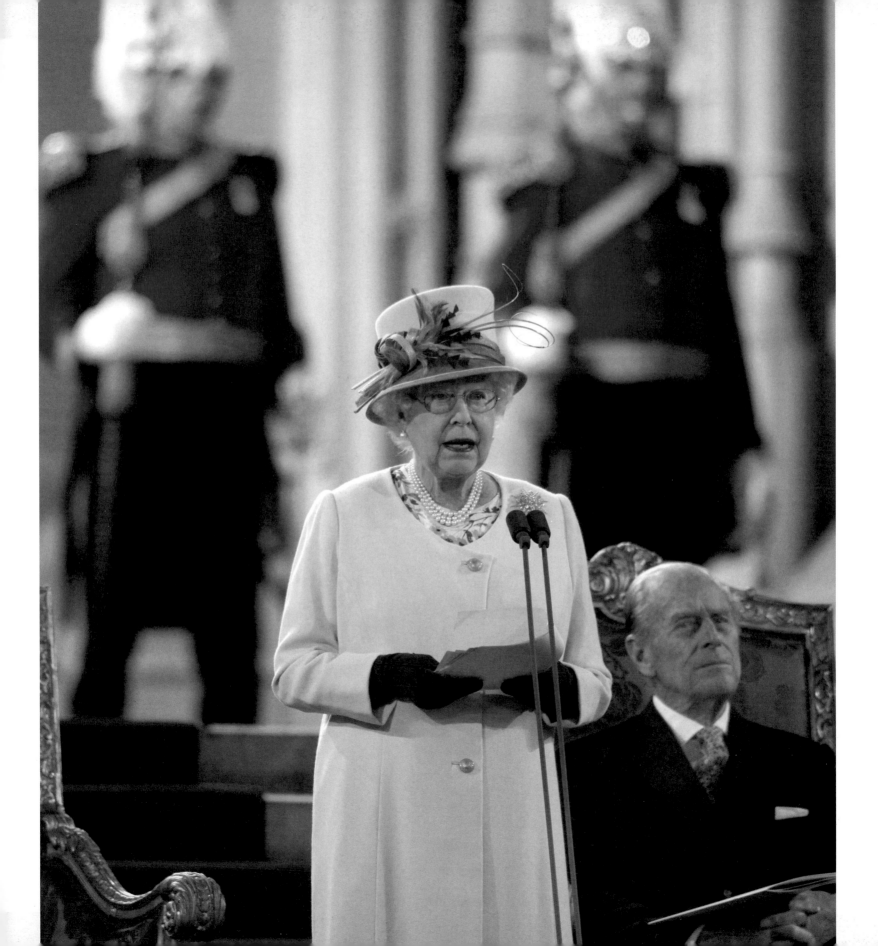

THE QUEEN OF STYLE

Throughout her reign the Queen has become known for her bright outfits designed to make her stand out from the crowds. Her Diamond Jubilee style was no exception, as she paraded every colour from bright pink to dazzling blue, diamond white to sunny yellow on her travels throughout the year.

The Queen also chose the landmark occasion to display some of her most meaningful pieces of jewellery, from the diamond and pearl shell brooch belonging to her late mother that she wore on her accession anniversary, to the striking diamond and sapphire brooch that once belonged to her grandmother, Queen Mary, which she chose for the Epsom Derby.

As has been the case with every outfit in her 60-year reign, each dress, coat and hat was meticulously planned in advance to perfectly suit the Queen and the occasion. From the decision to wear green for her trip to Northern Ireland to her choice of a white dress and coat to stand out against the red and gold of the Royal Barge during the Thames Diamond Jubilee Pageant, each piece of clothing helped to ensure that the Queen made the perfect impression.

Most of her outfits were crafted by her Personal Assistant and Senior Dresser Angela Kelly, who works only for the Queen and has forged a very close and trusting relationship with her since being employed by the Royal Family in 1993. In a 2007 interview Kelly said: "We are two typical women. We discuss clothes, make-up, jewellery. We say, 'Would this piece of jewellery look nice with that outfit?', and things like that."

However, the Queen also showed off the creations of other designers in 2012, wearing several pieces by Stewart Parvin, who designed her granddaughter Zara Phillips' wedding dress, and also an outfit by Karl Ludwig Rehse, who has been designing for her for more than 20 years.

The landmark occasion of the Diamond Jubilee called for some stunning new outfits, such as the glittering golden cocktail gown she wore to the concert outside Buckingham Palace. However, the Queen was also seen recycling some favourite pieces that she has worn in previous years, such as the pale pink coat and hat she wore on her March visit to Manchester.

And there are certain elements of the Queen's style that keep reappearing, such as her white or black satin gloves, the Swarovski crystals that decorated many of her Jubilee outfits, the pearl earrings and necklace and the handbag that she carries over her left arm.

RIGHT: **The Queen visits Dersingham Infant and Nursery School in King's Lynn, Norfolk, on the 60th anniversary of her accession, 6th February 2012.**

For the 60th anniversary of her accession the Queen reminded everyone of her close relationship with her parents by choosing a piece of jewellery that belonged to her late mother. The diamond and pearl shell brooch had been worn by the Queen Mother on her 100th birthday in 2000, and the Queen had it pinned to her left shoulder as she visited schoolchildren in Norfolk 12 years later.

She wore it with a grey, white and turquoise wool dress, coat and matching hat designed by Angela Kelly.

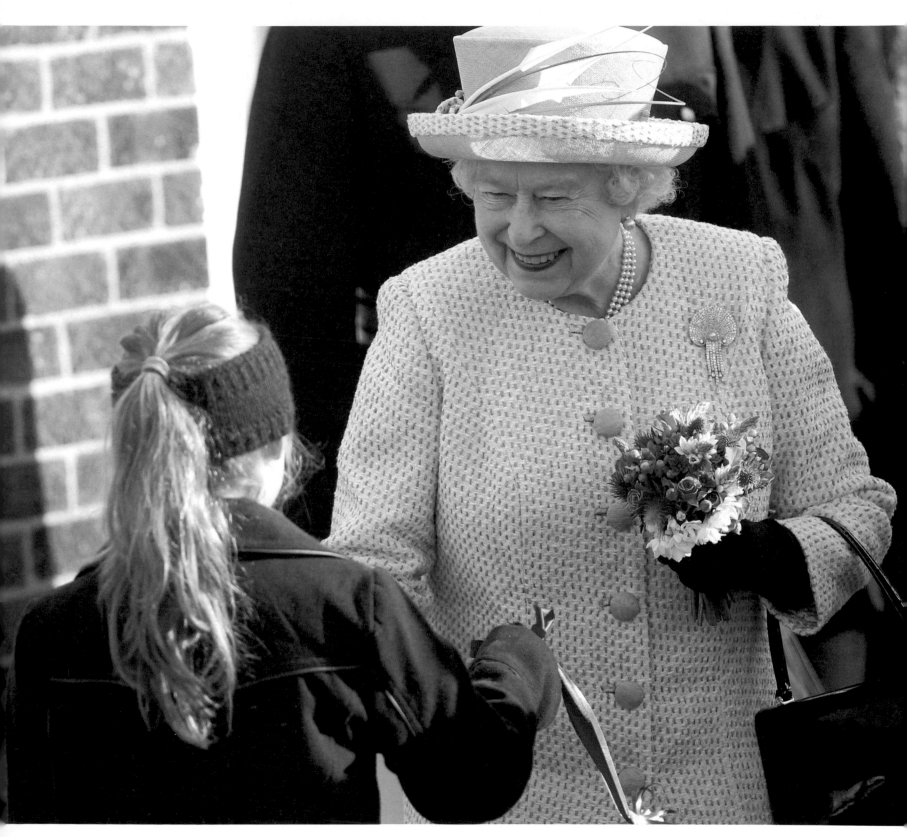

EPSOM DERBY

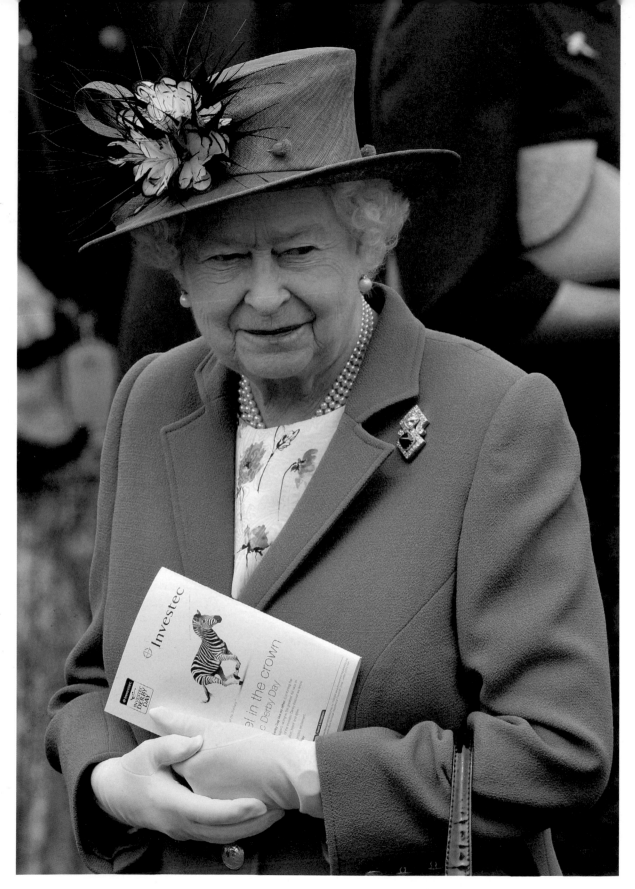

LEFT: The Queen attends the Epsom Derby on the first day of the Diamond Jubilee weekend, 2nd June 2012.

The Queen chose a rich royal blue to mark the start of the Diamond Jubilee extended weekend. Her crepe wool coat was worn over a white silk floral pattern dress, both designed by couturier Stewart Parvin. She teamed this with a matching hat by Rachel Trevor-Morgan, who has been one of the Queen's milliners since 2006. Pinned to her left shoulder was a striking brooch she had inherited 59 years ago in her Coronation year of 1953. The diamond and sapphire brooch had belonged to her grandmother, Queen Mary – given to her by her sister, the Empress Feodorovna of Russia, as a wedding present in 1893.

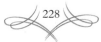

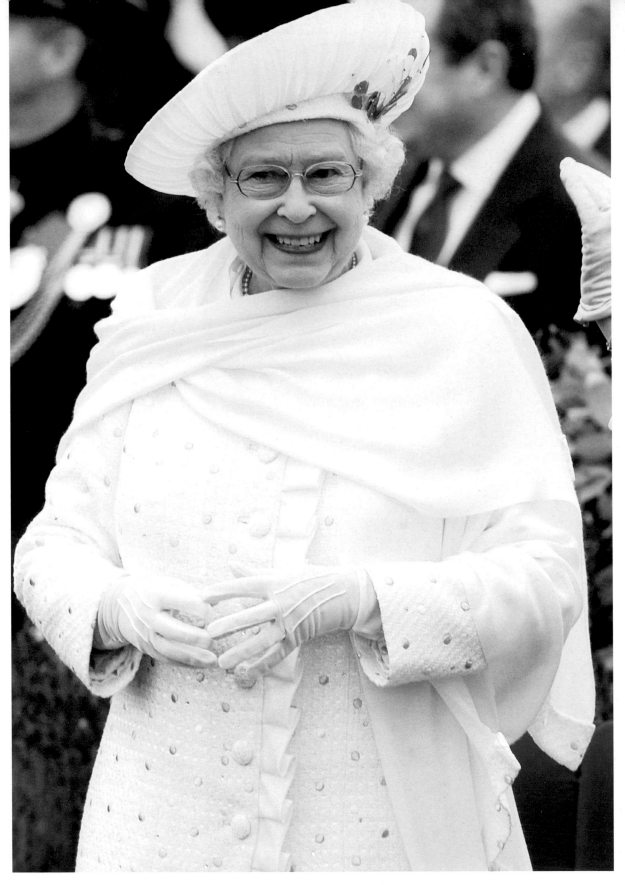

THAMES PAGEANT

LEFT: The Queen on Royal Barge the *Spirit of Chartwell* during the Thames Diamond Jubilee Pageant, 3rd June 2012.

One of the most talked about outfits of the Queen's Diamond Jubilee year, the dress and coat she wore for the Thames River Pageant, was in place over a year before the occasion. Designed by Angela Kelly to stand out against the rich colours of the Royal Barge, the sparkling white boucle dress and coat was braided with silk ribbon. In a nod to her three Jubilees it incorporated silver and gold spots and had crystals to represent diamonds. Her white hat also had a silver and gold decoration.

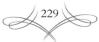

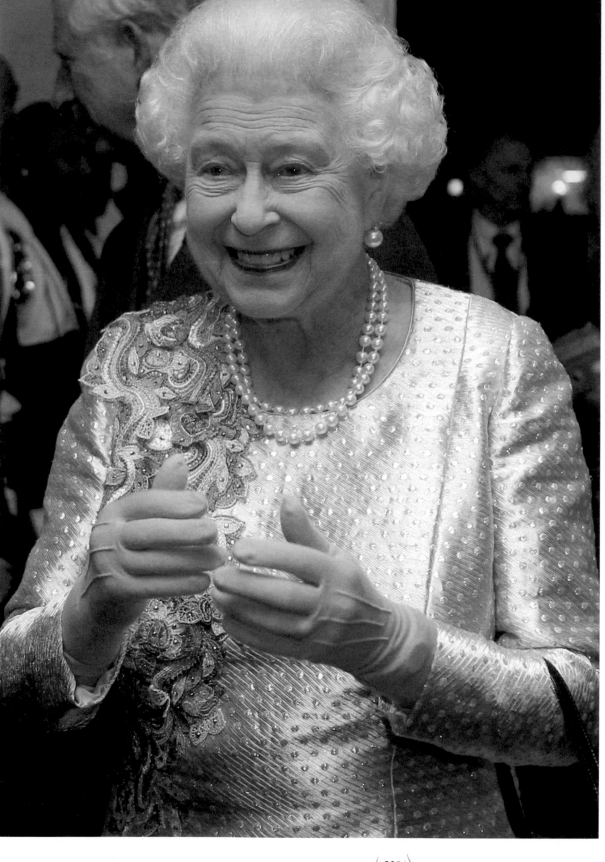

CONCERT

LEFT: The Queen backstage after the Diamond Jubilee concert at Buckingham Palace, 4th June 2012.

When the Queen arrived at the Buckingham Palace concert her outfit was concealed by a long black cape. But when she removed the cape to go on stage she shimmered in a stunning cocktail dress of gold lamé designed by Angela Kelly, with sweeping trimmings of antique gold lace and covered in Swarovski crystals. She chose not to wear anything on her head but was not without her silk gloves.

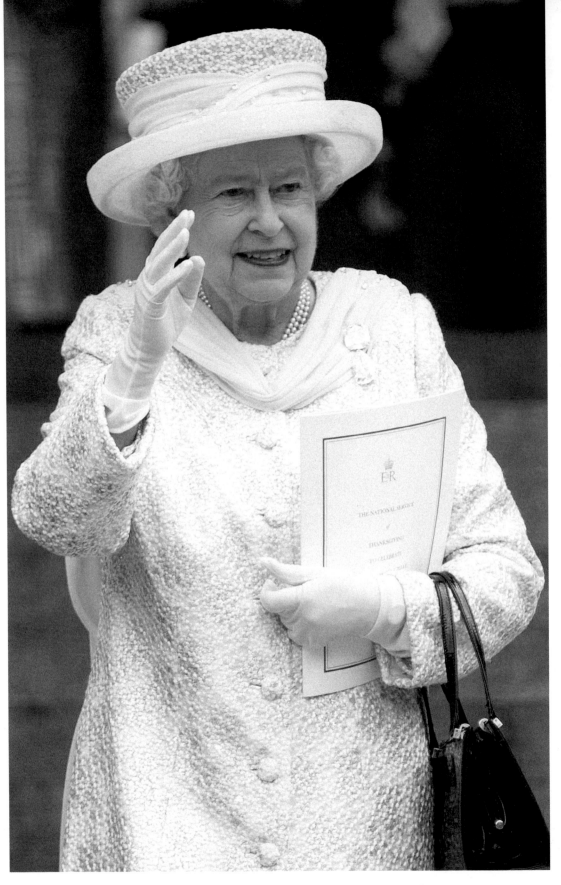

SERVICE OF THANKSGIVING

LEFT: The Queen waves to the crowds from the steps of St Paul's Cathedral following the Diamond Jubilee Service of Thanksgiving, 5ᵗʰ June 2012.

Another Angela Kelly creation, the mint green and white outfit the Queen wore to the Service of Thanksgiving was scattered with Swarovski crystals. The fine silk tulle dress was embroidered with tiny mint green star-shaped flowers embellished with silver thread, and the matching hat and coat also included pieces of mint green chiffon.

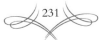

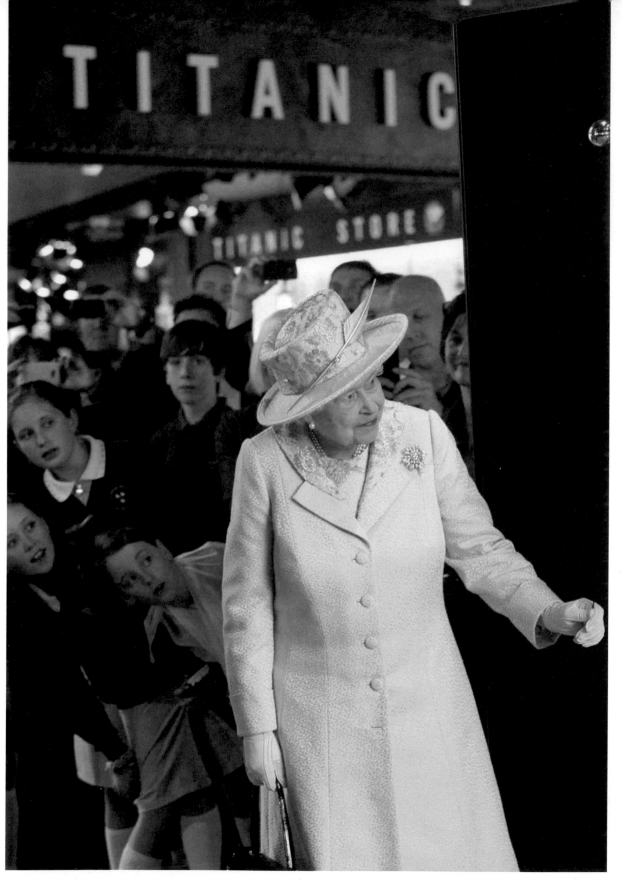

NORTHERN IRELAND

LEFT: The Queen visits the Titanic museum in Belfast during her visit to Northern Ireland, 27th June 2012.

The Queen chose a pale shade of green for her visit to Northern Ireland, with a matching dress, coat and hat designed by Angela Kelly. She teamed this with gloves by glove-maker Genevieve Lawson, who holds a royal warrant. She also wore a 38-diamond frosted sunflower brooch, a nod to the purpose of her visit as the sunflower has associations as a symbol of peace.

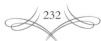

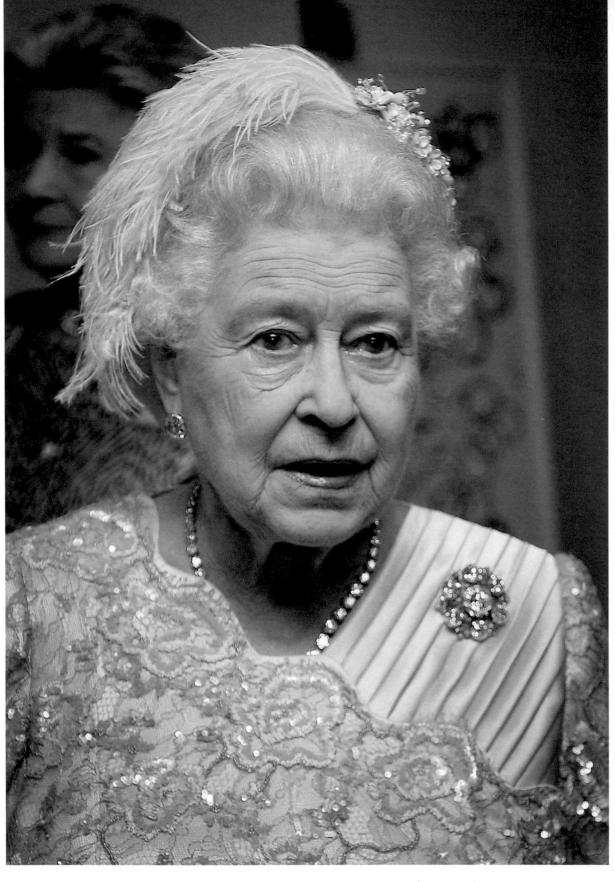

OLYMPIC GAMES OPENING CEREMONY

LEFT: The Queen at the Opening Ceremony of the London Olympic Games, 27th July 2012.

The Queen chose an Angela Kelly peach-coloured cocktail dress with a lace bodice and pleated skirt to perform a mock skydive into the Olympic Games Opening Ceremony.

Accessorized with a matching headpiece with handmade porcelain flowers, the Queen wore the outfit twice – once to film the scenes with Daniel Craig in Buckingham Palace, where she appeared to climb into a helicopter, and again at the Opening Ceremony to create the appearance of having travelled through the sky.

Her outfit was topped off with the glittering King William IV brooch, also known as his wife Queen Adelaide's brooch. Created in 1830 it consists of six large diamonds and several smaller ones, and was also worn by Queen Victoria.

A FASHIONABLE FAMILY

Every member of the Royal Family dressed to impress as the Diamond Jubilee put them centre stage at events broadcast across the world. Kate, whose clothes always attract international attention, showcased the creations of several British designers, including her wedding dress designer Sarah Burton for Alexander McQueen. The young duchess has become renowned for wearing outfits several times, and the Diamond Jubilee year was no exception, where she appeared in previously worn dresses, coats, shoes and accessories.

BELOW: **Members of the Royal Family on the steps of St Paul's Cathedral after the Diamond Jubilee Service of Thanksgiving, 5th June 2012.**

And she didn't just put designer clothes on display. Kate was also an ambassador for the high-street, choosing a Whistles dress for the Buckingham Palace concert.

Prince Charles' wife, Camilla, also championed British craftsmanship, often favouring the creations of couturier Bruce Oldfield.

As well as looking stylish in their own right, members of the Royal Family also have to make sure they are co-ordinated when they attend official engagements together. When the Queen invited Camilla and Kate on a visit to luxury London department store Fortnum & Mason in March the trio all wore varying shades of blue. And when Camilla, Sophie and Kate watched their husbands take part in the Order of the Garter Service they all chose matching shades of pastels and creams, with almost identical nude shoes.

Yet it wasn't just the women whose fashion attracted attention in the Diamond Jubilee year. Prince Harry joined Kate on Vanity Fair's international best-dressed list for the first time in 2012, hailed for the smart but casual wardrobe he showcased throughout the year.

BELOW: **The Queen, Camilla and Kate visit London department store Fortnum & Mason, 1st March 2012.**

The three most senior female royals in Britain chose varying shades of blue for their joint visit to Fortnum & Mason in March. The Queen led the way, wearing the department store's signature colour of duck-egg blue in an outfit by Angela Kelly. Camilla's nautical-themed dress is by Bruce Oldfield, and Kate chose a blue coat dress by Italian fashion house Missoni.

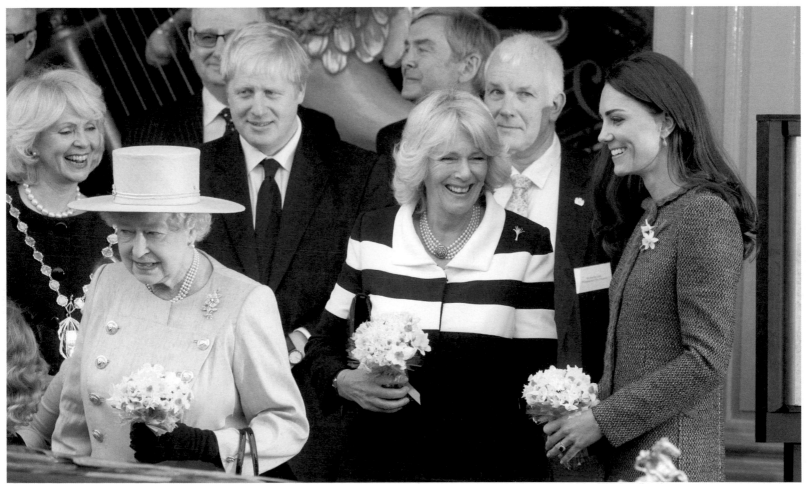

ABOVE: **Sophie, Countess of Wessex, shows off an extravagant hat by milliner Jane Taylor for a Westminster Abbey service to mark Commonwealth Day, 12th March 2012.**

RIGHT: **Camilla, Duchess of Cornwall, in a striking gold coat by Bruce Oldfield and hat by milliner Philip Treacy, 5th June 2012.**

BELOW: Princesses Beatrice and Eugenie on the steps of St Paul's Cathedral for the Diamond Jubilee Service of Thanksgiving, 5th June 2012.

Having been ridiculed for their outfits at the 2011 wedding of Prince William and Kate Middleton, Princesses Beatrice and Eugenie chose simple and stylish dresses in the Diamond Jubilee year. Complementing each other in shades of purple and blue, both wore Kurt Geiger shoes and hats by Stephen Jones.

Beatrice wore a coat-dress by Italian designer Kinder Aggugini and Eugenie's dress was by British designer Suzannah.

ABOVE: Sophie, Kate and Camilla in co-ordinated outfits for the Order of the Garter Ceremony, 18th June 2012.

This trio of royal ladies all chose matching shades of cream and pastel with almost identical nude heels to watch their husbands in the Order of the Garter Ceremony.

Kate's fondness for her LK Bennett nude heels has become well known and this picture prompted a spate of articles about how Sophie and Camilla had chosen to follow in her footsteps. Kate teamed her shoes with a coat-dress by Alexander McQueen and a hat by Jane Corbett. Camilla chose nude heels by Stuart Weitzman at Russell and Bromley with a cream Anna Valentine dress and dramatic Philip Treacy hat. Sophie opted for a bespoke suit by Bruce Oldfield and Jimmy Choo heels.

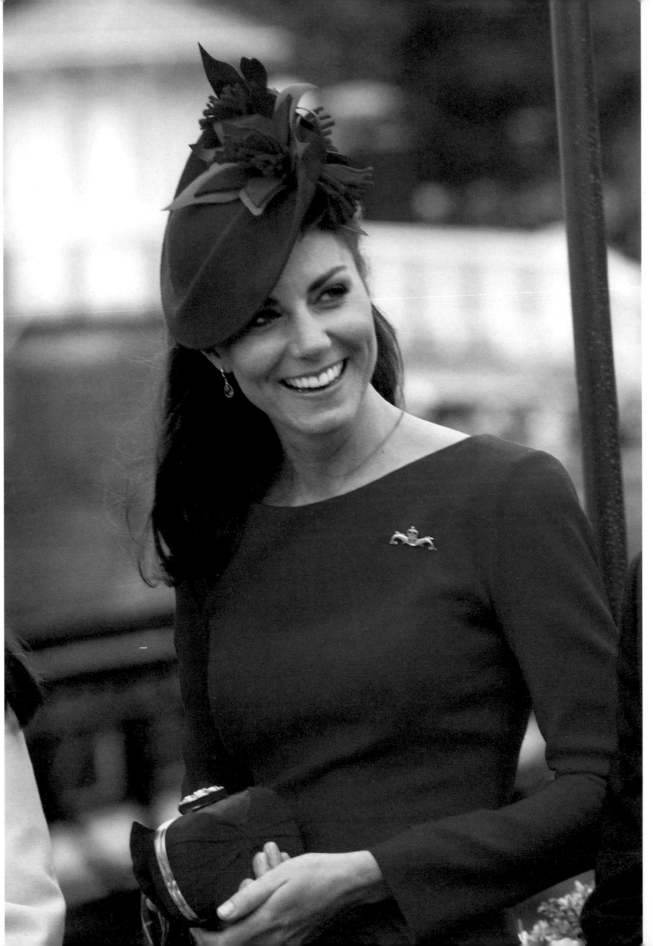

LEFT: Kate arrives for the Thames Diamond Jubilee Pageant, 3rd June 2012. She chose to showcase the designs of Alexander McQueen several times in the Jubilee year, picking a striking red dress to sail down the River Thames. And in a nod to her and William's Scottish titles of the Earl and Countess of Strathearn, Kate carried a Strathearn tartan scarf with her McQueen clutch handbag.

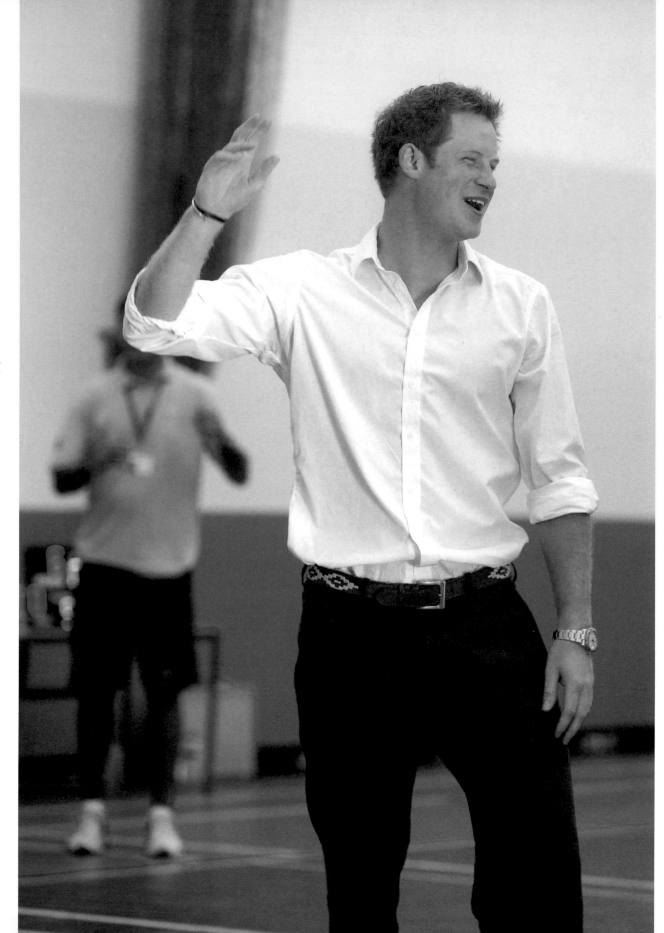

RIGHT: **Prince Harry jokes around on the basketball court at Bacon's College as he, Prince William and Kate launch their new sports coaching initiative, Coach Core, ahead of the London Olympic Games, 26th July 2012.**

CHAPTER TEN

A DIAMOND FUTURE

"We are reminded here of our past, of the continuity of our national story and the virtues of resilience, ingenuity and tolerance which created it. I have been privileged to witness some of that history and, with the support of my family, rededicate myself to the service of our great country and its people now and in the years to come."

Queen Elizabeth II Diamond Jubilee address to Parliament, 20th March 2012

RIGHT: **The Queen, Prince William, Kate and Prince Harry on the Buckingham Palace balcony on the final day of the Diamond Jubilee weekend, 5th June 2012.**

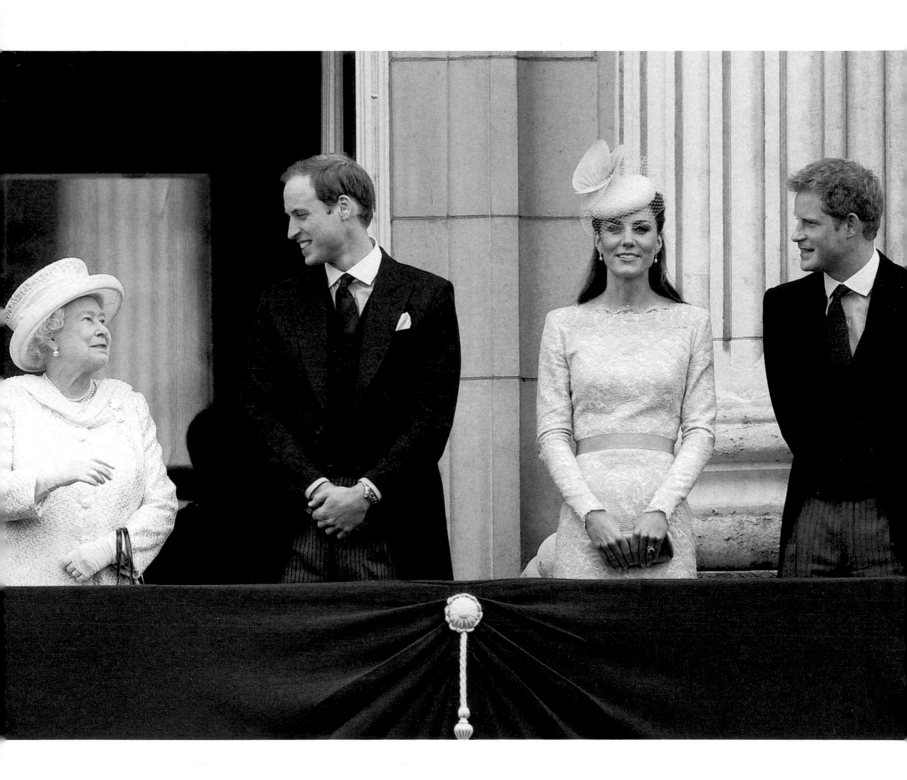

A QUEEN FOR EVERY AGE

Before the Diamond Jubilee celebrations were over some spoke of the possibility of the Queen celebrating a Platinum Jubilee in 10 years time. If she were to celebrate this milestone in 2022 she would be 95 years old, and Prince Philip would be 100.

With 2012 only just coming to a close, this seems a long way off, a distant possibility.

Yet the way the Queen continues to carry out hundreds of engagements every year despite already being well into her 80s suggests that this feat is anything but impossible.

Her cousin Margaret Rhodes, who chats with the Queen most Sundays, has said she will "never" retire.

She added: "She has said herself, 'It's a job for life. It has been a question of maturing into something that one has got used to and accepting that this is your fate'... She has a sense of duty and a lifelong commitment."

Yet even the Queen cannot defy the ageing process. In her Diamond Jubilee year she and Prince Philip did not travel abroad as they had done in her Silver and Golden Jubilees.

Instead the Queen dispatched her family, suggesting she is beginning to think about passing the baton of her huge workload to the younger generations of royals. And nothing could make her more confident in the long-term future of the Monarchy than the way Prince William and Kate have captivated the world since their wedding in April 2011.

Prince Charles, too, saw a surge in popularity in the Diamond Jubilee year, with polls after the June weekend suggesting the public's affection for him had rocketed. After years of turmoil following the breakdown of his marriage to the "People's Princess" Diana and the public's reluctance to accept his new wife, Camilla, the heir to the throne had finally found a secure place in the nation's hearts.

And the Queen could also be proud that royals highly unlikely to inherit the throne were carving a future for themselves based on their achievements. Prince Andrew's daughter Eugenie followed in her sister Beatrice's footsteps by gaining her university degree in 2012, and Princess Anne's daughter Zara Phillips made history with her London 2012 Olympic silver medal.

In a 2012 interview with US TV network ABC to mark his grandmother's Diamond Jubilee Prince William said: "There's such scrutiny on the job you have to be very very careful how you carve your path but I think she's done it brilliantly."

What the Queen herself thinks of her 60 years remains something of a mystery, since throughout her reign she has never given an interview, and those around her say she never will. Instead, it is through her actions that she has spoken to her people, by quietly carrying out her work day in day out, making herself indispensable to every government, to every generation.

William's brother Harry told ABC in the Diamond Jubilee year: "She has managed to get the family to move with the

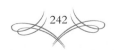

times and I think that's incredibly important. You can't get stuck in an old age situation when everything around you is changing."

One day the time will come when her authority and her duties are passed on to the new generation – maybe in five years' time, maybe in 10 years, maybe not for another 15 or even 20 years.

But no matter what age Queen Elizabeth II reaches, no matter how long her reign, her appeal will always remain timeless. She is a Diamond Queen for every generation.

BELOW: **The Queen and Kate chat while visiting Leicester together at the launch of the Queen and Prince Philip's Diamond Jubilee UK tour, 8th March 2012.**

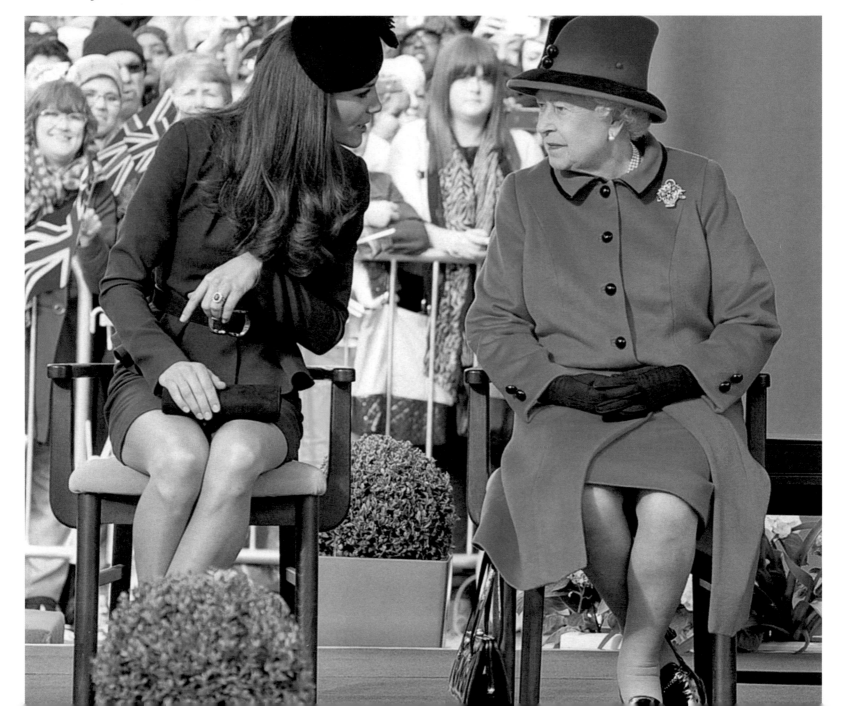

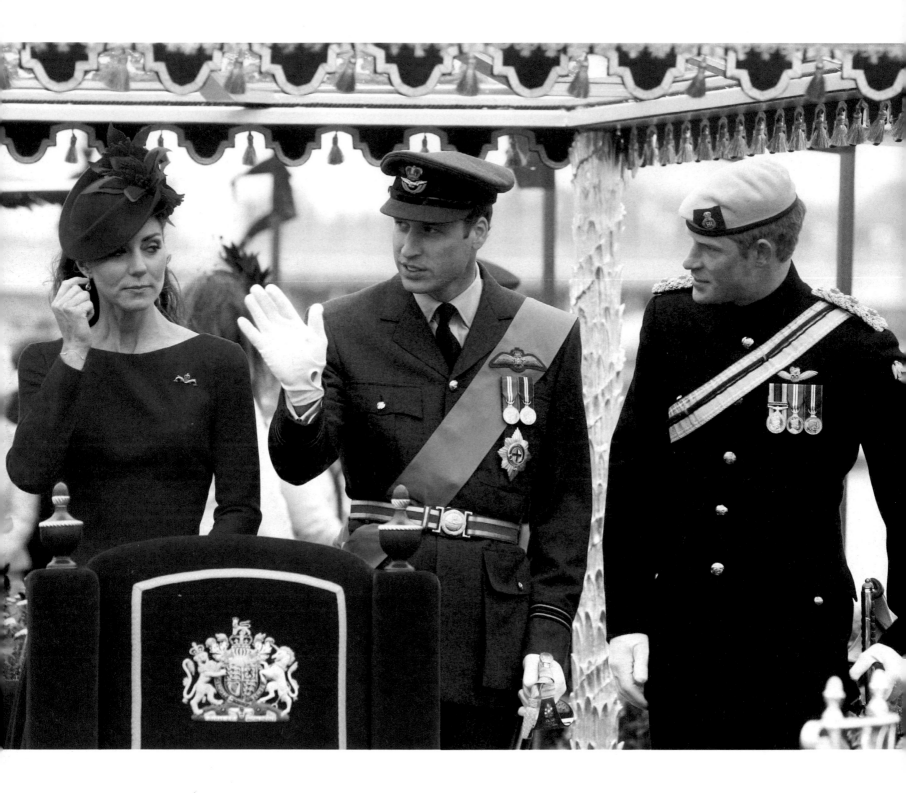

ABOVE: Prince William, Kate and Prince Harry on Royal Barge the *Spirit of Chartwell* during the Thames Diamond Jubilee Pageant, 3rd June 2012.

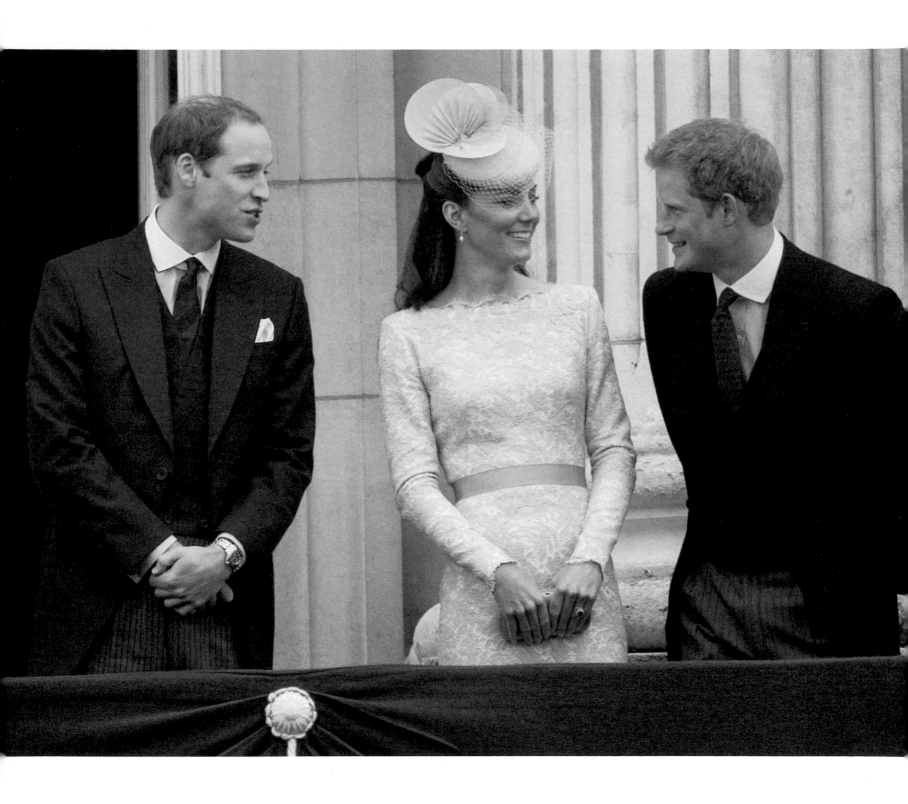

ABOVE: Prince William, Kate and Prince Harry on the Buckingham Palace balcony on the final day of the Diamond Jubilee weekend, 5th June 2012.

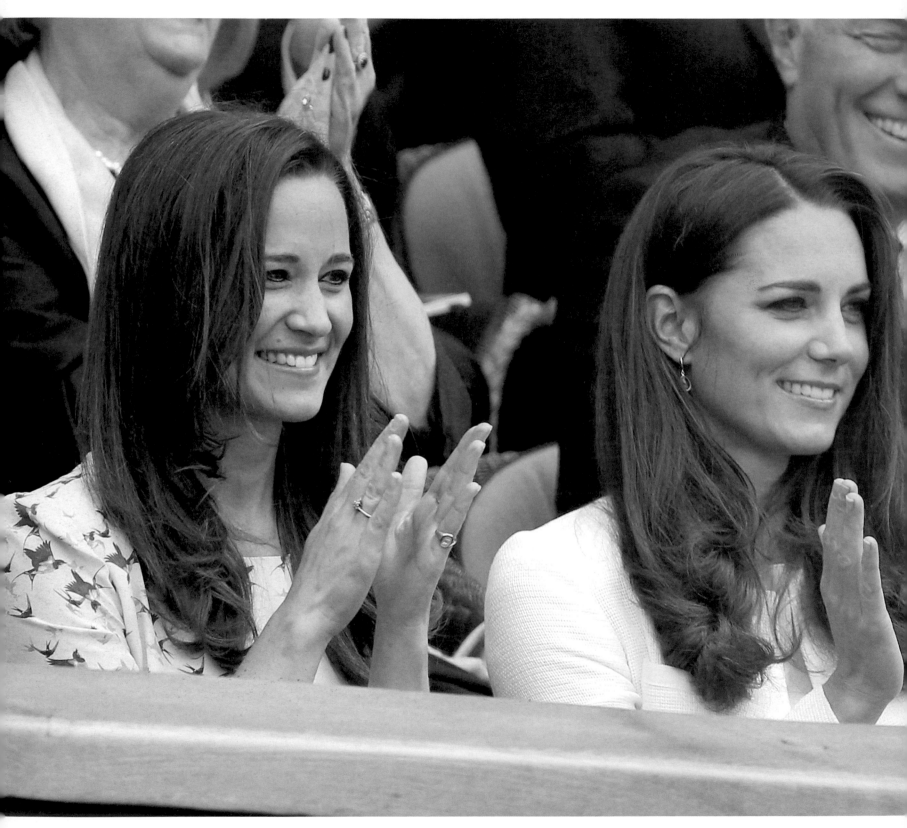

LEFT: Kate and her sister Pippa Middleton cheer on British tennis player Andy Murray in the Wimbledon final from the royal box. Murray was aiming to be the first Brit since Fred Perry in 1936 to win the men's singles, but he lost to Roger Federer in four sets, 8th July 2012.

RIGHT: Princess Eugenie graduates from Newcastle University with a 2.1 combined degree in English and History of Art, 11th July 2012.

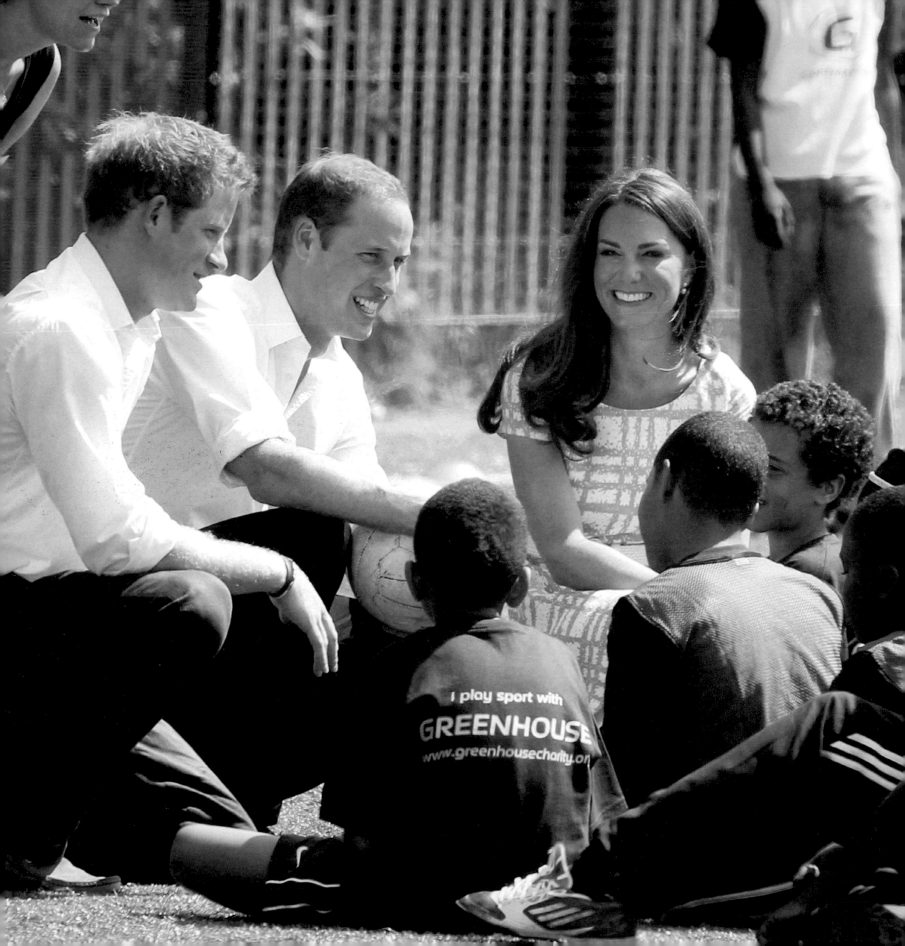

ABOVE: **Prince William, Kate and Prince Harry sit behind Prime Minister David Cameron and his wife, Samantha, at the Opening Ceremony of the London Olympic Games, 27th July 2012.**

LEFT: **Prince William, Kate and Prince Harry meet children at Bacon's College, London, to launch their new programme, Coach Core, which aims to train the next generation of sports coaches, 26th July 2012.**

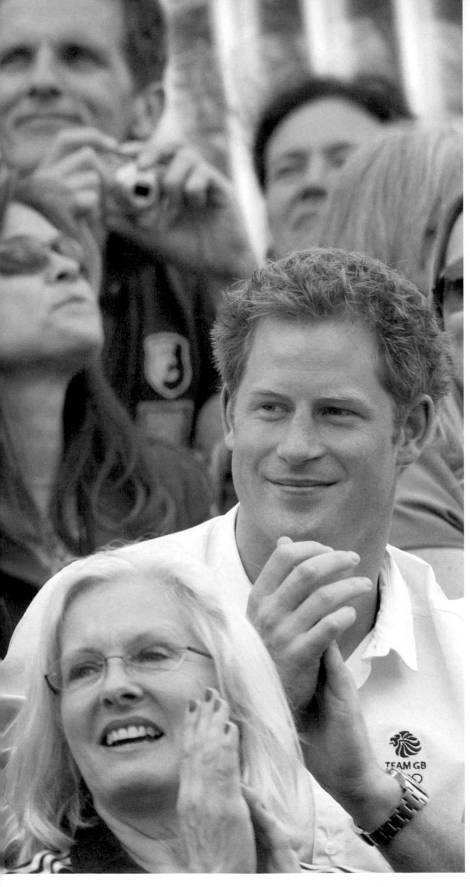

LEFT: Prince William, Kate and Prince Harry cheer on their cousin Zara Phillips as she competes on High Kingdom in the British equestrian team at the London Olympic games, 31st July 2012.

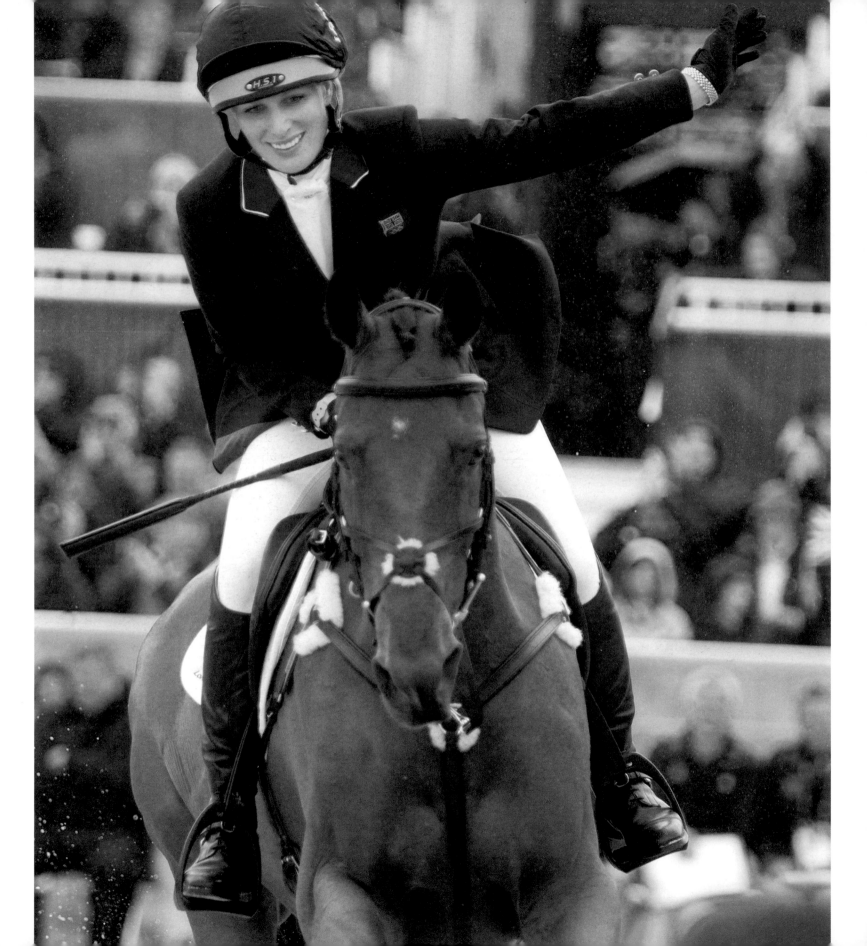

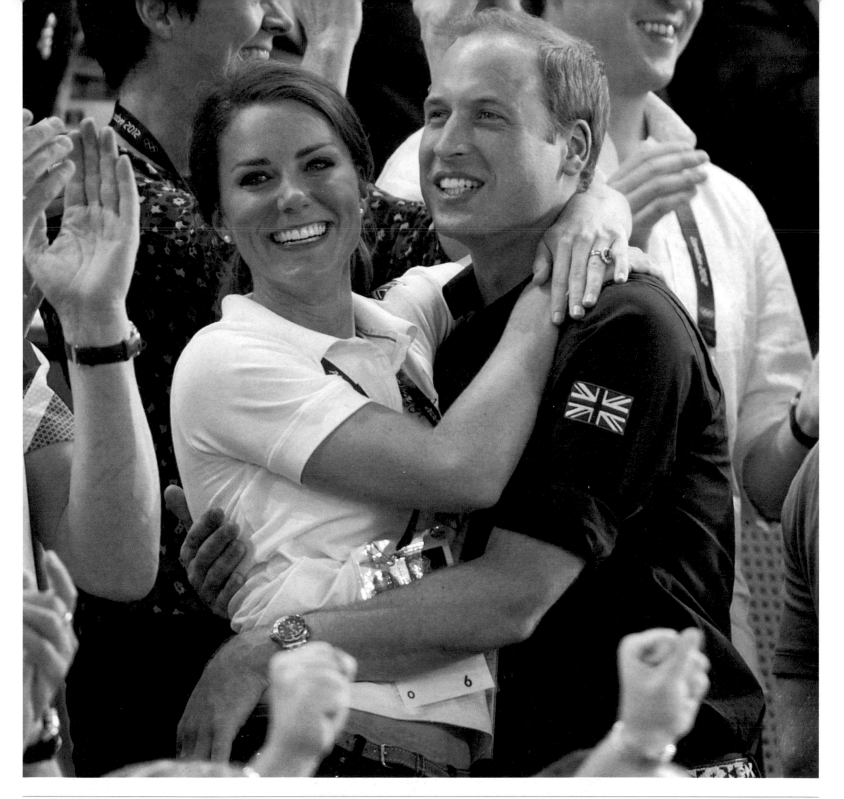

ABOVE: **Prince William and Kate hug as the British men's sprint team take gold in the cycling at the London Olympic Games, 2nd August 2012.**

LEFT: The Queen's granddaughter Zara Phillips riding her horse High Kingdom during the London Olympic Games, 31st July 2012.

"Thank you all."

Queen Elizabeth II message of thanks to the nation following the extended weekend of Diamond Jubilee celebrations, 5th June 2012

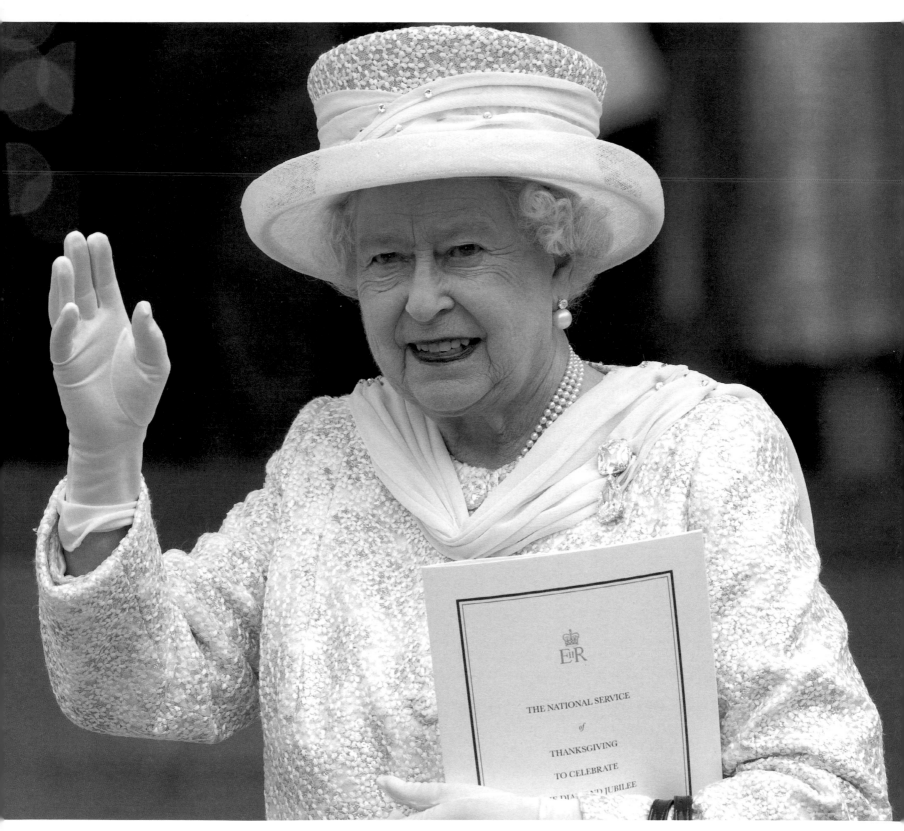

THANKS AND ACKNOWLEDGEMENTS

This book comes at the end of an extremely busy and exciting year for the Royal Family, and therefore an extremely busy and exciting year for this Royal Reporter.

I feel very proud and lucky to have enjoyed a ring-side seat at all the major events the Queen and Royal Family have taken part in during 2012, and to in some small way have helped document their history through my work.

However, this account of the Diamond Jubilee would not have been possible without the expertise of many people.

I would like to thank Richard Havers and the team at Haynes Publishing for giving me the opportunity to write this book and for their tireless work in making it a reality.

It was not easy sifting through the thousands of incredible pictures taken by *Mirror* and *Reuters* photographers to select the best ones to tell this story, and it would have been impossible without the expert help of Fergus McKenna, David Scripps and the team at Mirrorpix.

I would like to thank the editorial team at the *Daily Mirror* for giving me the opportunity to report on such an exciting beat: *Daily Mirror* and *Sunday Mirror* Editor Lloyd Embley, *Mirror* Editor (Weekdays) Peter Willis and Head of Content Chris Bucktin. And thanks also to Group Managing Editor Eugene Duffy and Deputy Managing Editor Aidan McGurran for their support and advice, and former *Daily Mirror* Editor Richard Wallace for giving me the Royal Reporter position in December 2010.

Since I started in the role I have got to know many members of the Buckingham Palace and St James' Palace press offices and I would like to thank them for always being ready and willing to assist with any query, particularly Ailsa Anderson and Ed Perkins at Buckingham Palace and Miguel Head and Nick Loughran at St James' Palace.

Finally, I would like to thank my nearest and dearest for supporting me unconditionally in everything I choose to do.

They are my parents Elizabeth and David, my sisters Caroline and Louise, and my wonderful boyfriend Gary.